Put any picture you want on any state book cover. Makes a great gift. Go to www.america24-7.com/customcover

*Utah 24/7* is the sequel to *The New York Times* bestseller *America 24/7* shot by tens of thousands of digital photographers across America over the course of a single week. We would like to thank the following sponsors, the wonderful people of Utah, and the talented photojournalists who made this book possible.

**SALT LAKE CITY**
"This is the place," proclaimed the Mormon prophet and president Brigham Young when he and his 148 pioneers arrived at the mouth of a mountain canyon above the Salt Lake Valley on July 24, 1847.
*Photo by Chuck Wing, Deseret Morning News*

**DK**

LONDON, NEW YORK, MUNICH, MELBOURNE, and DELHI

Created by Rick Smolan and David Elliot Cohen

24/7 Media, LLC
PO Box 1189
Sausalito, CA 94966-1189
www.america24-7.com

First Edition, 2004
04 05 06 07 08 10 9 8 7 6 5 4 3 2 1

Published in the United States by
DK Publishing, Inc.
375 Hudson Street
New York, NY 10014

DK Publishing, Inc. offers special discounts for bulk purchases for sales promo-
tions or premiums. Specific, large-quantity needs can be met with special
editions, personalized covers, excerpts of existing guides, and corporate
imprints. For more information, contact:

Special Markets Department
DK Publishing, Inc.
375 Hudson Street
New York, NY 10014
Fax: 212-689-5254

Cataloging-in-Publication data is available
from the Library of Congress
ISBN 0-7566-0085-5

Printed in the UK by Butler & Tanner Limited

First printing, October 2004

**ARCHES NATIONAL PARK**
Two natural phenomena—the lunar eclipse
of May 15, 2003, and the Delicate Arch—
shape the view in eastern Utah.
*Photo by Jim Hardy*

# UTAH 24/7

## 24 Hours. 7 Days.
## Extraordinary Images of
## One Week in Utah.

Created by Rick Smolan and David Elliot Cohen

DK Publishing

# About the America 24/7 Project

A hundred years hence, historians may pose questions such as: What was America like at the beginning of the third millennium? How did life change after 9/11 and the ensuing war on terrorism? How was America affected by its corporate scandals and the high-tech boom and bust? Could Americans still express themselves freely?

To address these questions, we created *America 24/7*, the largest collaborative photography event in history. We invited Americans to tell their stories with digital pictures. We asked them to shoot a visual memoir of their lives, families, and communities.

During one week in May 2003, more than 25,000 professionals and amateurs shot more than a million pictures. These images, sent to us via the Internet, compose a panoramic yet highly intimate view of Americans in celebration and sadness; in action and contemplation; at work, home, and school. The best of these photographs, more than 6,000, are collected in 51 volumes that make up the *America 24/7* series: the landmark national volume *America 24/7*, published to critical acclaim in 2003, and the 50 state books published in 2004.

Our decision to make *America 24/7* an all-digital project was prompted by the fact that in 2003 digital camera sales overtook film camera sales. This techno-logical evolution allowed us to extend the project to a huge pool of photographers. We were thrilled by the response to our challenge and moved by the insight offered into American life. Sometimes, the amateurs outshot the pros—even the Pulitzer Prize winners.

The exuberant democracy of images visible throughout these books is a revela-tion. The message that emerges is that now, more than ever, America is a supersized idea. A dreamspace, where individuals and families from around the world are free to govern themselves, worship, read, and speak as they wish. Within its wide margins, the polyglot American nation manages to encompass an inexplicably complex yet workable whole. The pictures in this book are dedicated to that idea.

—*Rick Smolan and David Elliot Cohen*

American nightlight: More than a quarter of a billion people trace a nation with incandescence in this composite satellite photograph.
*Photo by Craig Mayhew & Robert Simmon, NASA Goddard Flight Center/Visions of Tomorrow*

# 16 Cows, 66 Oxen

*by Lee Benson*

There is a place in the northern part of Utah, away from the cities, the salt flats, the reservations and the ski resorts, where two railroads once met and the present collided head-on with the past.

They drove a golden spike into the ground at Promontory Point that tenth day of May, 1869, connecting East to West, the Golden Gate to the Empire State, and the territory of Utah to the nation. What had begun 22 years before as a refuge for a religion on the run—when 148 Mormon pioneers, 16 cows, and 66 oxen settled the barren, uninhabited valley of the Great Salt Lake, then still a part of Mexico—became, overnight, a station on the main line.

Collisions between past and present have continued unabated ever since. As the photographs on these pages show, Utah is a place of contrast and change, of diversity and conformity. It's a difficult state to define: It is a desert famous for its snow with enough saltwater to cover Rhode Island, yet the closest ocean is 700 miles away. Utah's signature basketball team is the Jazz, while its signature musical group is the Mormon Tabernacle Choir. Butch Cassidy was born here and so was Marie Osmond. Its mountains contain both the largest open-pit copper mine on Earth and vast expanses of federally protected wilderness that can never be touched.

All the while, the landscape is transformed. Cities grow while red rock canyons shrink. Developers in their SUVs replace farmers on their John

**WELLSVILLE**
The Wellsville Ridge, designated a federal wilderness area in 1984, rises from the fertile Cache Valley to heights of more than 9,000 feet. Once devastated by overgrazing, its 23,000 acres now support moose, mountain lions, bighorn sheep, hawks, and eagles.
*Photo by Eli Lucero*

Deeres. The slick rock around Moab, once cursed by cowboys because their horses couldn't get traction, is now toasted by mountain bikers because it gives perfect traction to their fat tires. Park City, once the world's richest silver mountain is now home to the world's richest skiers.

Despite the ever-shifting landscape and continual tugs-of-war for control, the past resolutely keeps its grip. Nearly 70 percent of the state's population retains membership in the Church of Jesus Christ of Latter-day Saints, hearkening back, in one form or another, to those 148 pioneers, 16 cows, and 66 oxen. And the roots of temperance show. Utah remains dead last in the nation in per-capita alcohol consumption but first in the consumption of Jell-O. It has the highest birthrate in the country, the largest households, and the second-lowest death rate and poverty level. When the Olympic Winter Games were held in Salt Lake City and the vicinity in 2002, a one-for-all community spirit showed itself when more than 25,000 Utahns volunteered to help put on the games for no pay. The turnover rate in personnel during the three-week event was less than 4 percent.

And what of the golden spike that in large measure got everything started? They dug it up and put it in a museum in California. The train hasn't run past Promontory Point in years.

---

*Native Utahn* LEE BENSON *has been a columnist at the* Deseret Morning News *for 25 years. A graduate of Brigham Young University, he lives with his family in Park City.*

**SALT LAKE CITY**
State Street stretches southward from the
Utah State Capital Building for 22 miles.
This main thoroughfare is part of Salt Lake
City's original grid pattern—10-acre squares
separated by 132-foot-wide streets—laid out
by surveyors in 1848.
*Photo by Ravell Call, Deseret Morning News*

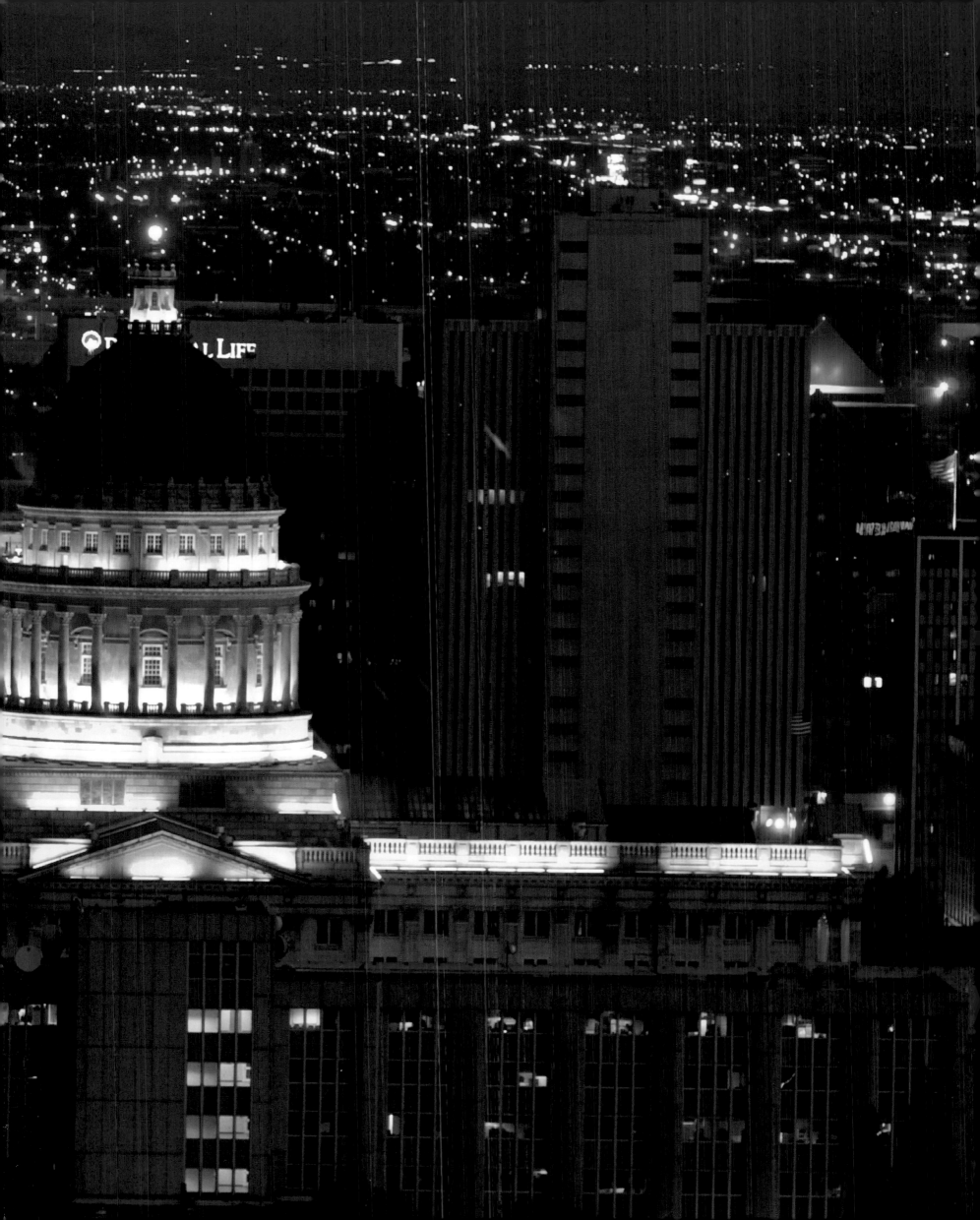

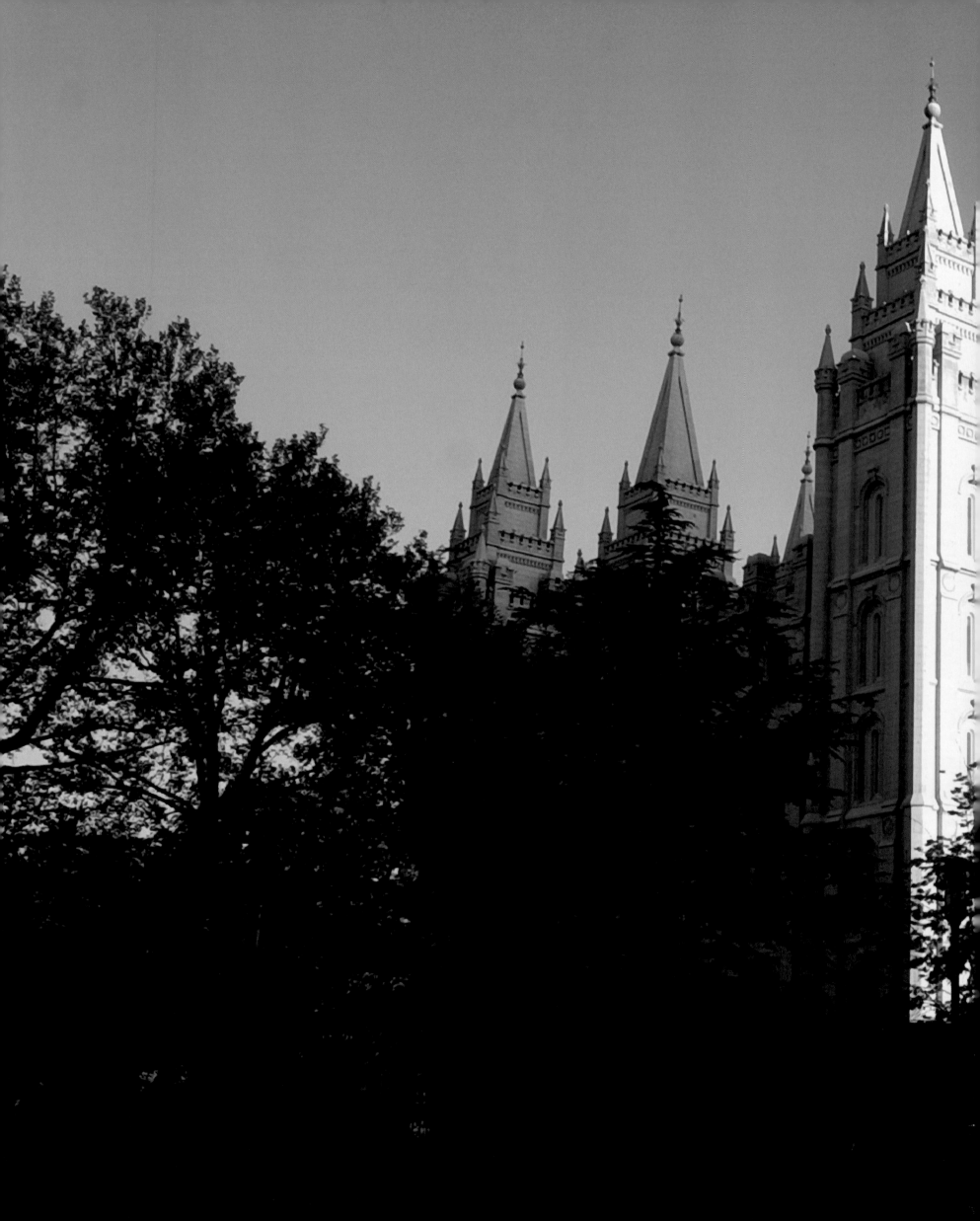

**SALT LAKE CITY**
Brigham Young's brother-in-law designed the 225-foot-tall Salt Lake Temple with Gothic and Romanesque lines reaching toward the heavens. The designer intended the temple to "appear distinctive without seeming strange," says Paul Anderson, a curator at the Brigham Young University Museum of Art.
*Photo by Scott G. Winterton,*
*Deseret Morning News*

**BONNEVILLE SALT FLATS**
The Bonneville Salt Flats, a remnant of the once vast Pleistocene-Era Lake Bonneville, are so flat that some who walk the crystalline surface claim to detect the earth's curve. A shallow layer of water floods the 30,000-acre flats each winter and dries by summer, leaving a level crust of salt that's rendered smooth by the winds.
*Photo by Trent Nelson*

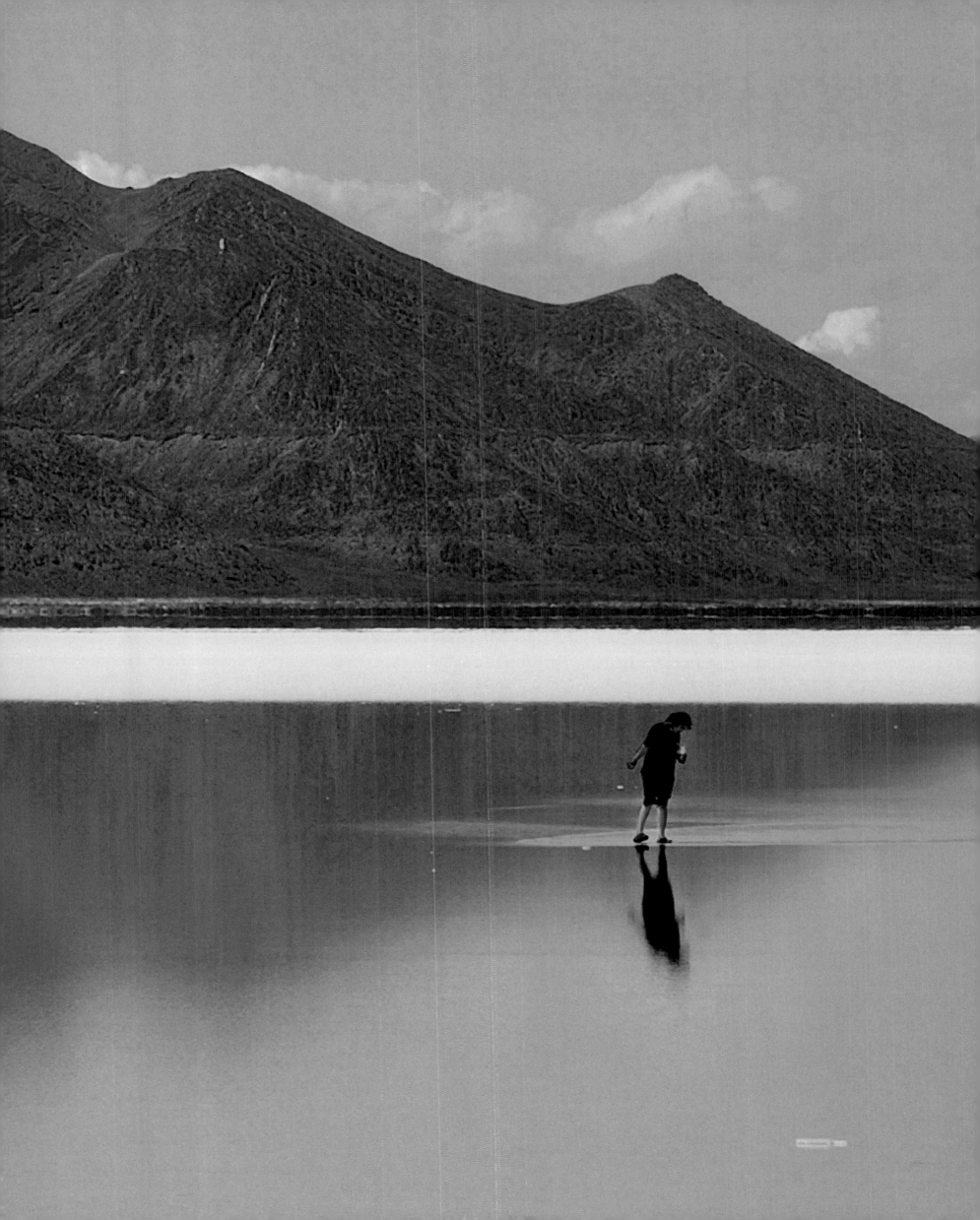

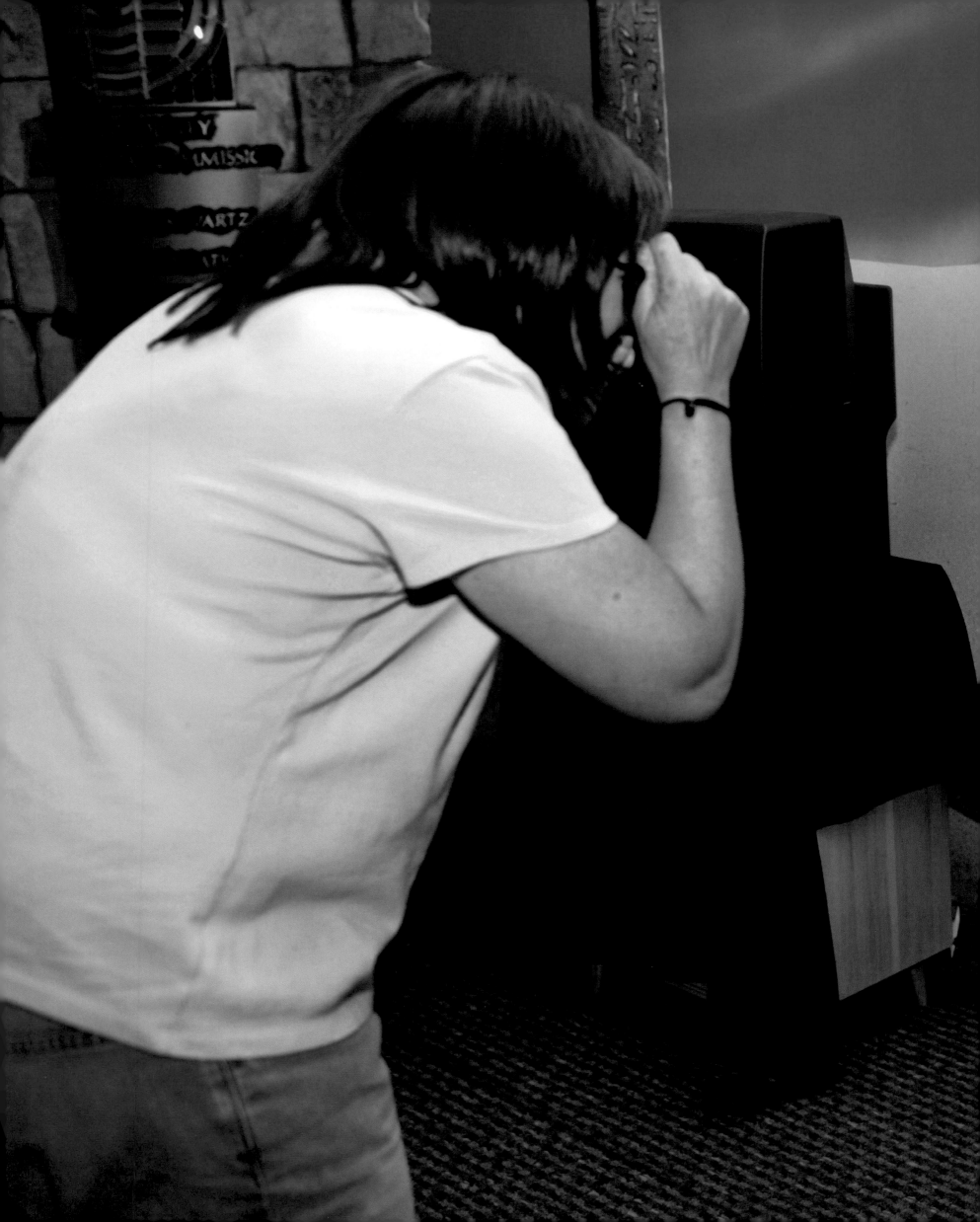

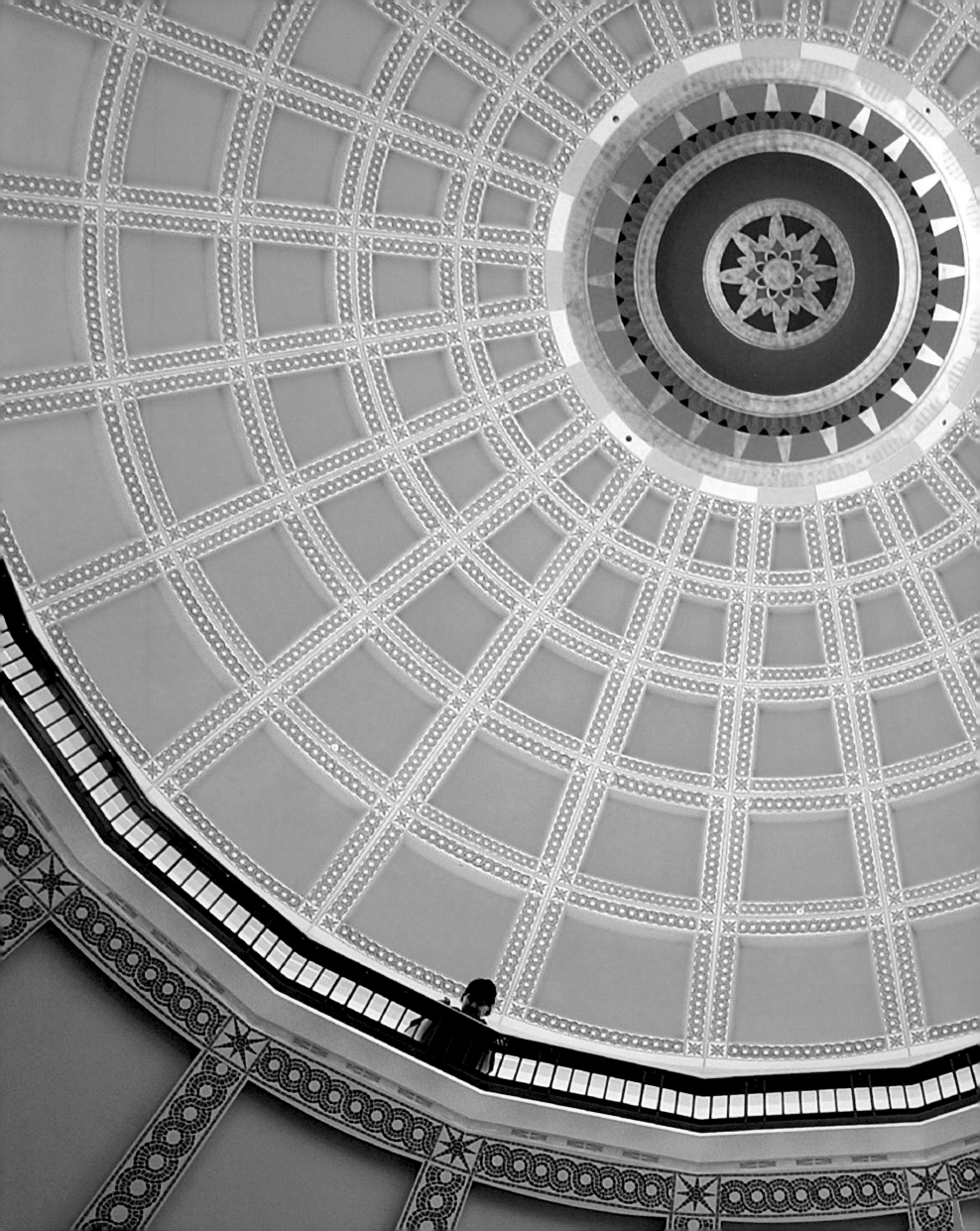

**SALT LAKE CITY**
Janitorial services provider Mario S. Ocampo peeks over the railing beneath the retro rotunda of the state's Scott Matheson Courthouse, built in 1997.
*Photo by Johanna Kirk,*
*Deseret Morning News*

**FARMINGTON**

After work, Ed Johnson unwinds during a game of elevator with his 3-year-old daughter Eliza. She is a unique middle child—with twin older sisters, 7, and twin younger brothers, 10 months.

*Photo by Ravell Call, Deseret Morning News*

Hearth & Home

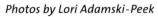

**PROVO**

George and Rebecca Monsivais have 15 children. After their 12th child, George had a dream that his wife was pregnant again. "That made us feel we were supposed to continue," adds Rebecca. They have, however, decided that Emma, 3, will be their last. Absent are sons Jacob and Hiram who are completing their two-year missions for the Mormon Church.

*Photos by Lori Adamski-Peek*

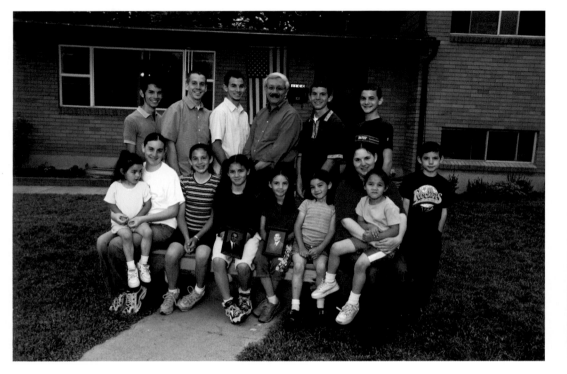

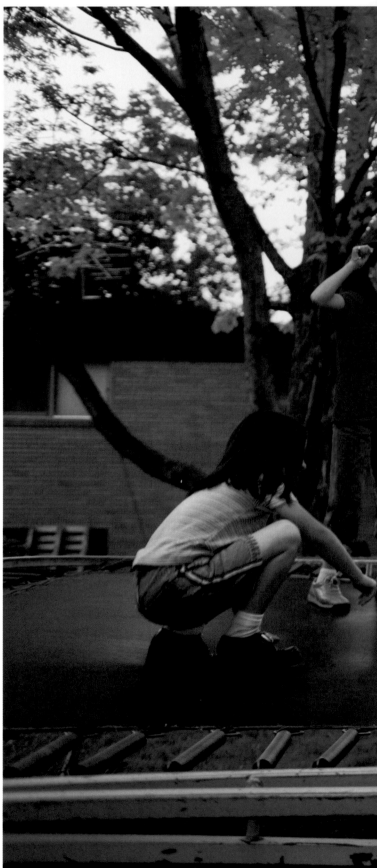

**PROVO**

A quartet of Monsivais play trampoline games in the backyard. To help reduce friction and keep things flowing in the house, the family has three televisions, three refrigerators, two washers, and two dryers. All the children share clothes and double up in the home's six bedrooms.

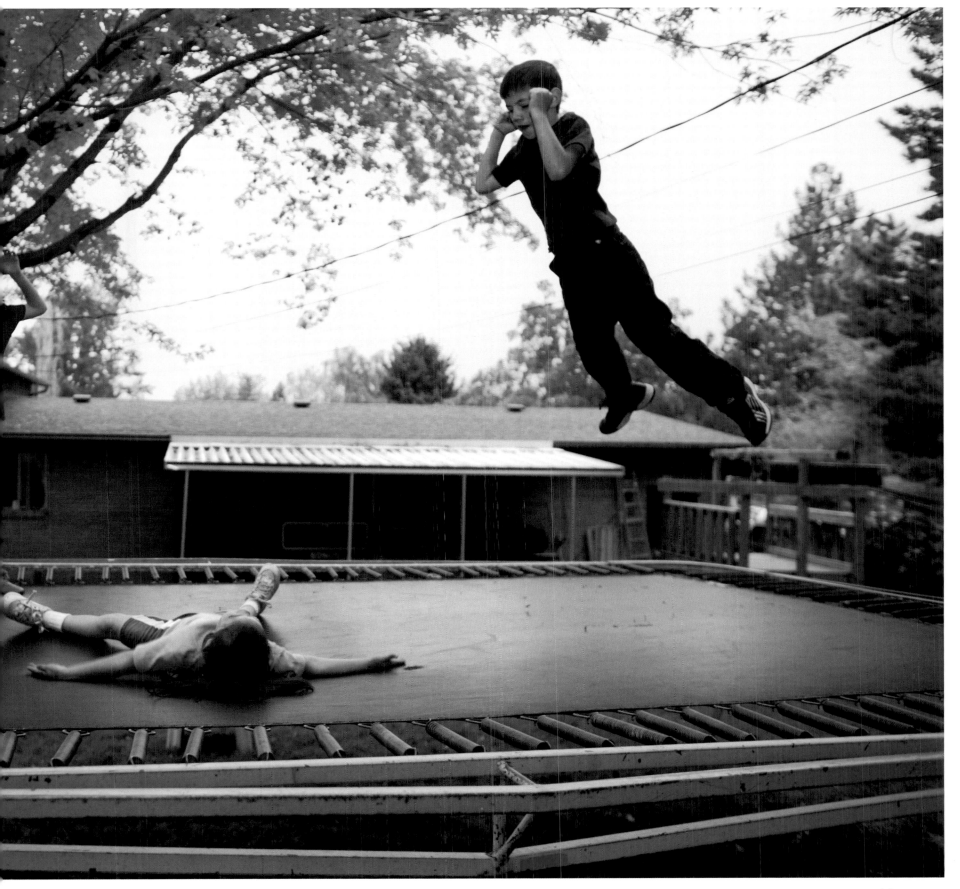

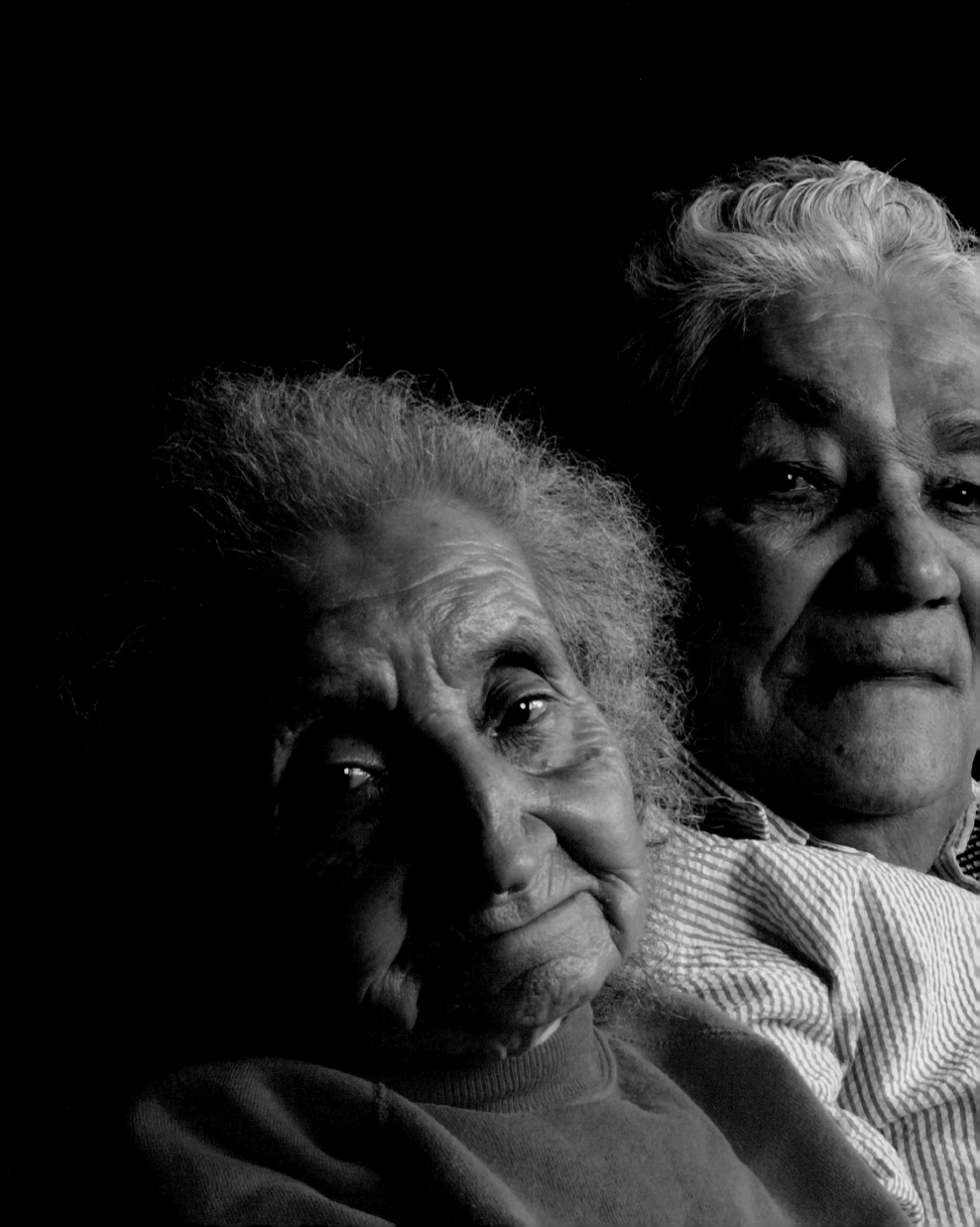

**SALT LAKE CITY**
Susie Archuleta, Isidora Garcia, Rose Rodriguez, Hyrum Orullian, and Mary Etta Waschau spend a good part of most days at Neighborhood House, an adult day care center. "We give our visitors' caregivers some relief," says Executive Director Victoria Mori. "And it seems the seniors who come here don't feel so isolated."
*Photo by Ravell Call, Deseret Morning News*

**SALT LAKE CITY**

Newlyweds Kelly and Rebecca Bartlett's romance ignited when they met on the Weber State track field and she beat him at both discus and hammer. The young students, 6'3" and 6'2" respectively, found they had more than sports in common. According to Rebecca, "He said, 'If you want to hang out, call me.' So I did."
*Photos by Ravell Call, Deseret Morning News*

**SALT LAKE CITY**

After the wedding, Rebecca Bartlett couldn't wait to kick off her heels. Both she and husband Kelly are superb athletes. She's attending Weber on a track scholarship; Kelly played high school football and was offered a baseball scholarship to a junior college—despite a prosthetic lower leg starting four inches below the knee.

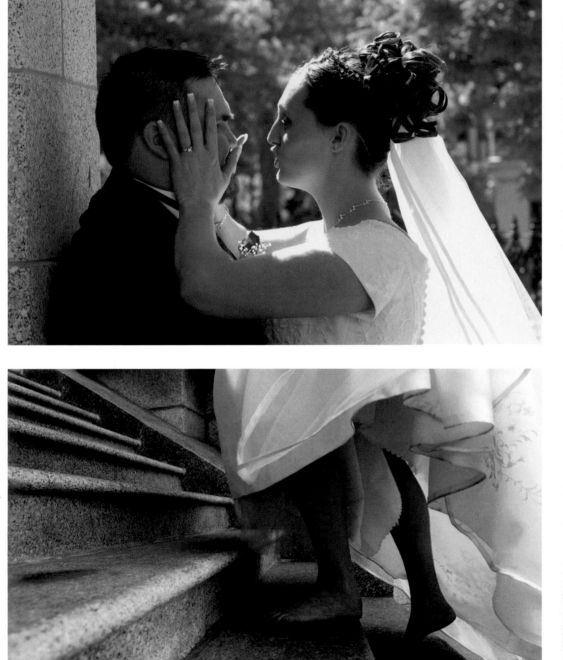

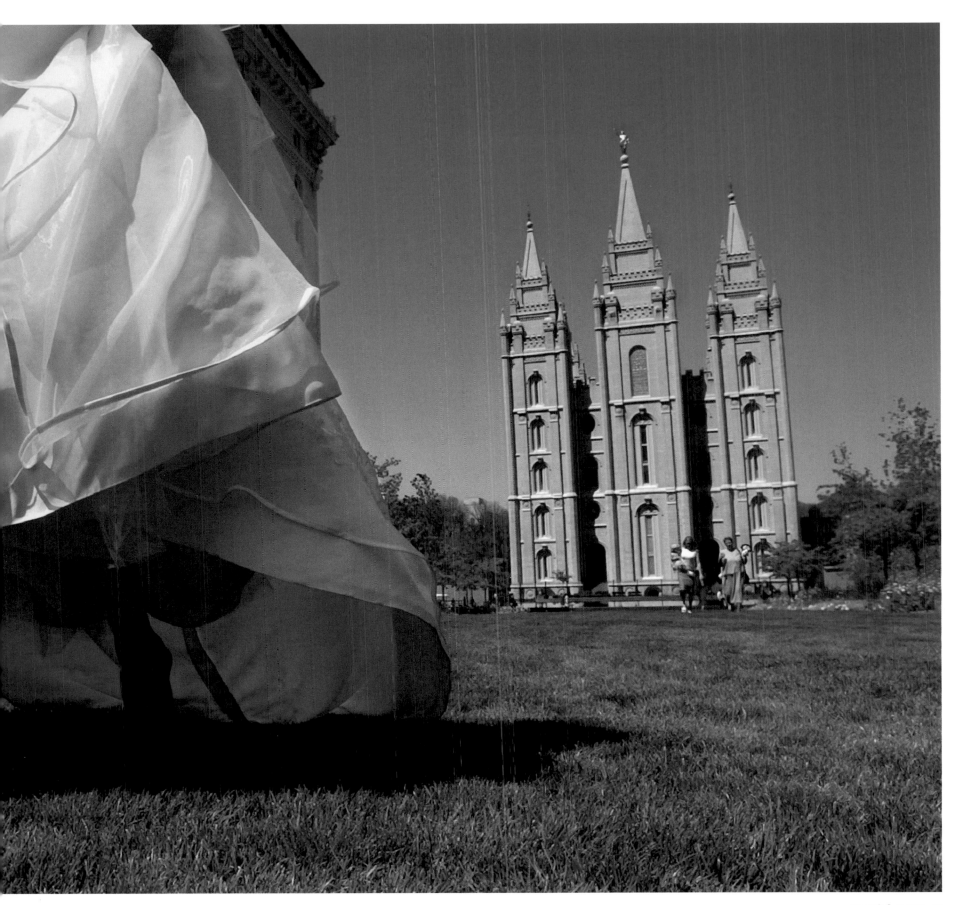

## SALT LAKE CITY

To be married inside the Salt Lake Temple or "sealed for eternity" (as the Bartletts were), a couple must be church members in good standing and have a "temple recommend" from a high church official.

**BOUNTIFUL**

Eleven miles north of Salt Lake City, the town of
Bountiful was an ideal setting for suburb seekers
in the 1950s and 60s. The town's population
more than doubled, and its demographics shifted
from farmers to doctors, educators, lawyers, and
executives. It's a good place for kids like 3-year-
old Bridger Jefferies.
*Photo by Rick Egan, The Salt Lake Tribune*

**WENDOVER**

At a dusty trailer park in Wendover, Utah, Manuel Resendez (left) chills with his father José and friend Rigo Marquez. Many of the Resendez's neighbors in this largely Latino migrant community work in nearby Wendover, Nevada where scrub brush and desert motels morph into manicured lawns and casinos.

*Photo by Chuck Wing, Deseret Morning News*

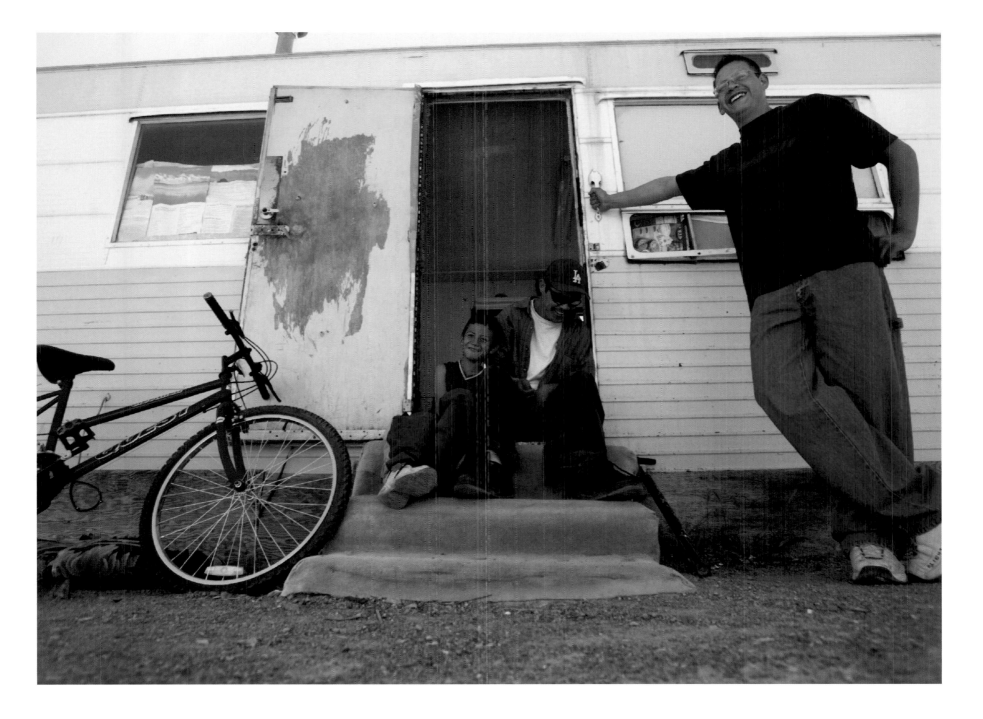

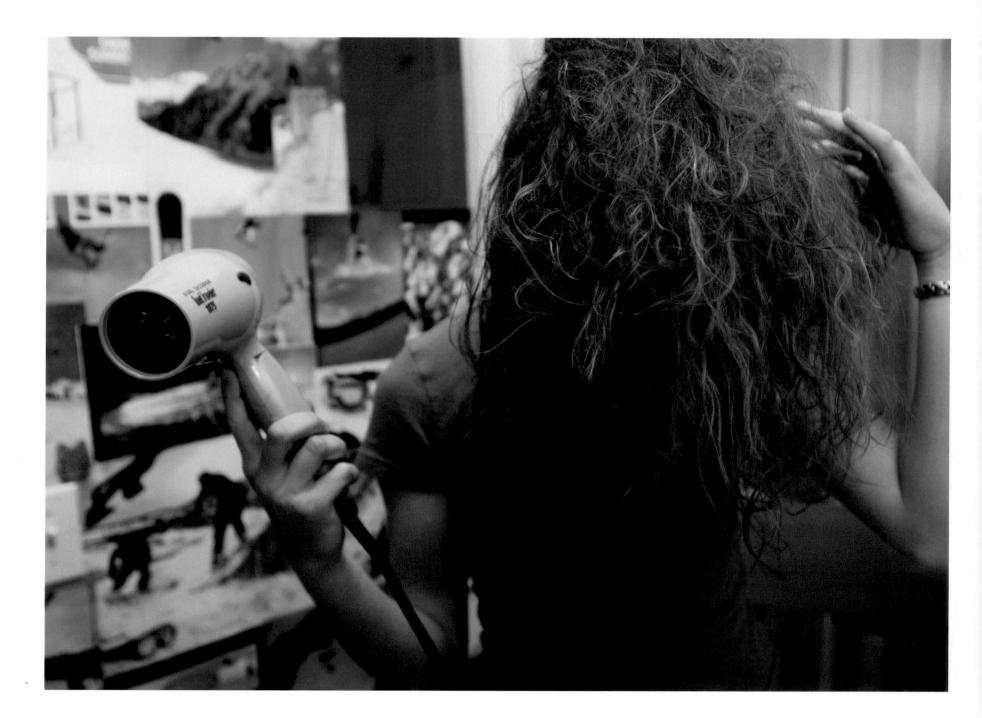

**PARK CITY**

What looks like a bad hair day is really just the start of Devin Peek's morning ritual. The brunette, 15, started playing tennis when she was 7 and was ranked second in the state in the Girls 14 Singles division in 2002.
*Photo by Lori Adamski-Peek*

**BICKNELL**

On her family's 1-acre property, Jessica Wood, 7, feeds a special formula to Chocolate Milk, her 4-week-old dogie lamb. "Dogie" refers to a lamb that has been abandoned by its ewe. In Chocolate Milk's case, she was the weakest of three newborns and mom had enough milk for just two.
*Photo by Laura Seitz, Deseret Morning News*

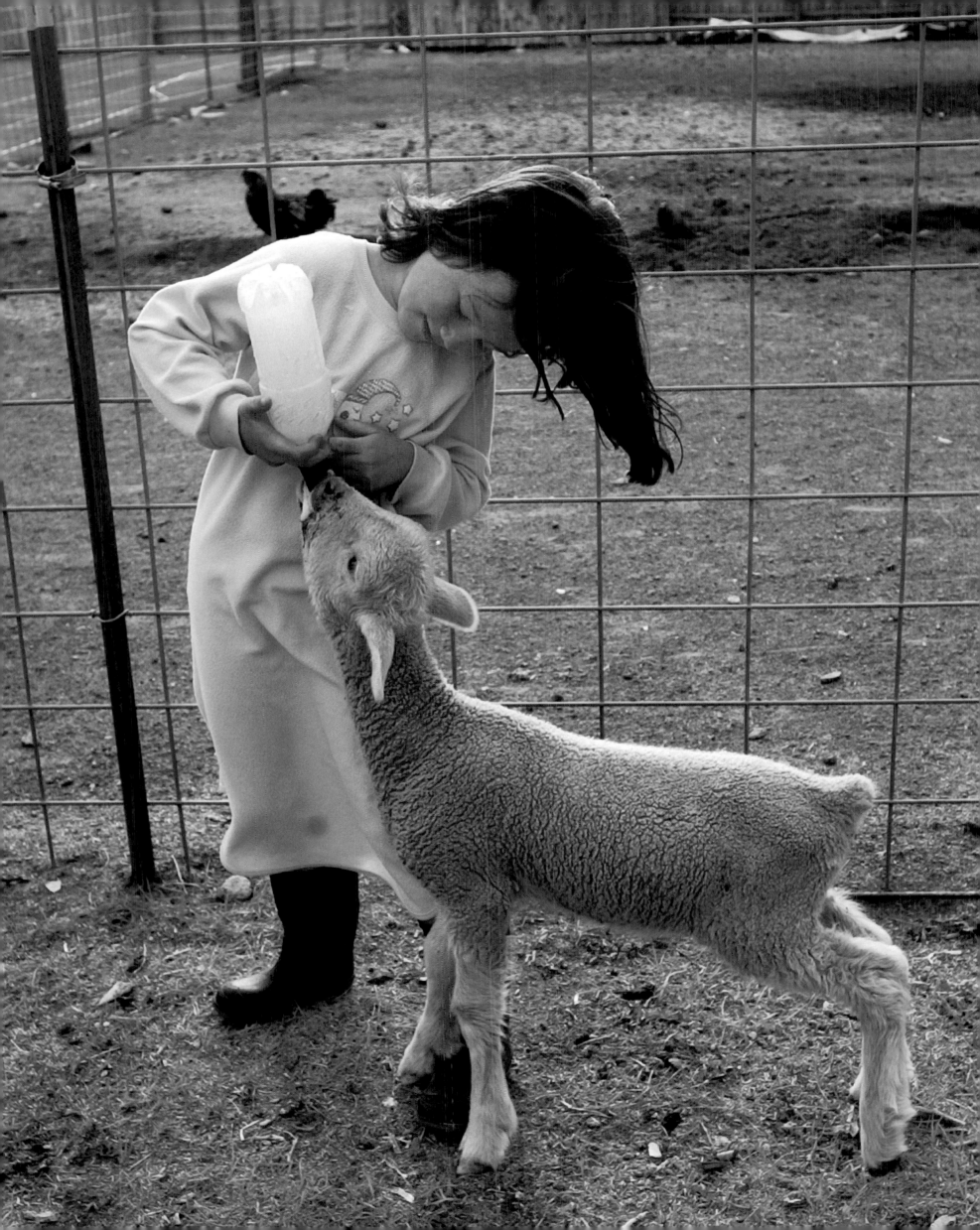

Willow tugs on his halter as Melanie Smith feeds Buddy a snack. Melanie helps her family move cattle from Idaho, where they now live, to ancestral grazing land in Lynn every spring. They head 'em back to Idaho in late fall.
*Photos by Bruce Shields*

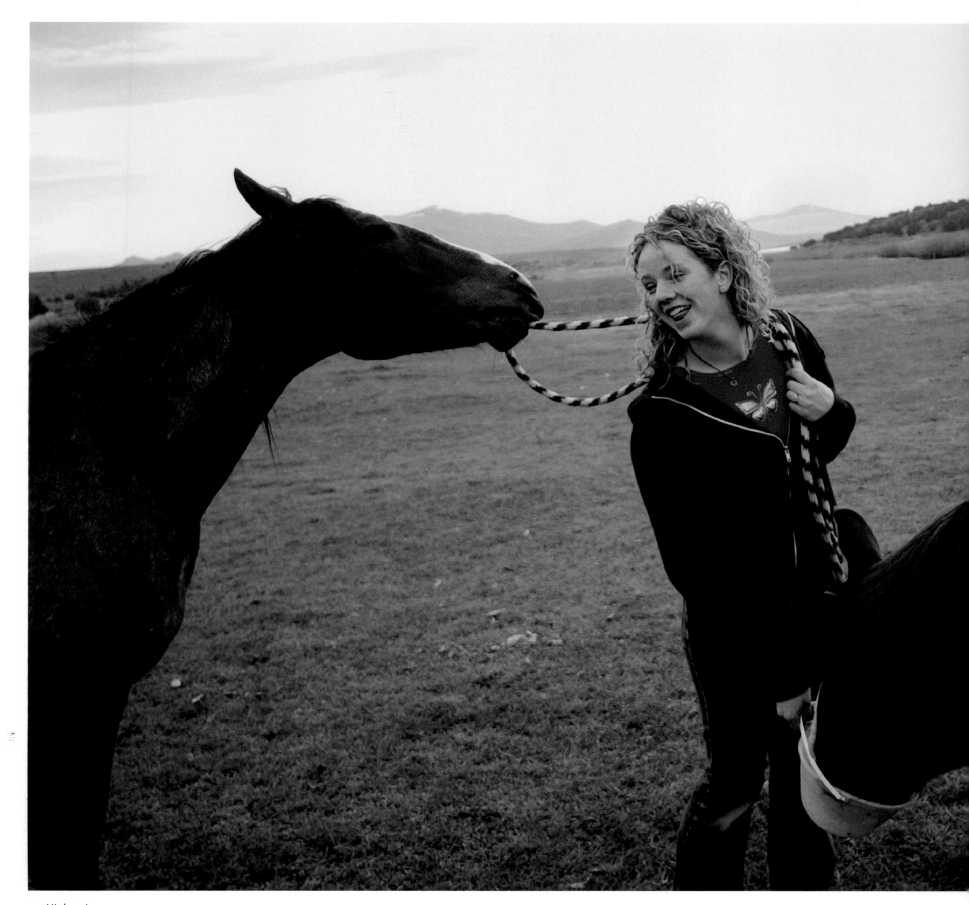

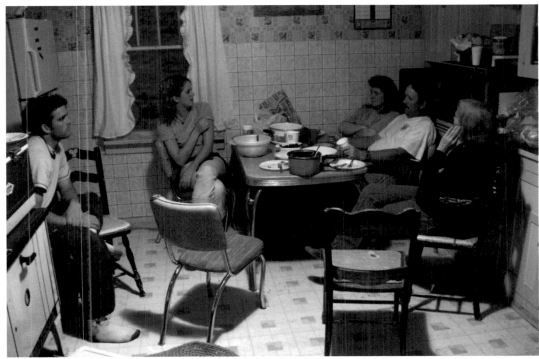

## LYNN

Brian Grush, Melanie Smith, Connie and Reid Smith, and LeAnn Neibaur relax in Lynn on property homesteaded by Connie and LeAnn's great-grandfather in 1882. Though everyone in the family has now moved to Idaho, they keep the land for grazing their own small herd of cattle. They also rent some of the land to other ranchers.

**SALT LAKE CITY**

Tahmina Martelli (left) immigrated to America in 1983 after seeking asylum from her native Bangladesh. As the city's Refugee Youth and Family Consortium Coordinator, Martelli now helps recent refugees from countries like Sudan and Afghanistan confront the cultural, linguistic, and economic challenges of life in a foreign land.
*Photos by Kent Miles*

**SALT LAKE CITY**

Tana Konesavanh from Laos (left) and two friends line up for a photograph outside the Hartland Apartments on Salt Lake City's west side. Some of the city's 50,000 refugees live in the apartment complex, which is literally on the other side of the railroad tracks from the rest of town.

**SALT LAKE CITY**

Sudan's bloody, 20-year civil war has forced more than four million Sudanese to flee their homeland. With the help of the International Rescue Committee and Catholic Community Services, more than 1,000 refugees have found peace in Salt Lake City.

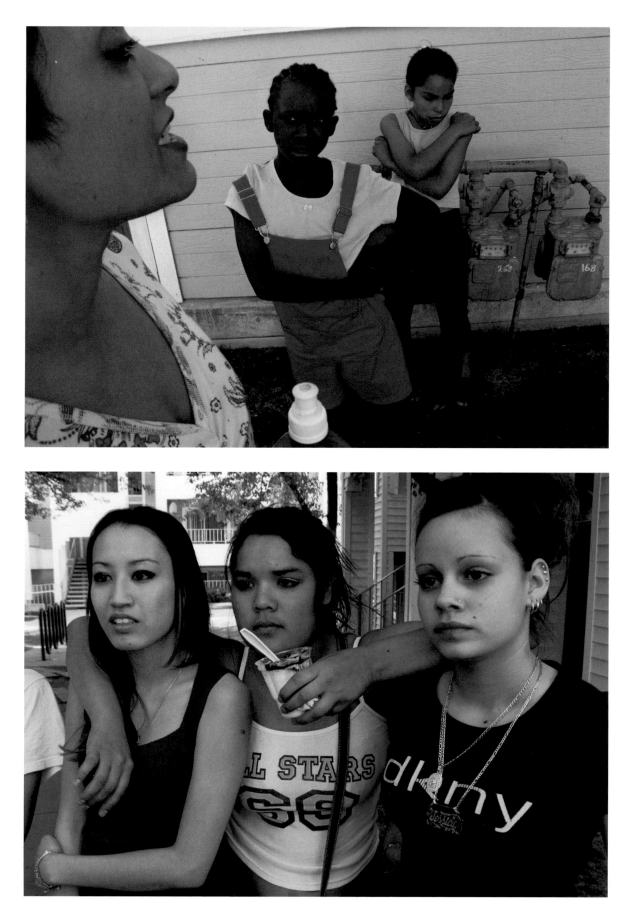

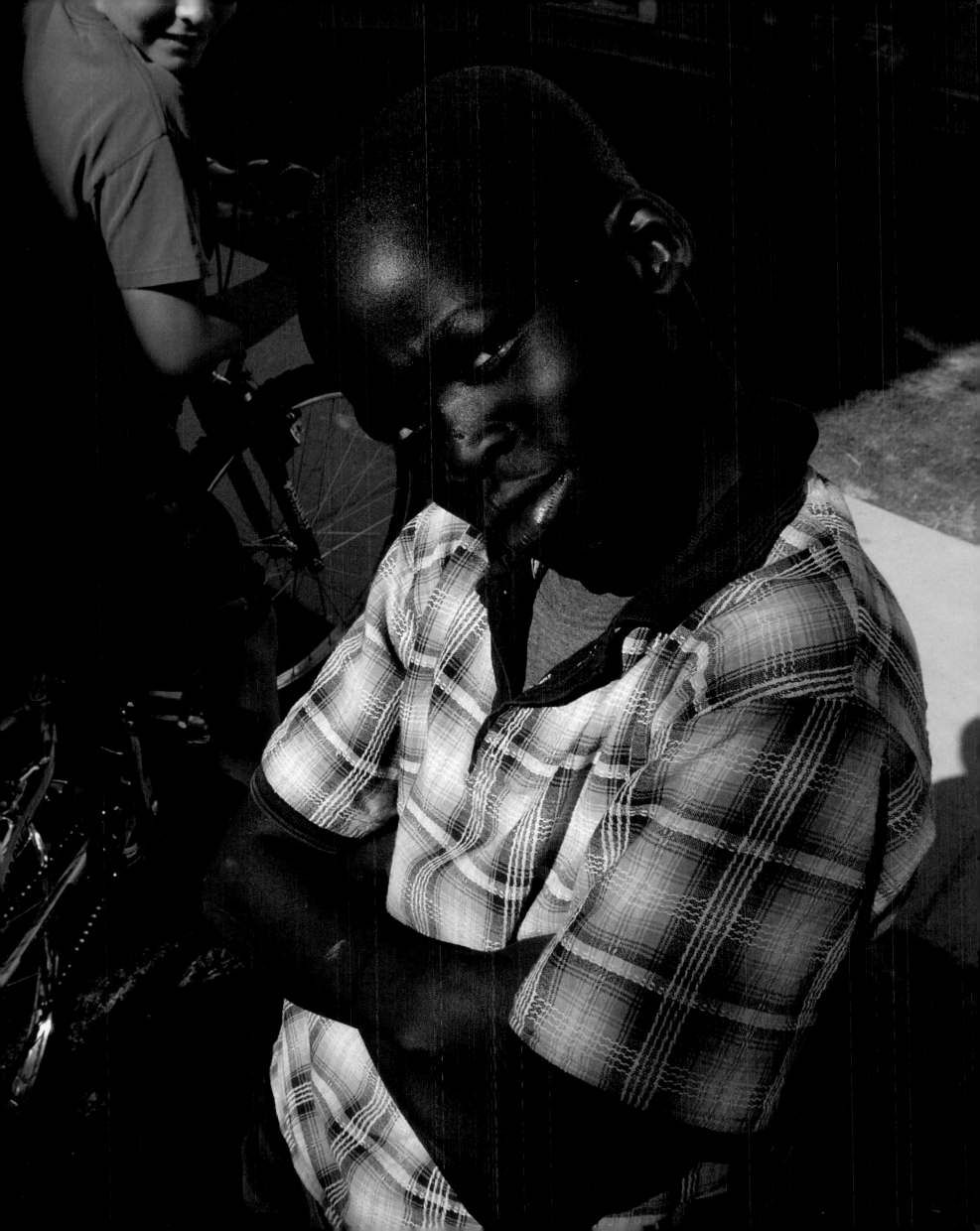

The year 2003 marked a turning point in the history of photography: It was the first year that digital cameras outsold film cameras. To celebrate this unprecedented sea change, the *America 24/7* project invited amateur photographers along with students and professionals to shoot and, via the Internet, submit digital images. Think of it as audience participation. Their visions of community are interspersed with the professional frames throughout this book. On the following four pages, however, we present a gallery produced exclusively by amateur photographers.

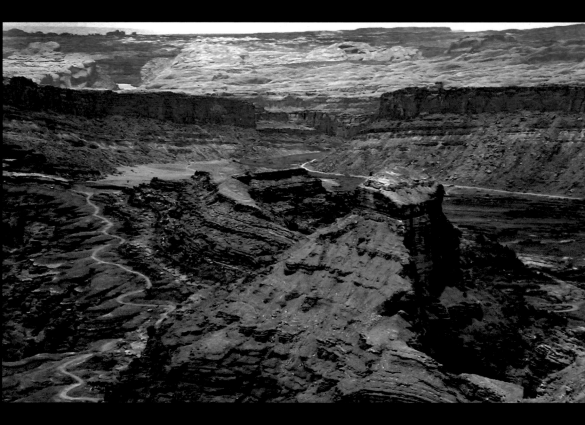

**SAN JUAN COUNTY** This remote canyon is accessible to hikers, mountain bikers, and four-wheel-drive jockeys via the Hurrah Pass Road (lower left). *Photo by Robert Fullerton*

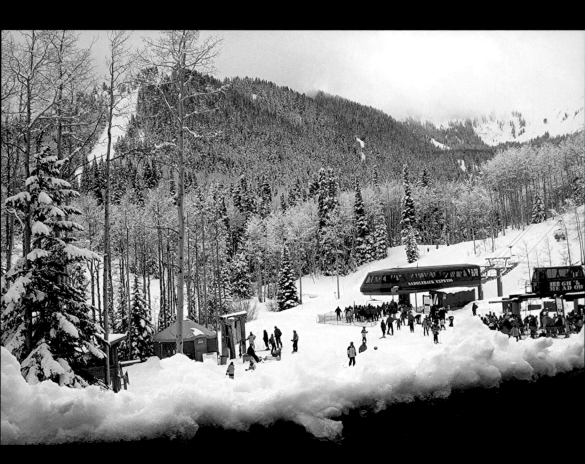

**PARK CITY** Utah has a total of 14 ski resorts, most of them clustered in the Wasatch Range, which collects 300 to 500 inches of champagne snow each year. *Photo by William Sams, Jr.*

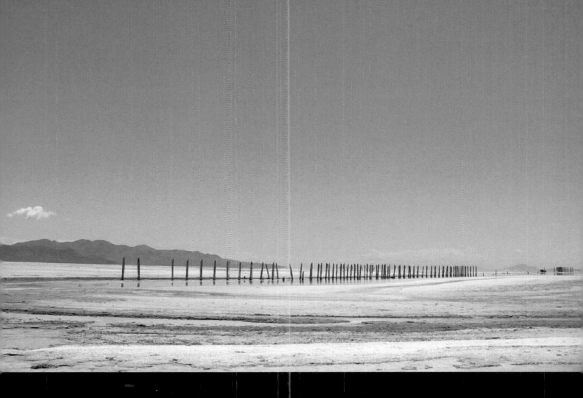

**PROMONTORY** In summer, when the rain just about stops, the salinity in Great Salt Lake can reach up to 7 percent, eight times that of the oceans. *Photo by James Donat*

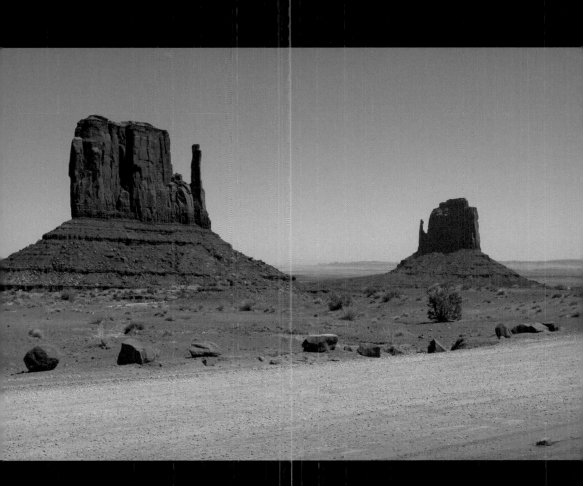

**MONUMENT VALLEY** It took several eras of geologic deposits to form Monument Valley, but just one Hollywood director and movie to make it famous—John Ford's *Stagecoach*. *Photo by Patrick Cunningham*

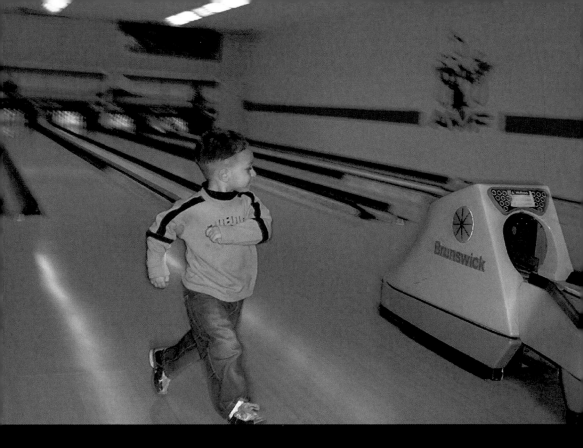

**OGDEN** Joshua Markley, 22 months, graduates from toy bowling to the real thing. The first-timer had a blast, yelling, "Look what I did!" with every frame. *Photo by David Therrien*

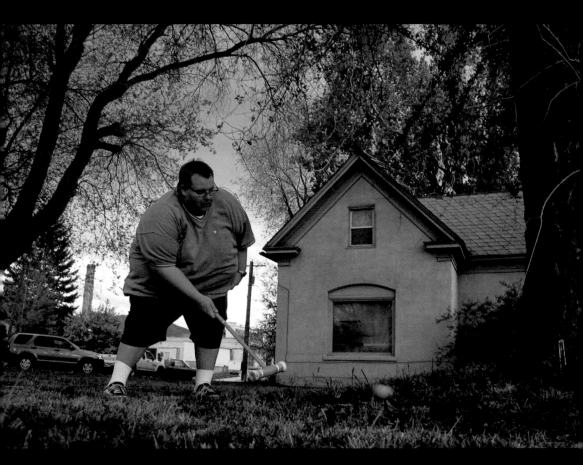

**LOGAN** A very sticky wicket: Joe Bradshaw fights his way through an extreme croquet course, which doubles as the ill-manicured lawn of friend and photographer Ryan Clayton. *Photo by Ryan Clayton*

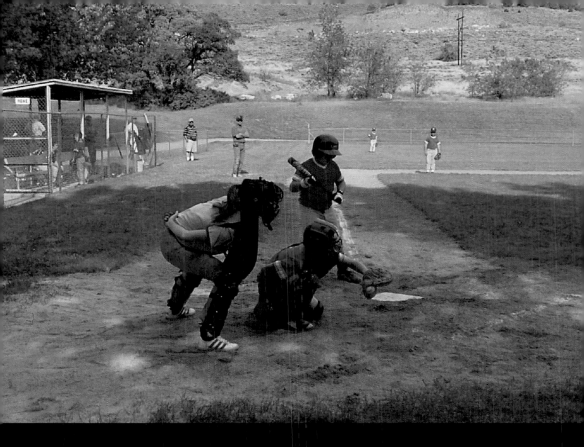

**WILLARD** Umpire KayAnn Tingey once called her 9-year-old son out on strikes. He didn't argue but complained to teammates that she didn't know what she was talking about. *Photo by Mark Christensen*

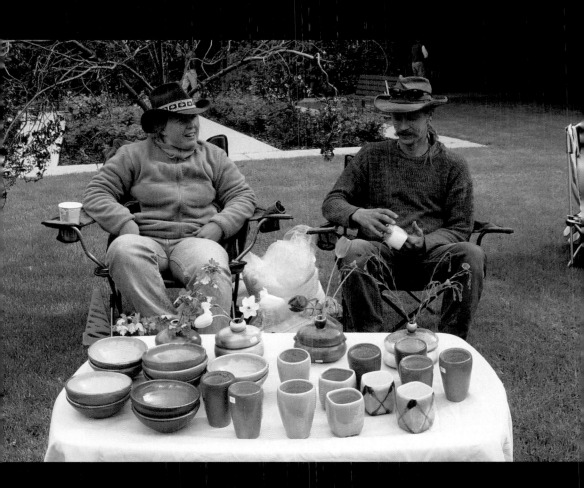

**LOGAN** Derrick Andersen and Karin Solberg purvey their pottery at the Cache Valley Gardeners' Market, a weekly outdoor exchange of local produce, folk music, and crafts. *Photo by Marianne Sidwell*

**MOSIDA**

Rodolfo Ventura came to these wide-open grazing lands on the west side of Utah Lake two years ago to make some money. Working as a sheepherder, he sends a portion of his salary back to his wife and 5-year-old son in Lima, Peru, and saves the rest for his college education, which he'll pursue when he returns home in late 2003.

*Photo by Jason Olson, Deseret Morning News*

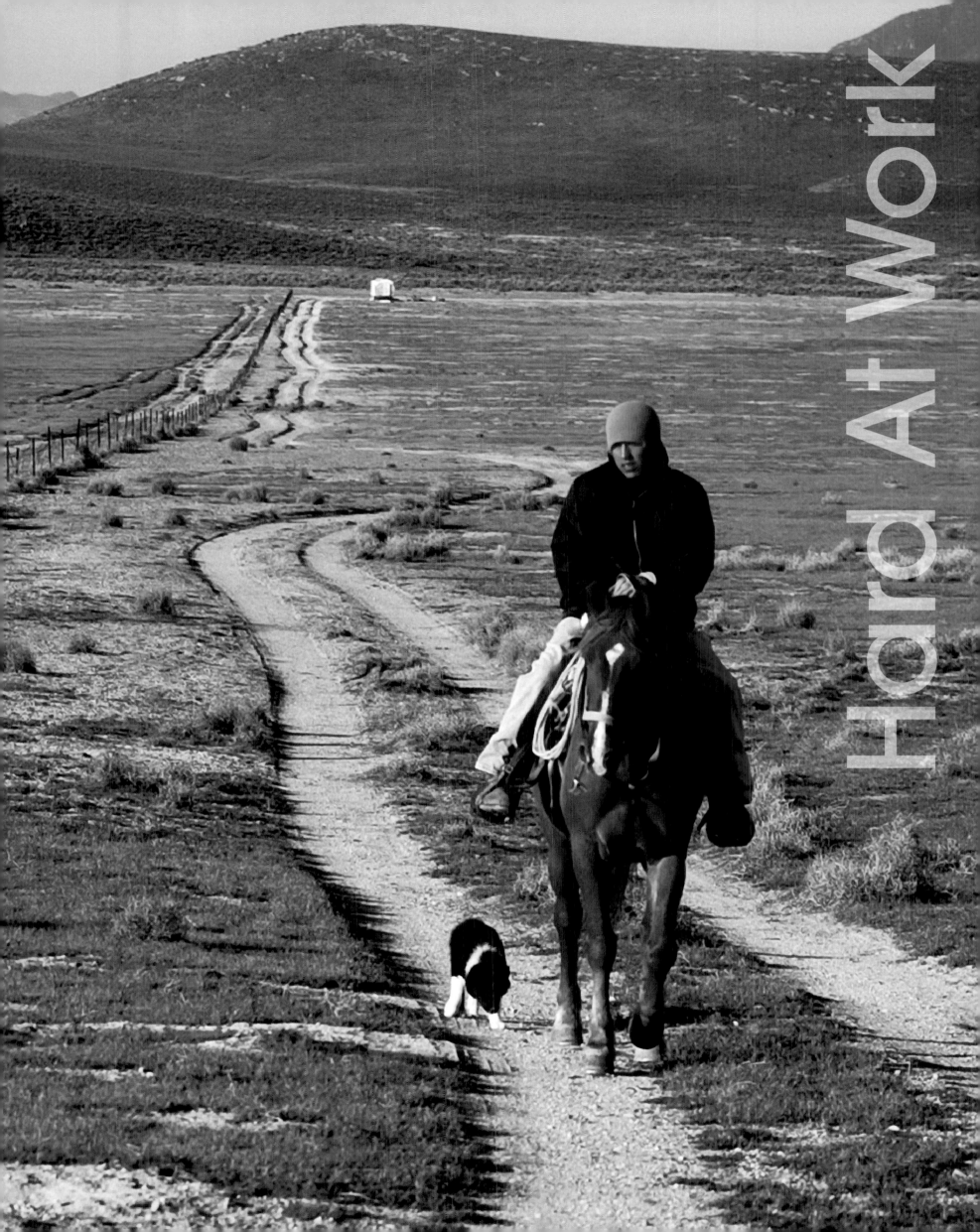

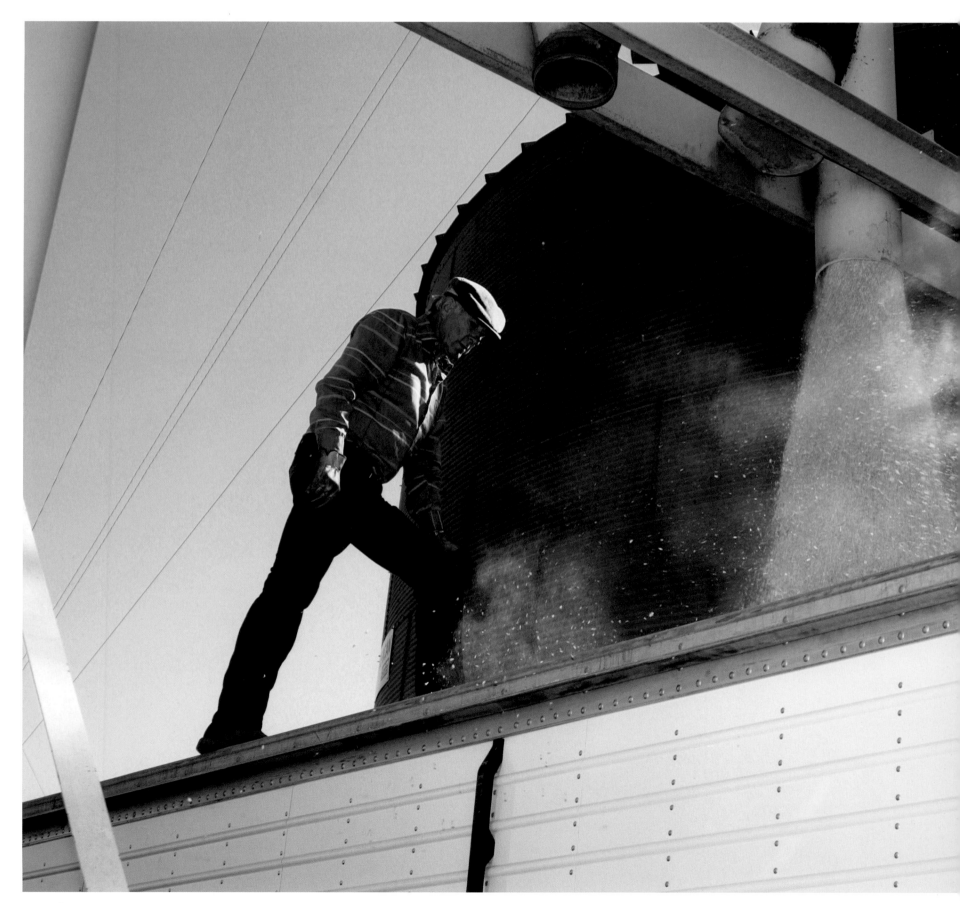

**GARLAND**

Junior Lish watches over a load of grain at Lish Grain Elevator, which stores wheat and barley from Utah and Idaho farms and transports it to flour mills in Ogden. Volume at the company, which Lish runs with his four sons, is down 50 percent compared with 1998, due to a state-wide drought that began in 1999 .
*Photo by Steve Harrington*

**ESCALANTE**

Warren Haycock operates a log loader at Skyline Forest Resources. The largest saw-mill in Utah, Skyline has a roughly 250-mile radial area from which raw logs are purchased. "The farther out you go, the higher your freight costs," says co-owner Steve Steed.
*Photo by Nick Adams*

**ST. GEORGE**

A tractor collects freshly cut hay in a field bordering a new subdivision. Construction is booming in this southern Utah town. Retirees from California and Nevada have pushed the population to nearly 52,000, a 50 percent increase in 10 years.
*Photo by Nick Adams*

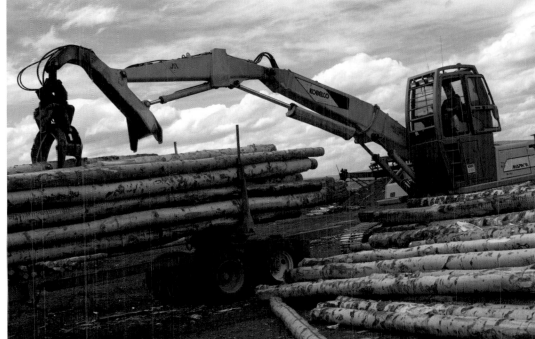

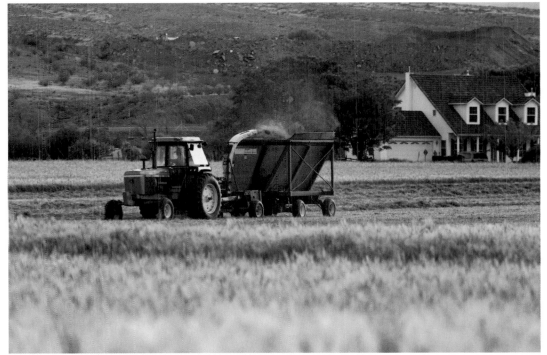

**LOGAN**
Lifelong trapezist Rafaela Ribeiro
performs on the Roman rings for the
Las Vegas–based Jordan World Circus,
which set up for the week at the Logan-
Cache County Fairgrounds.
*Photo by Eli Lucero*

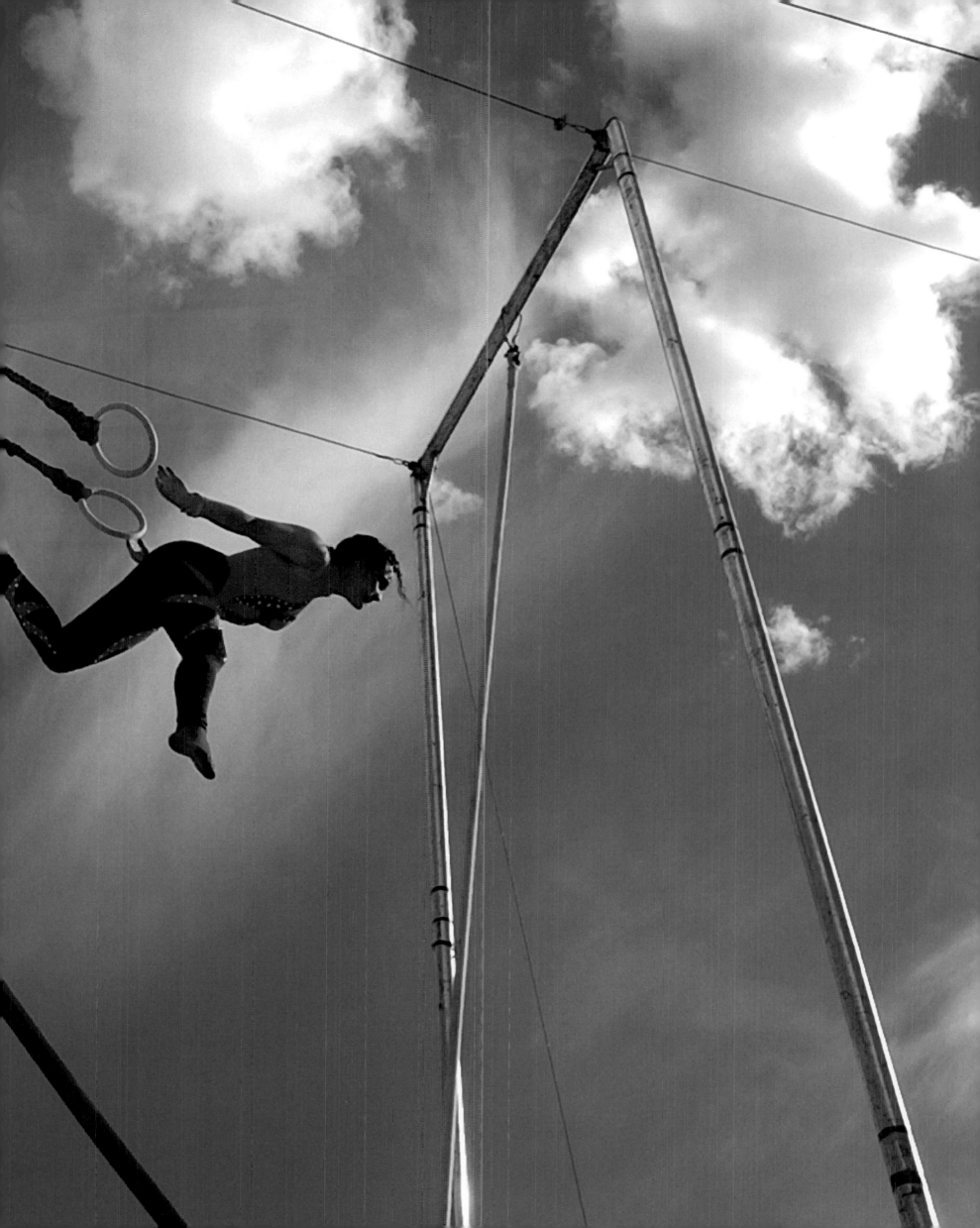

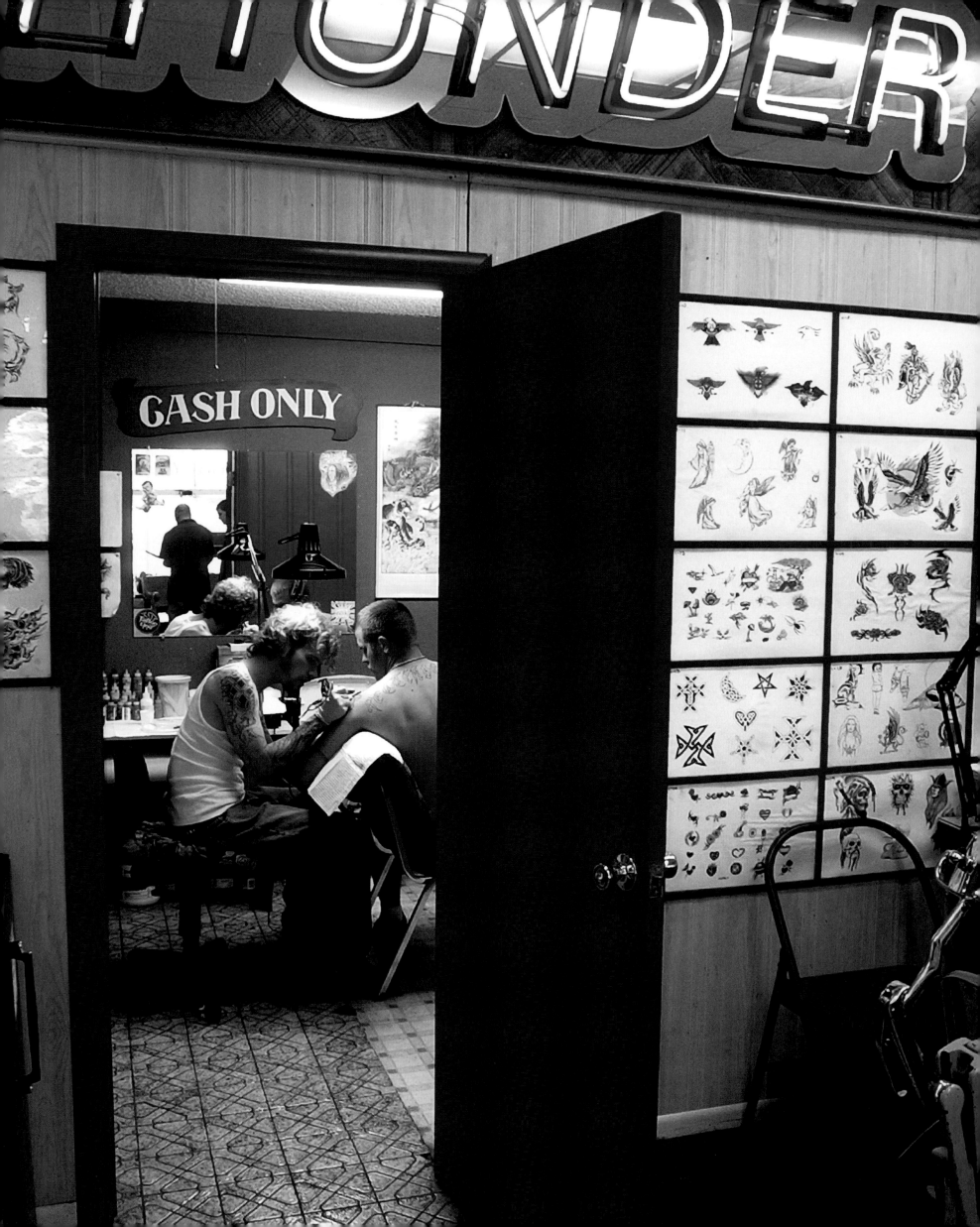

**SALT LAKE CITY**

"We're moving away from that ex-con, nasty biker-guy stereotype," says Southern Thunder Tattoo artist John Carpenter. With a background in charcoal drawing and oil painting, Carpenter represents a new class of tattooist; body art has become Carpenter's preferred mode of expression because, he says, "people are the only canvases who actually appreciate what you do."

*Photo by Johanna Kirk, Deseret Morning News*

**ST. GEORGE**

Guitarist Tovin Benson leaps from the drum riser during The Sugarland Run's set at the Electric Theater, a renovated movie house in St. George's historic district. The other members of the Provo-based, punk/rock/emo band are Jason Fitt, Mike McCaleb, and Eddie King.

*Photo by Nick Adams*

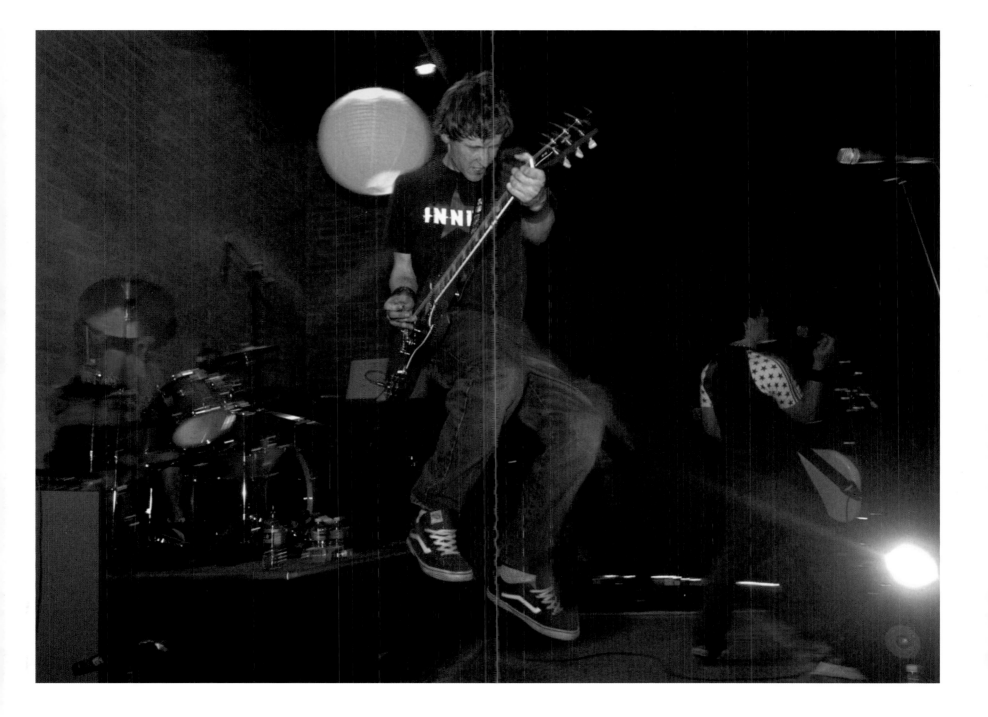

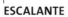

**ESCALANTE**

Greg Shakespear does headrig maintenance at Skyline Forest Resources. Shakespear owes his job to the five Steed brothers. Sixth-generation lumbermen, the Steeds worked at Utah Forest Products until December 2001, when a timber shortage and competition from outside companies forced management to close the sawmill. Pooling their resources, the Steeds bought the mill and saved 46 jobs.

*Photos by Nick Adams*

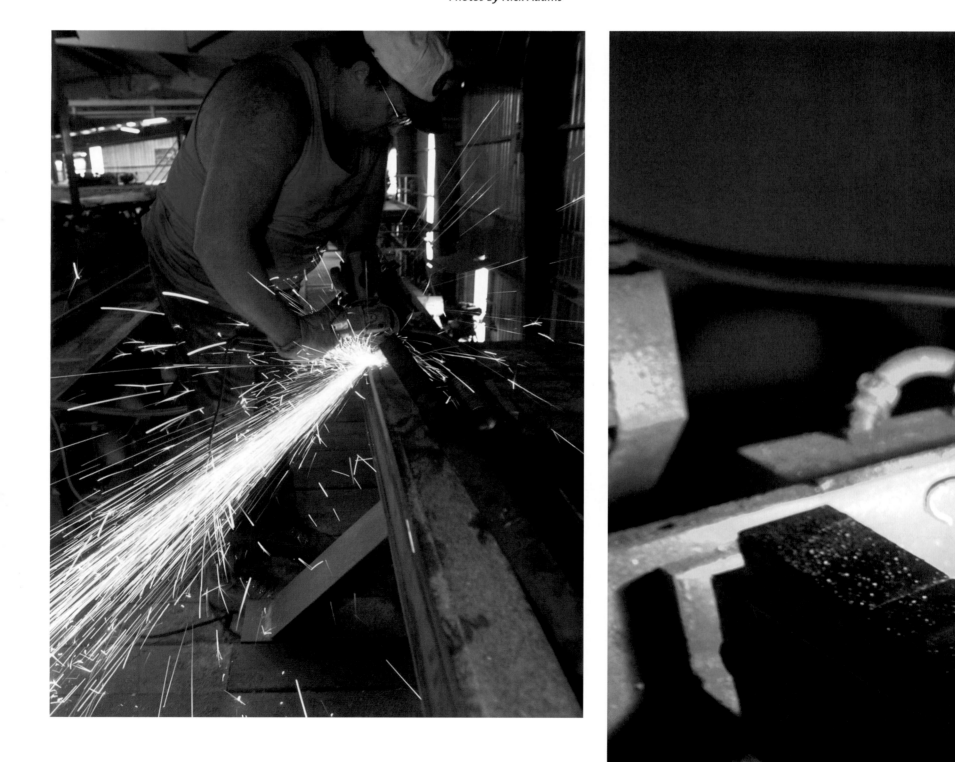

**ESCALANTE**

With nearly 700 jobs lost in the region's timber industry over the past 10 years, the Steed brothers have to work smart to keep their sawmill buzzing. By installing a resaw, which cuts smaller pieces of wood left over from the headrig, the mill prevents waste and maximizes production. Operator Tony Chavez checks the machine for hydraulic leaks.

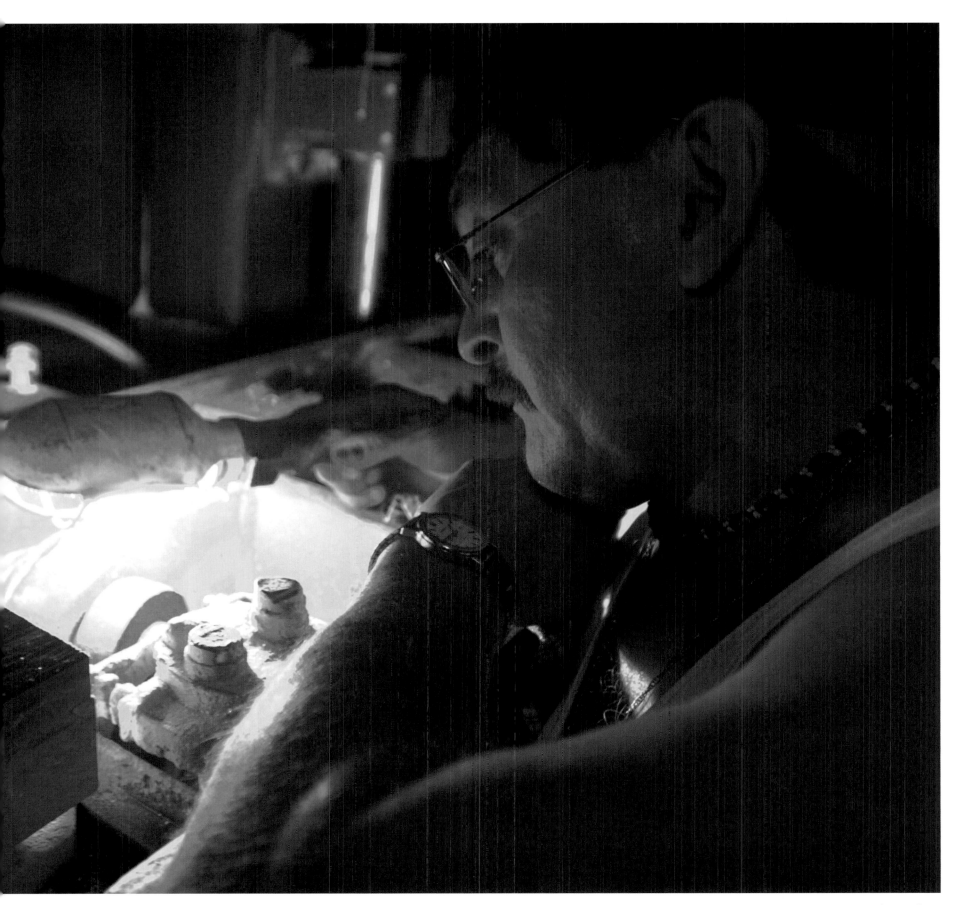

**BINGHAM CANYON**
Dwarfed by her haulage truck with its
12-foot wheels, driver Dawn Alexander
must ascend a ladder and stairs to reach
her seat. Haulage trucks, like everything
else at Kennecott Utah Copper Company,
run 24/7. They are used to transport copper
ore to an in-pit crusher and to haul waste
rock to a dump site outside the mine.
*Photo by Scott G. Winterton,*
*Deseret Morning News*

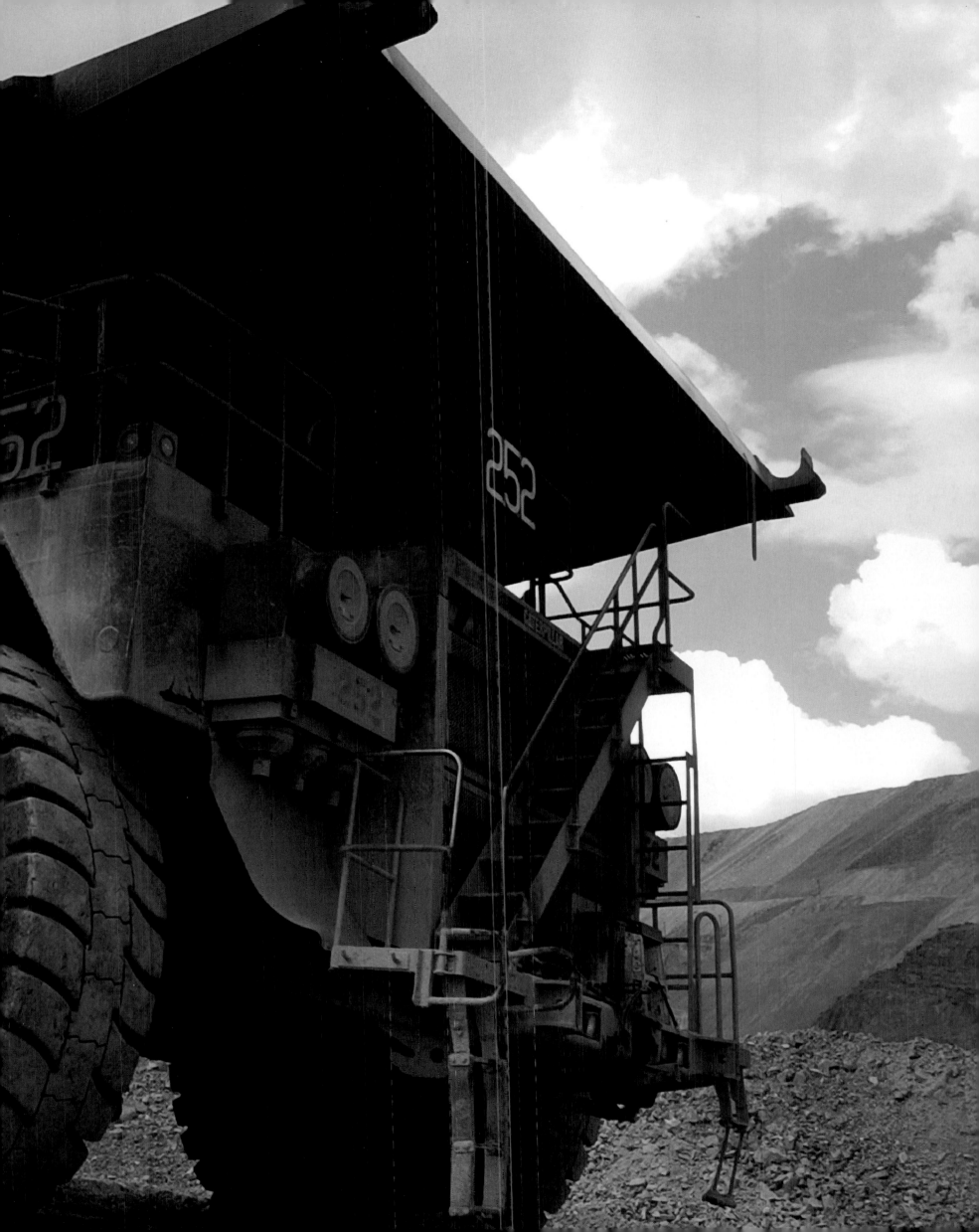

**BINGHAM CANYON**
Each week haulage trucks transport 3 million tons of rock along the main road of Kennecott's copper mine. A third of the rock is actually copper ore, which is processed to make electrical wire.
*Photos by Scott G. Winterton,*
*Deseret Morning News*

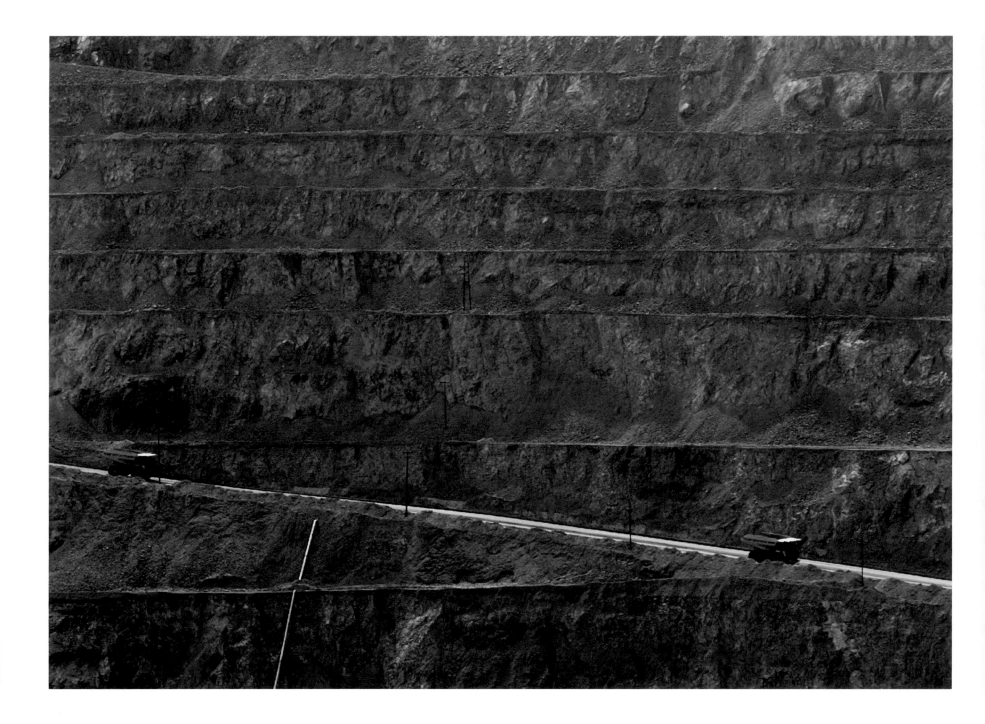

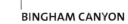

## BINGHAM CANYON

Although copper was discovered in Bingham Canyon in the late 1860s, no mining occurred until the company opened in 1903. Now, two to three times a day, a slurry explosive of ammonium nitrate and diesel rips the ground, loosening it for ore extraction at the world's largest open pit copper mine.

**OGDEN**

Air Force Reserve Major Tom Klingensmith prepares to board his F-16 for morning maneuvers at Hill Air Force Base. His unit, the 419th Fighter Wing, was the first in the Air Force to fly combat missions in Afghanistan after 9/11. The 419th fliers also played a key role in the war with Iraq.
*Photo by Lori Adamski-Peek*

**KAYSVILLE**

After years of driving trucks for other companies, Sandra Phelps started her own business, Chariots of Fire, in 2000. Based in Bullhead City, Arizona, she and her 12-wheeler transport automobiles through four western states. "This job has given me more freedom than I thought I'd ever have," she says. Phelps stopped in Kaysville to have some work done on her taillights.
*Photo by Lori Adamski-Peek*

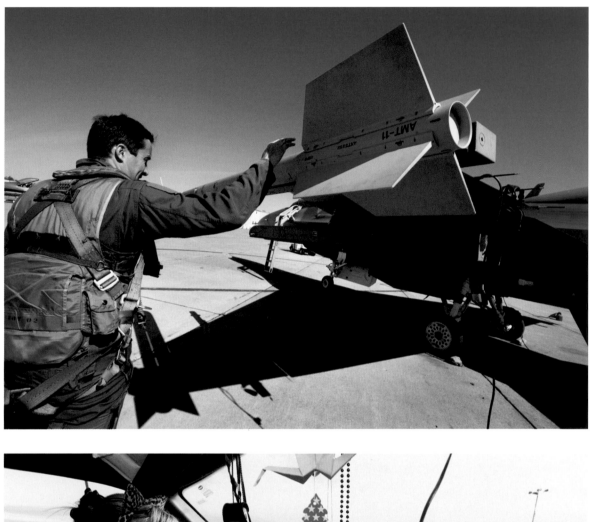

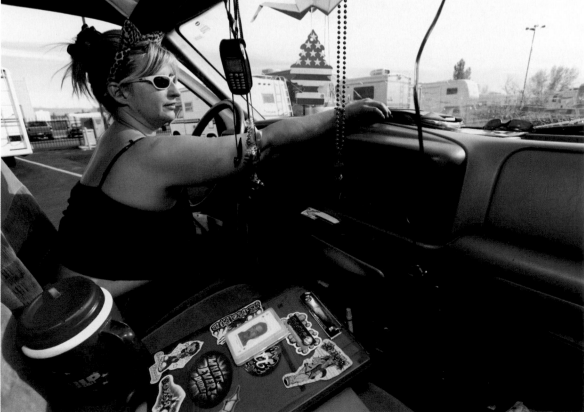

## OGDEN

In a vacant lot on Wall Avenue, migrant workers offer themselves up for day-labor jobs. They also hitchhike to orchards in Willard to pick fruit during the day and sleep beneath the plum trees at night. Many of Utah's seasonal workers travel back and forth between Sinaloa and Michoacan, Mexico, and Ogden.

*Photo by Robert Johnson, The Standard Examiner*

## SALT LAKE CITY

Downtown Fire Station No. 2 is the city's busiest, responding to an average of 20 emergencies a day. Captain Jim Andrew, firefighter John Knowlton, and various firehouse teams responded on May 16 to calls about an overheated air conditioner, a natural gas line break, and medical emergencies.

*Photo by Chuck Wing, Deseret Morning News*

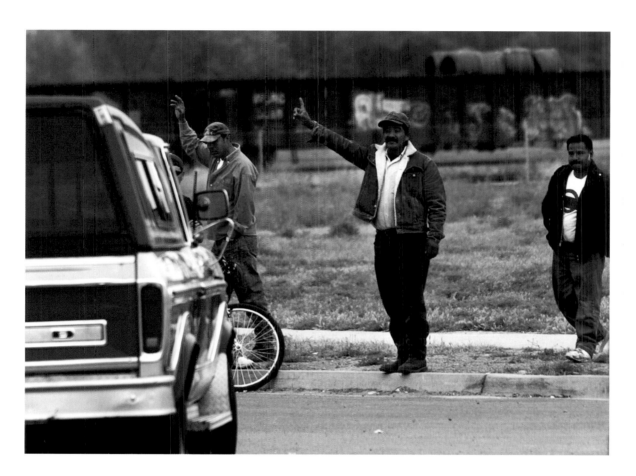

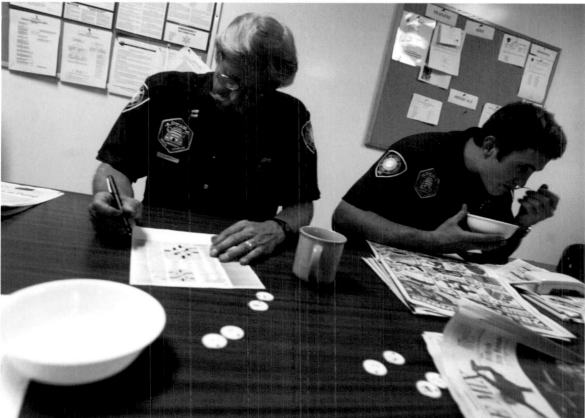

**HEBER CITY**
A barrel of laughs: Clint Willis, 17, tries to force pal Shane Williams, 18, off a makeshift bucking bull set up in Clint's backyard.
*Photo by Keith Johnson,*
*Deseret Morning News*

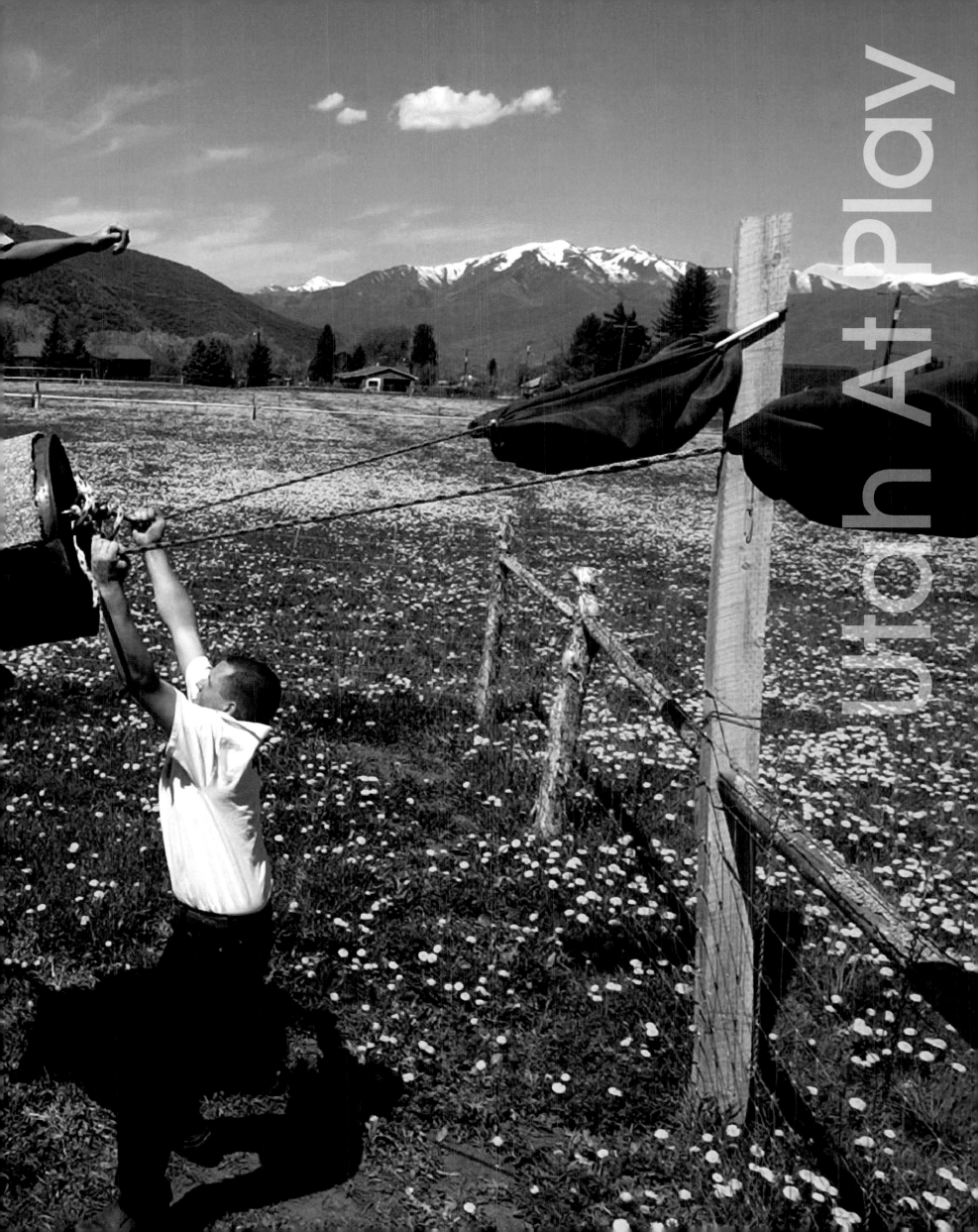

**PARK CITY**
Eleven-year-old Zac Fear jumps the spine at Park City Skate Park. Built by the city, the 6-month-old facility is a quarter acre of molded concrete jumps, bowls, and ridges. Zac and his pals love it. So do business owners. The park keeps the skaters and skateboarders off their property.
*Photo by Peter A. Chudleigh*

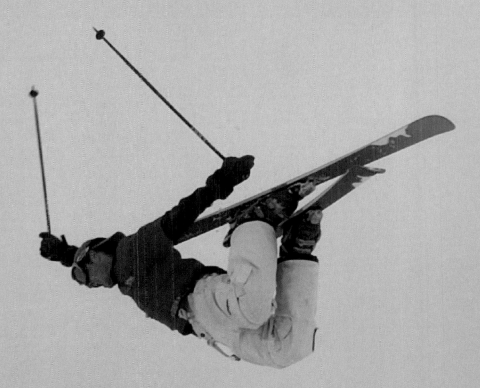

### SNOWBIRD

No Fear: Brandon McFarland, 26, executes a back flip 11,025 feet in the air off "The Wave," a natural ski jump at Snowbird Ski Resort. A former gymnast, McFarland taught himself the feat six years ago, landing upright on his first attempt. He says, "I think it takes more guts than skill."

*Photo by Ravell Call, Deseret Morning News*

**PROVO**

With a surface area of 150 square miles, Utah Lake is the largest natural freshwater lake west of the Mississippi. Home to the native Ute, Paiute, and Shoshone peoples in the 1800s, it is now a haven for sailors, water-skiers, and windsurfers.
*Photo by Johanna Kirk,*
*Deseret Morning News*

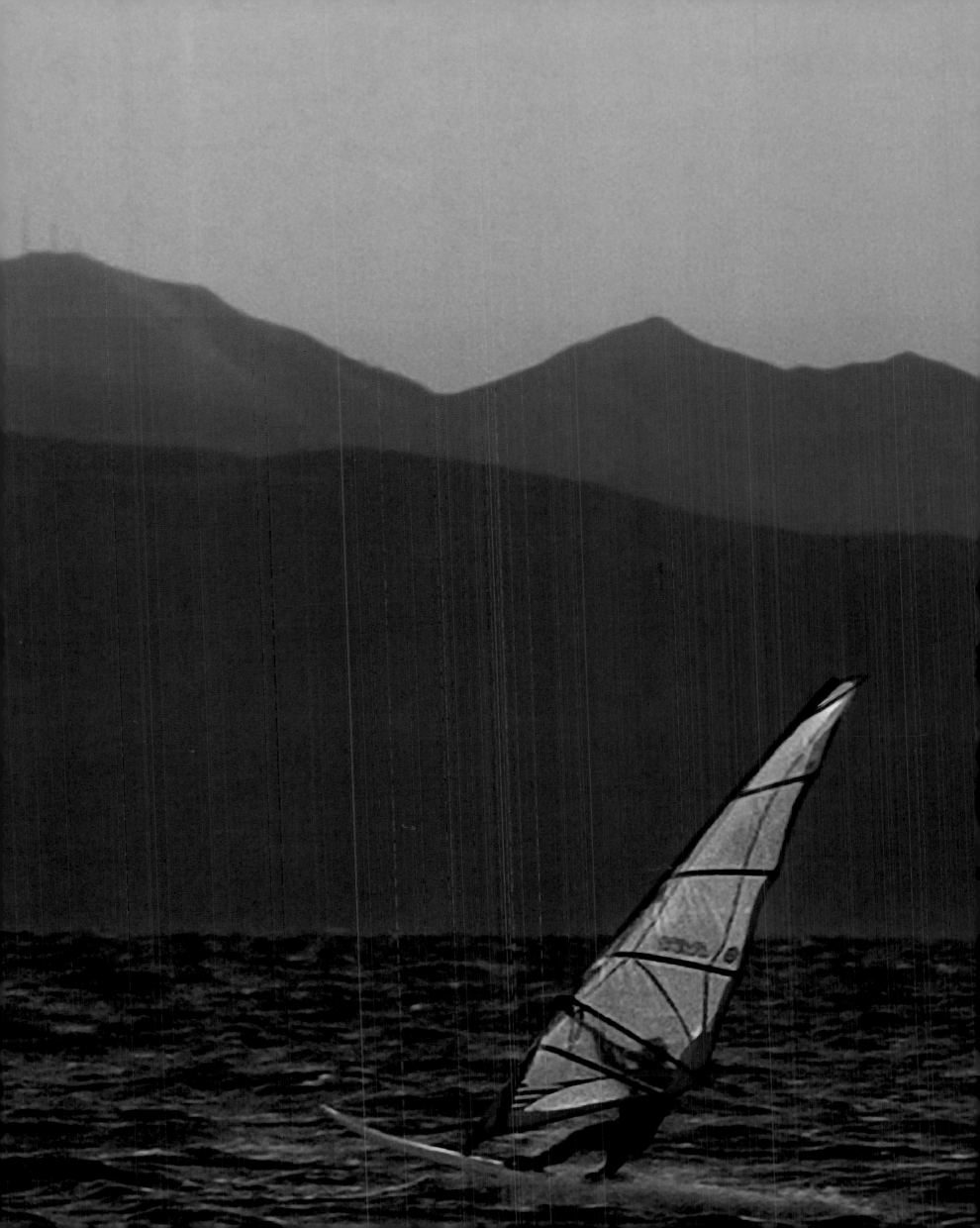

**ST. GEORGE**
Dustin Adair, 8, stands up to the brunt of the spillway of a small diversion dam on the Virgin River. The main draw at a popular swimming spot, the 12-foot-high dam diverts water to an irrigation ditch.
*Photos by Nick Adams*

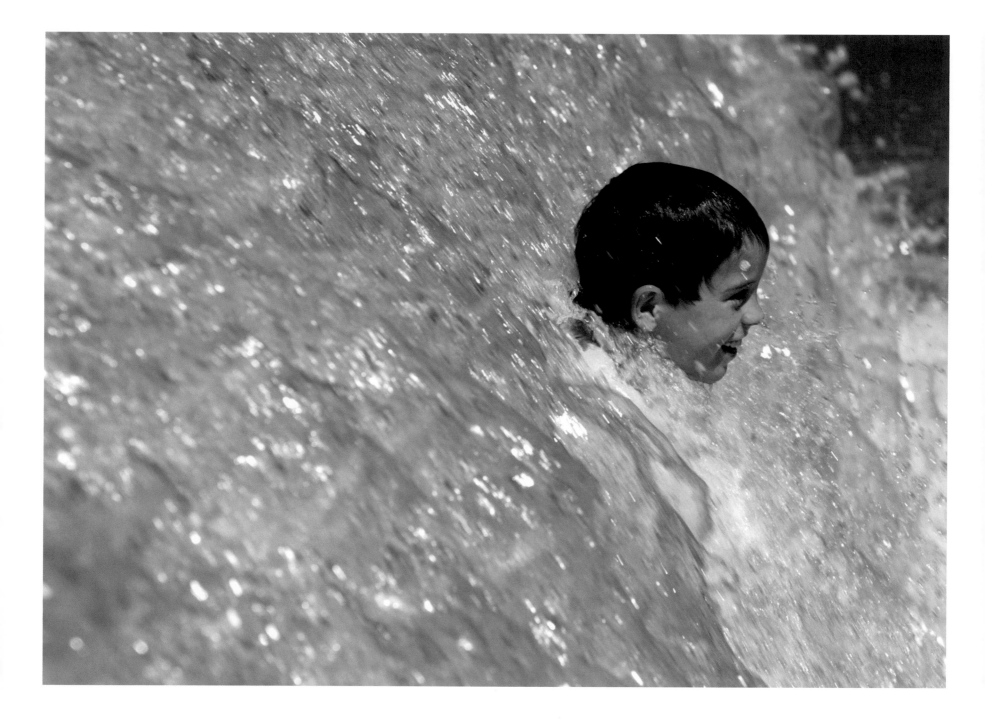

**ST. GEORGE**
Artie Martello wipes out while trying to ride a
pipe on his skimboard in the Virgin River.

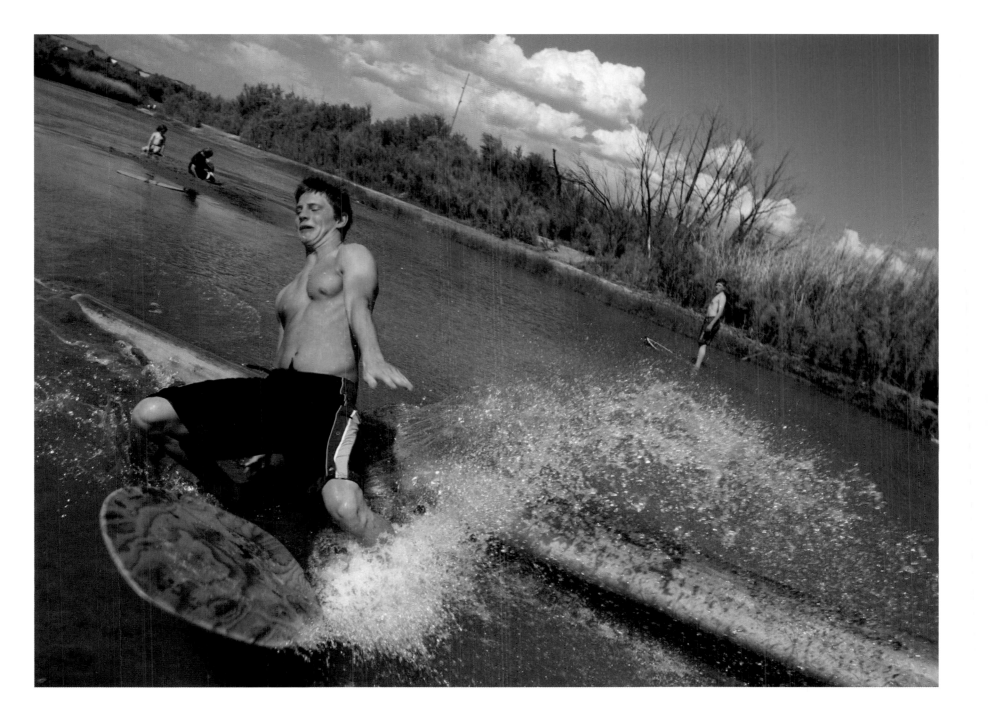

**DRAPER**

Filmmaker, musician, mountaineer, and aerobatic hang glider, Bill Heaner soars above the hills of Point of the Mountain. Heaner has flown for just seven years, yet he won the 2000 Aerobatic Hang Gliding Championship with his superlative loops, spins, and rolls. Only 30 people in the world have the skills—and guts—to compete in the event.
*Photo by Jeffrey D. Allred,*
*Deseret Morning News*

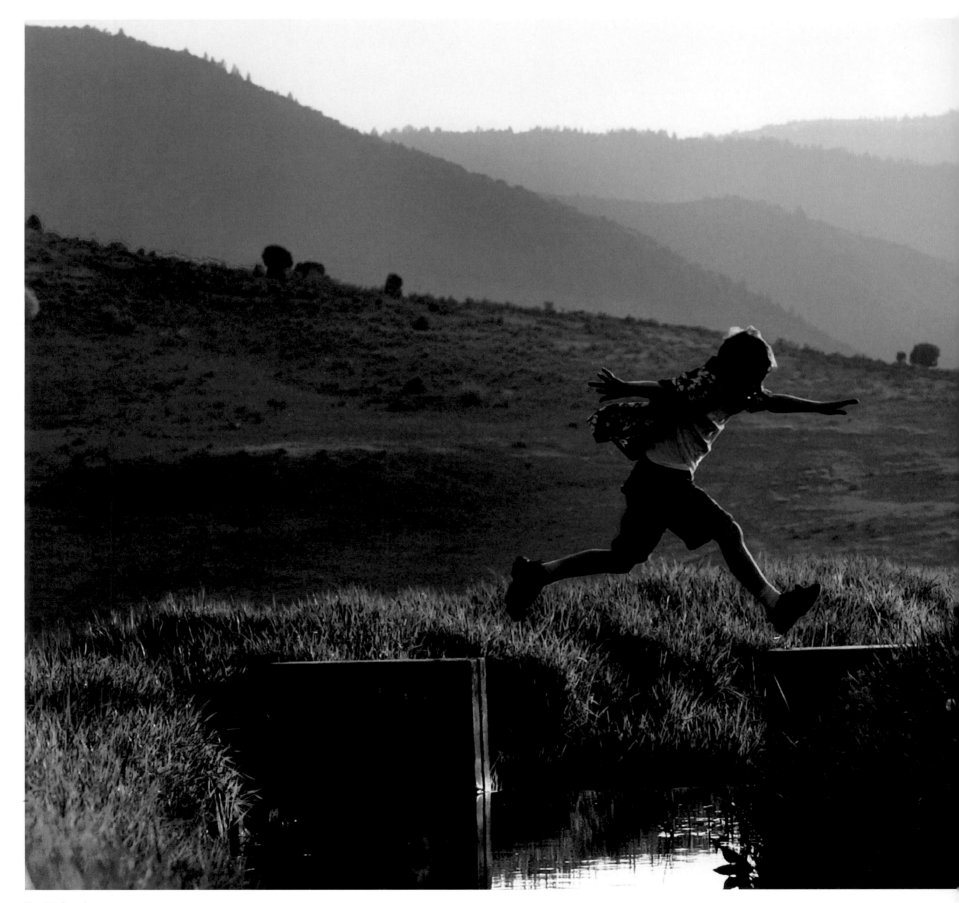

**BLACKSMITH FORK CANYON**
Little brother takes the dare. Taylor Bigler, 7, jumps a dam across Rock Creek for the edification of big brother Travis, 13, and his buddy Dillon Barclay, 12. The boys are taking part in a church-sponsored campout for fathers and sons at Hardware Ranch, a 19,000-acre Rocky Mountain elk preserve and recreation area.
*Photos by Ravell Call, Deseret Morning News*

**BLACKSMITH FORK CANYON**
Reveille at 6 a.m., flag raising, and a pancake breakfast is the morning routine for 120 fathers and sons at Hardware Ranch. Named for the Box Elder Hardware Company that sold the land to the state of Utah in 1945, the ranch became a preserve to reduce the friction between elk herds and the farmers who encroached on their feeding areas.

**BLACKSMITH FORK CANYON**
William Cox, 11, specializes in marshmallows roasted to golden-brown perfection. "I'm pretty good at frying an egg, too," he brags.

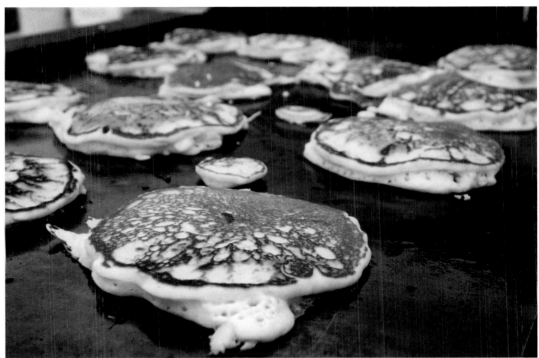

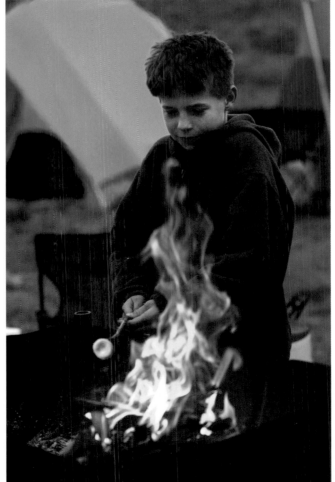

**BLACKSMITH FORK CANYON**
Todd Garrett pitches shoes with son John, 13,
while dinner cooks at the Hardware Ranch
campout. The ranch is a winter home to 600
Rocky Mountain elk that migrate from the
high country to feed on the 300 tons of hay
the spread produces during the summer.
*Photo by Ravell Call, Deseret Morning News*

**MANTI**
Laeysa Sudweeks and Dancer gallop to the finish line in the barrel racing competition at the Jackpot Rodeo. Laeysa starting riding when she was 2 years old.
*Photos by Lori Adamski-Peek*

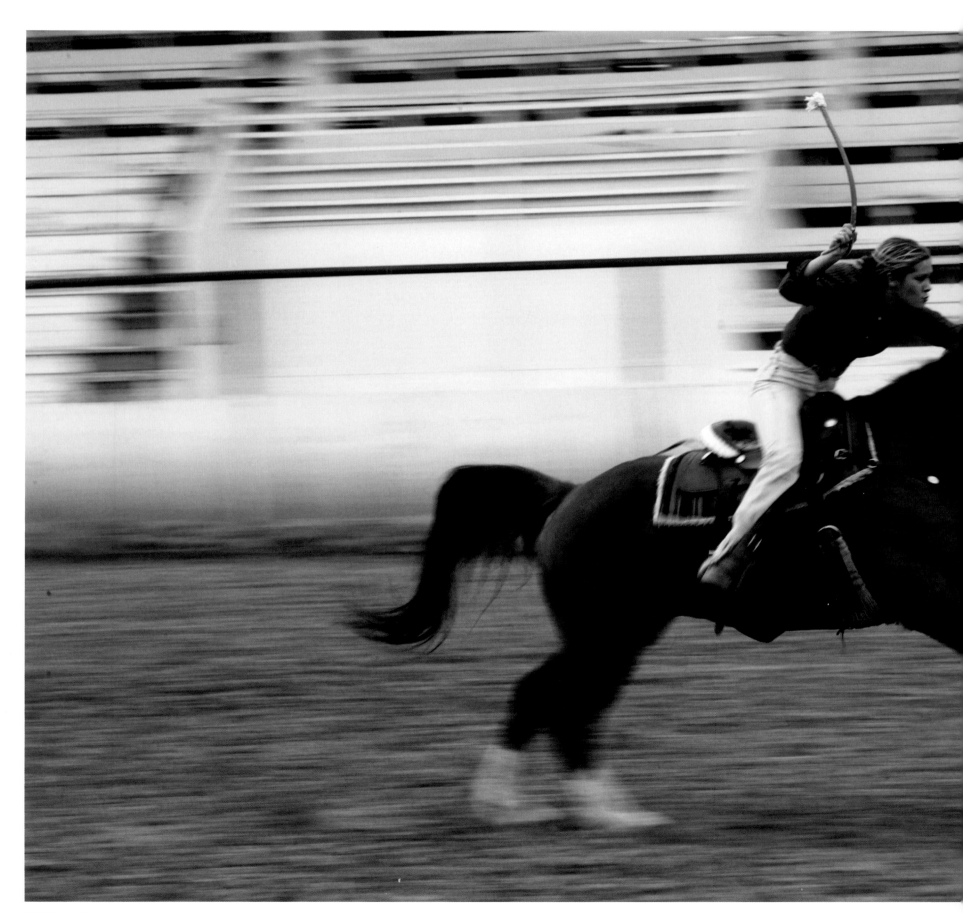

**MANTI**

In addition to being a barrel racer, Laeysa Sudweeks, 15, is the 2003 Ute Stampede Rodeo Queen. To win, she had to compete in a reining pattern and answer detailed questions about horses and rodeos. Laeysa plans to compete for Miss Rodeo Utah, but she has to wait a few years. The minimum age for the statewide title is 19.

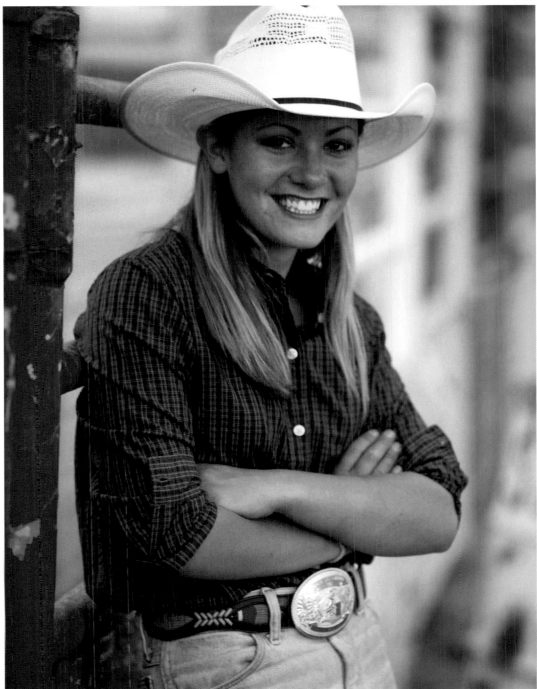

**ZION NATIONAL PARK**
Five hundred feet off the ground, Kim Csizmazia plots her solo ascent up Lunar Ecstasy route on Moonlight Buttress in Zion National Park. Known as "color country," Zion's shear sandstone canyons are a mecca for rock climbers.
*Photo by Sallie Dean Shatz*

**ZION NATIONAL PARK**

One hundred and thirty-five pounds of pure muscle, Kim Csizmazia carries 20 pounds of camelots, carabiners, slings, nuts, and ascenders to aid her solo climb. Solo ascents are difficult and dangerous. Regarded as one of the best climbers in the world, Csizmazia, 36, describes her passion for climbing as "an essential fatty acid."
*Photos by Sallie Dean Shatz*

**ZION NATIONAL PARK**

A hanging camp is home during Csizmazia's 1,200-foot, two-day climb. The route is broken into eight pitches, each pitch the length of her 150-foot rope. After reaching the top of a pitch, she lowers herself to clean the climbing gear from the crack. As she rappels, her body weight acts as a counterweight, hauling up her gear.

**ZION NATIONAL PARK**

To shoot these images, Sallie Dean Shatz ascends and descends a 1,200 foot pre-rigged rope system that allows her to move around Csizmazia as she climbs. Csizmazia's decision to climb Lunar Ecstasy prove to be an auspicious one. She slept under the full moon and watched as a lunar eclipse cast its shadow across the canyon walls.

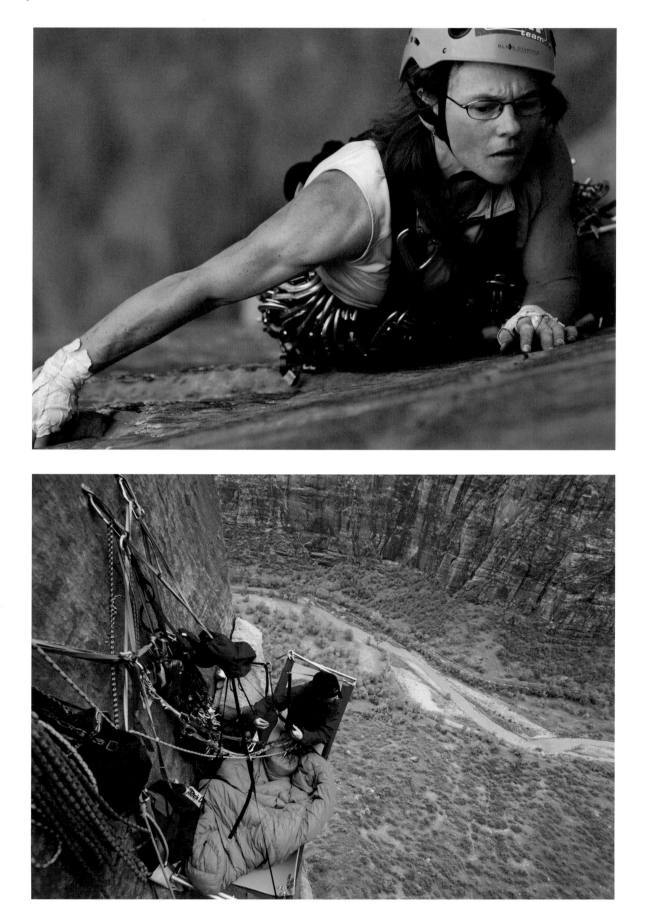

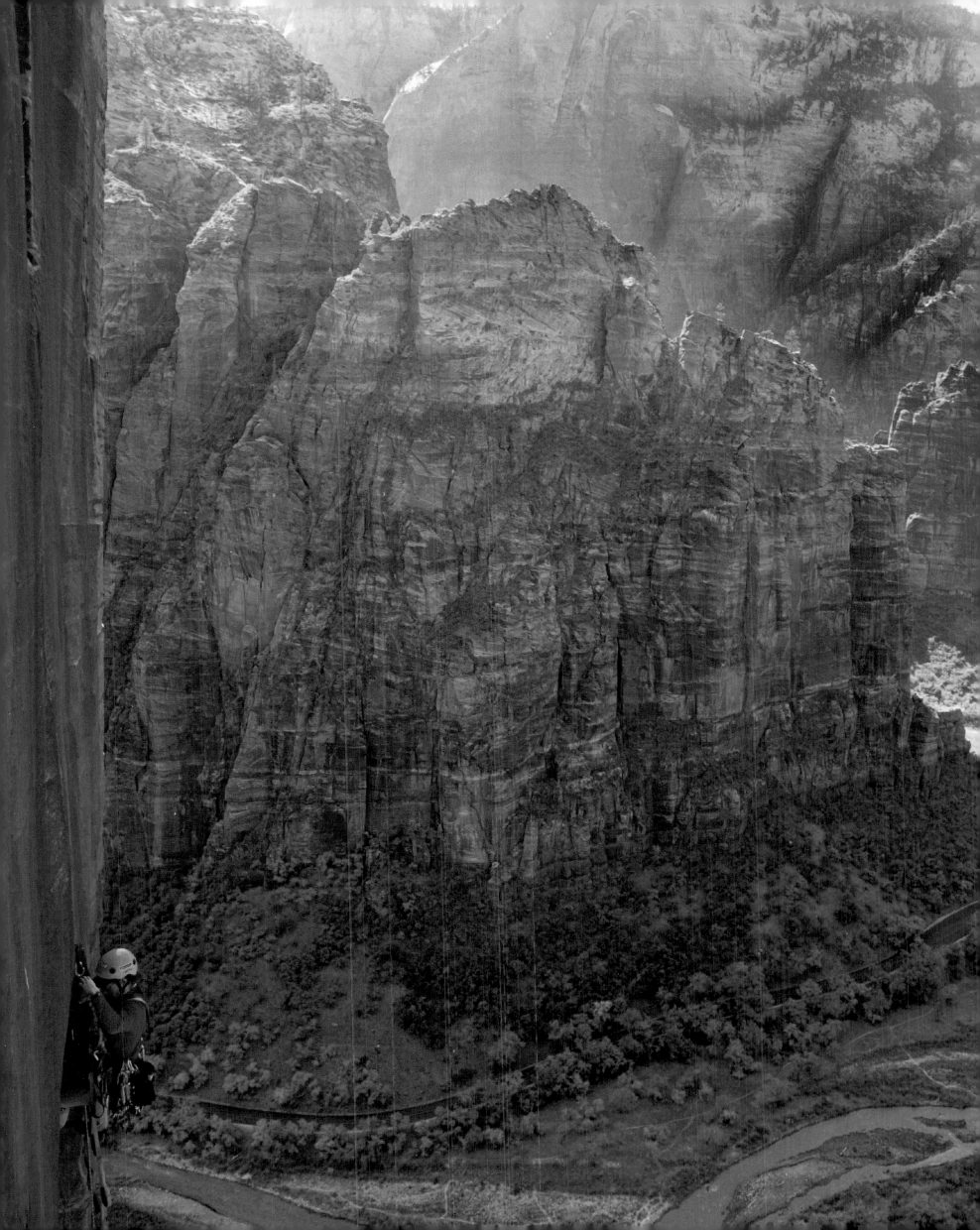

**SALT LAKE CITY**
At the annual Emerson Elementary School Carnival, a child slides down the lower portion of the 40-foot Jurassic Survivor.
*Photo by Trent Nelson*

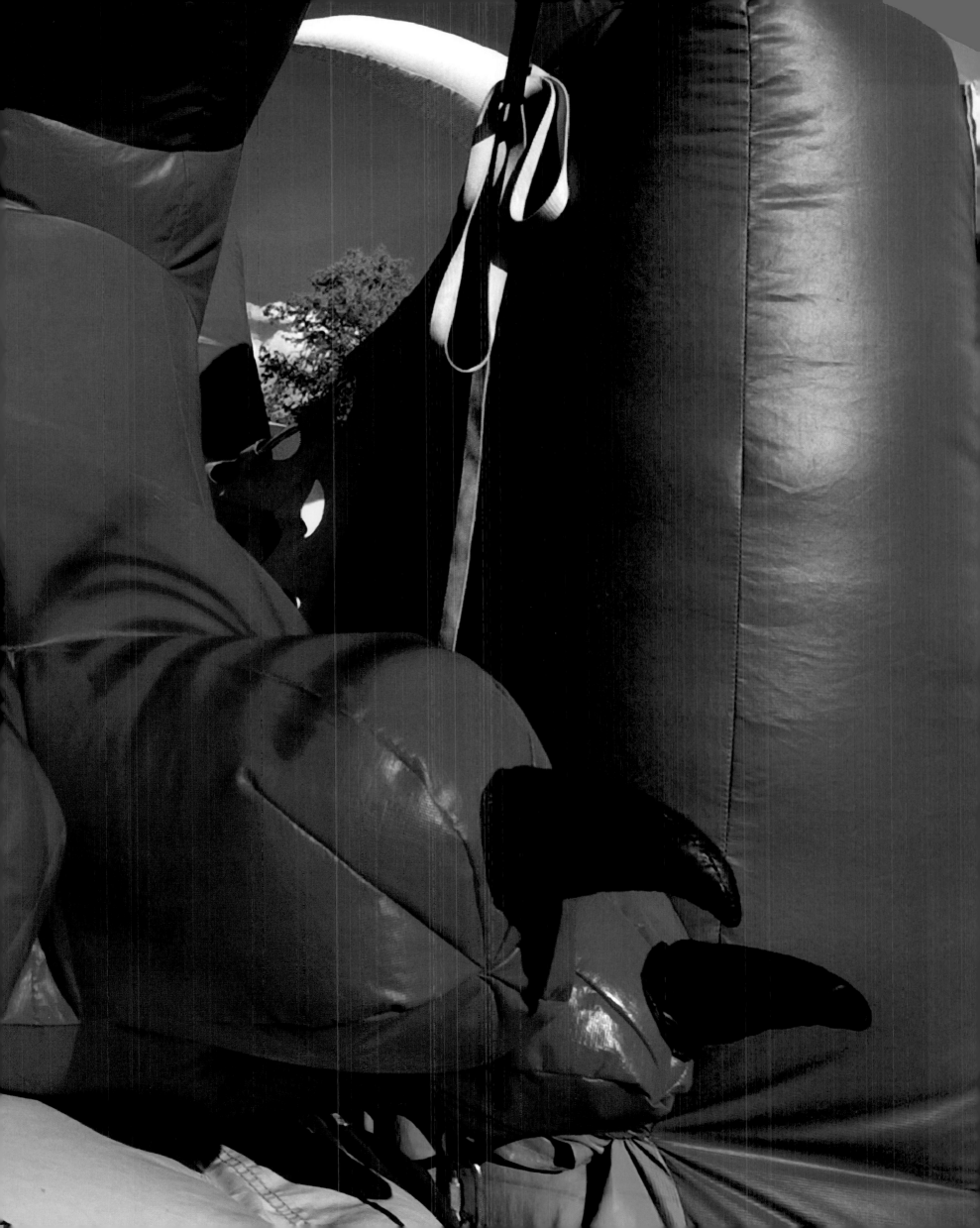

**WEST VALLEY CITY**

Classic "mini cups" zip through a curve at Rocky Mountain Raceway. The half-scale stock cars were created in 1995 as an easy and economical way for beginners to get involved in racing. Capable of a maximum speed of 45 mph, mini cups require less maintenance than their 150-mph, full-size counterparts. With a price tag of $7,000, they're one-fifth the cost.
*Photos by Scott G. Winterton,*
*Deseret Morning News*

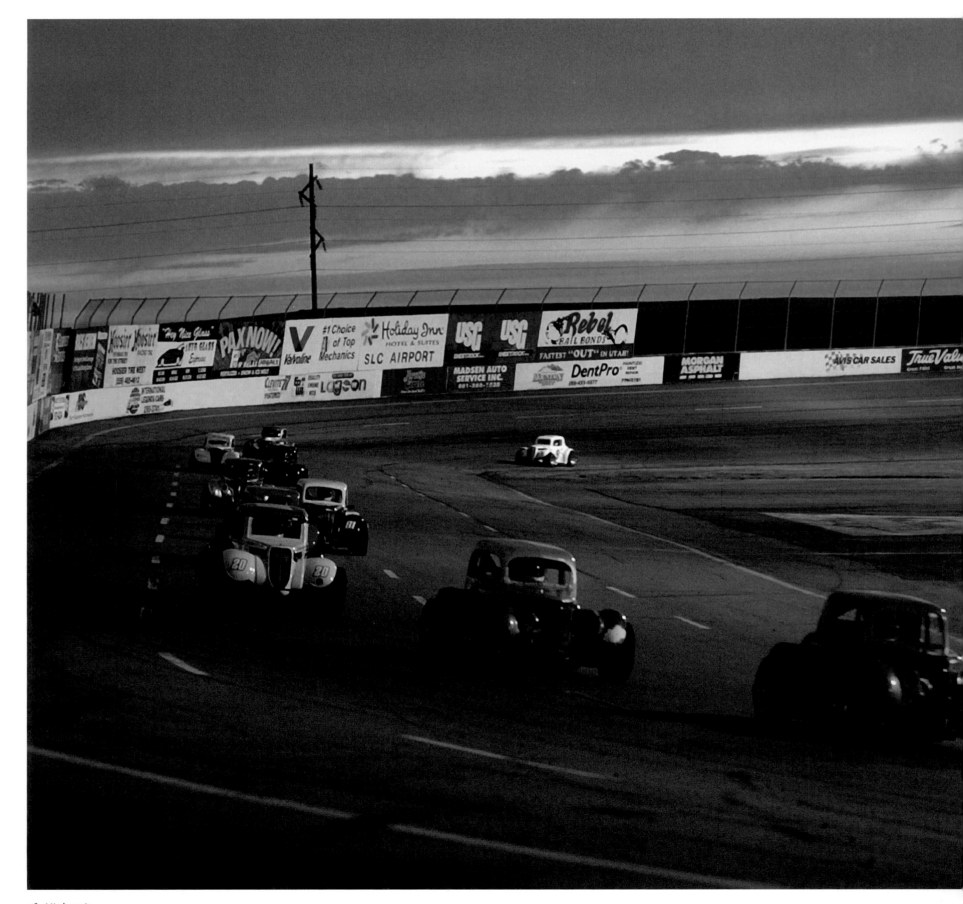

**WEST VALLEY CITY**

For the past four summers Kathryn Lovendahl, 11, has spent every Saturday night with her parents and two cousins at the mini cup races. Her great-uncle and his two sons are regular competitors.

**WEST VALLEY CITY**

After squeezing into their classic mini cups, drivers line up for the start of a 20-lap race around the track. Rocky Mountain Raceway has inverted starts, which give slower cars a chance to lead the pack.

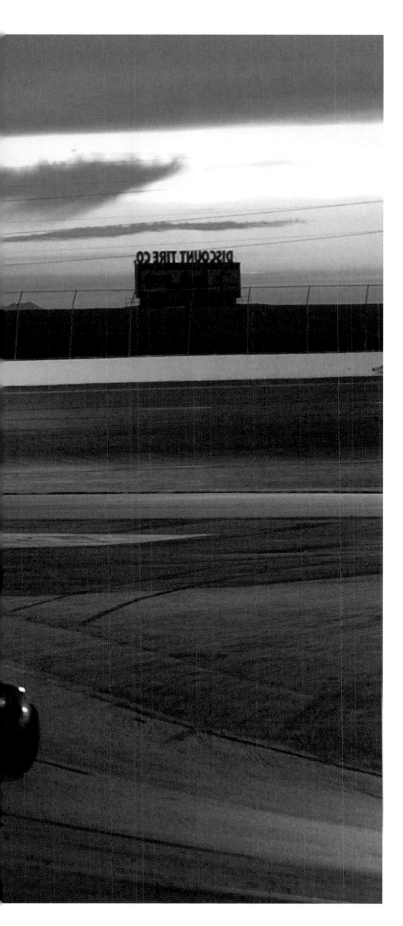

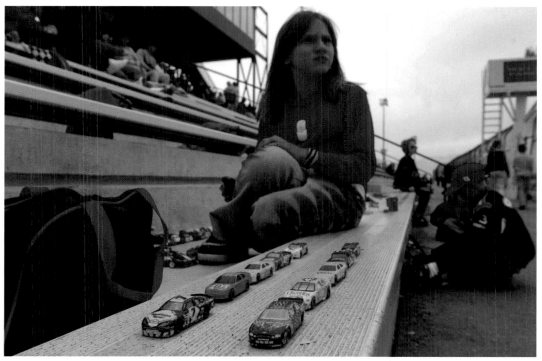

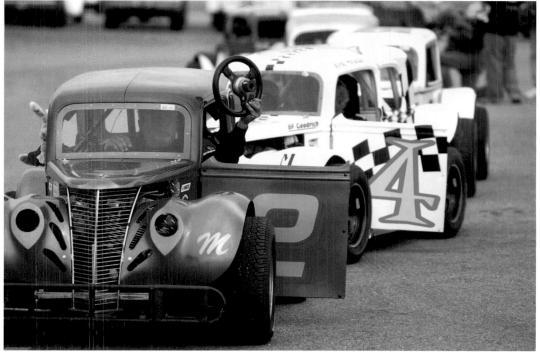

**PAYSON**

On the motocross course his father laid out, Jordan Carlisle, 16, gets big air with his Honda CR125. During the summer, Jordan spends most weekends competing in local motocross events.

*Photo by Jason Olson, Deseret Morning News*

**MOAB**

Slickrock Trail is a daredevil's destination, attracting more than 100,000 visitors a year. Most come to test their mountain bike skills. Ryan Kratzer, 27, comes to longboard, a sport even mountain bikers consider crazy. After all, bikes have brakes. Kratzer, who calls his sport "earth surfing," is best known for the "Kratzer McTwist," where he spins the board 360 degrees in midair.

*Photo by Lori Adamski-Peek*

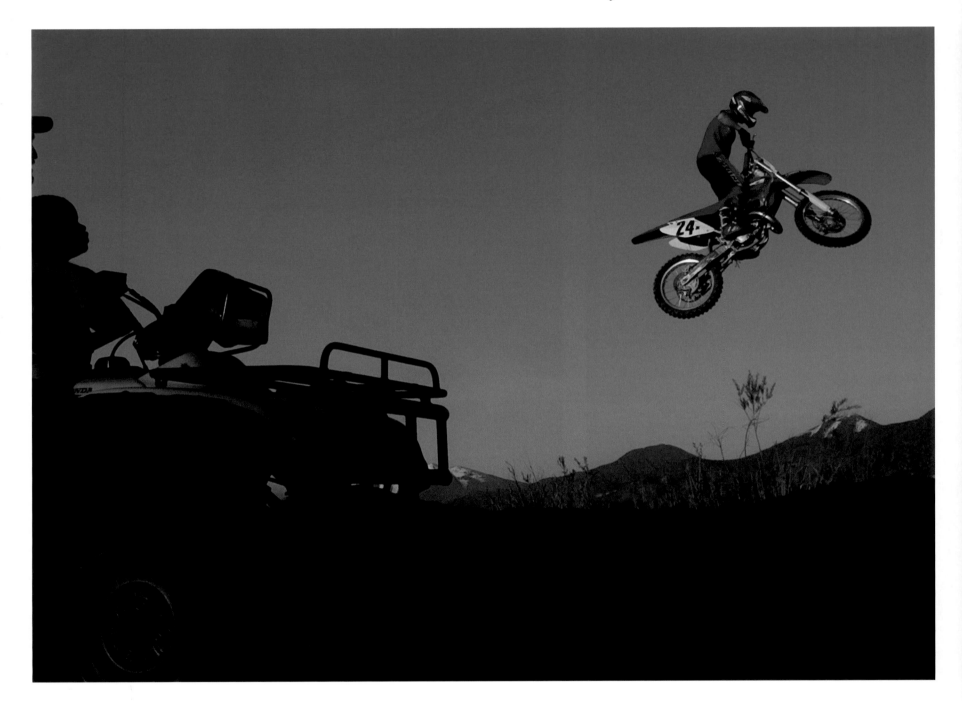

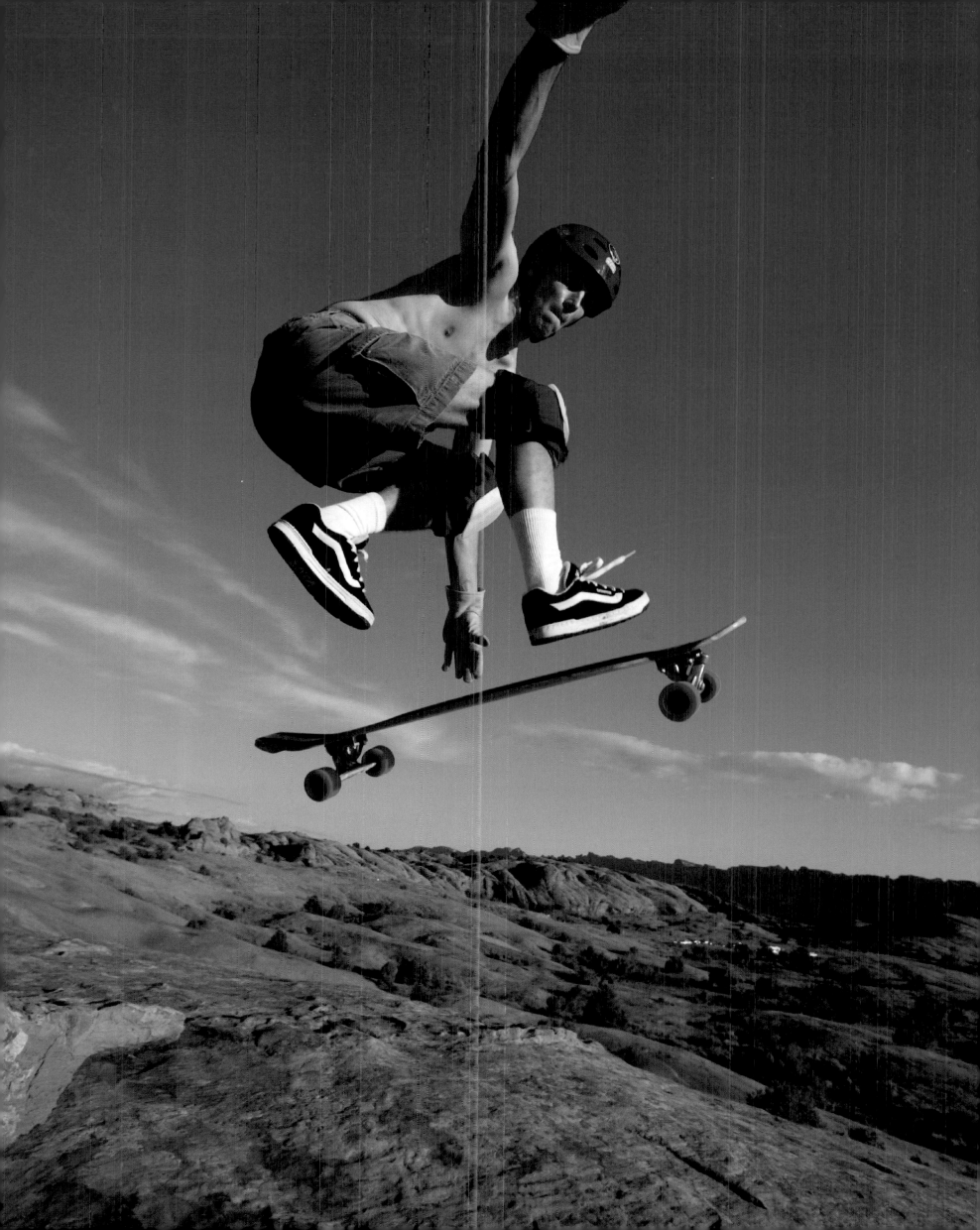

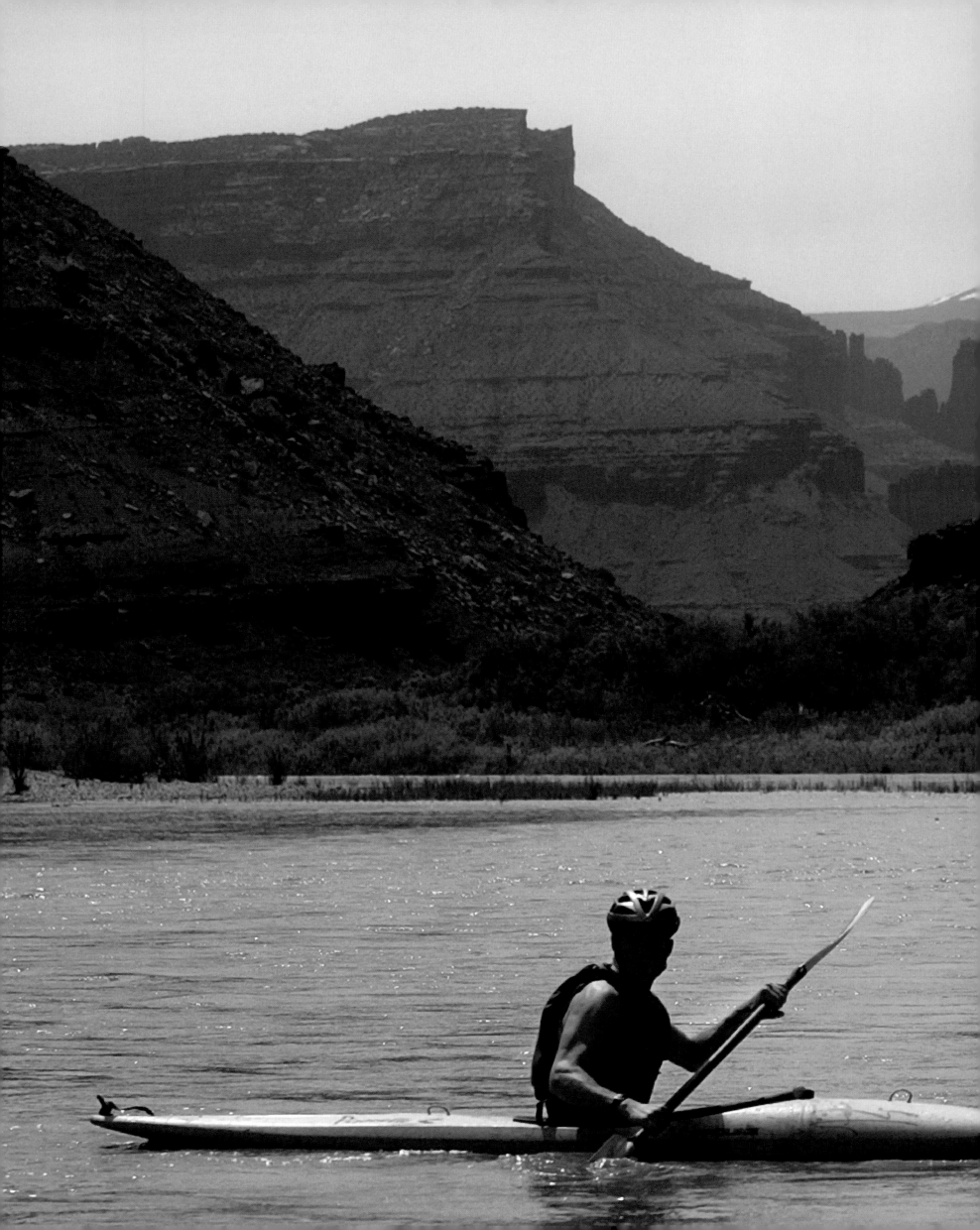

**GRAND COUNTY**
Lawyer Scott Martin kayaks down the
Colorado River during a special two-day
camping trip with board members, donors,
and clients of SPLORE—Special Populations
Learning Outdoor Recreation and Education.
More than 80 percent of the beneficiaries
of the nonprofit wilderness and education
organization have disabilities.
*Photo by Rick Egan, The Salt Lake Tribune*

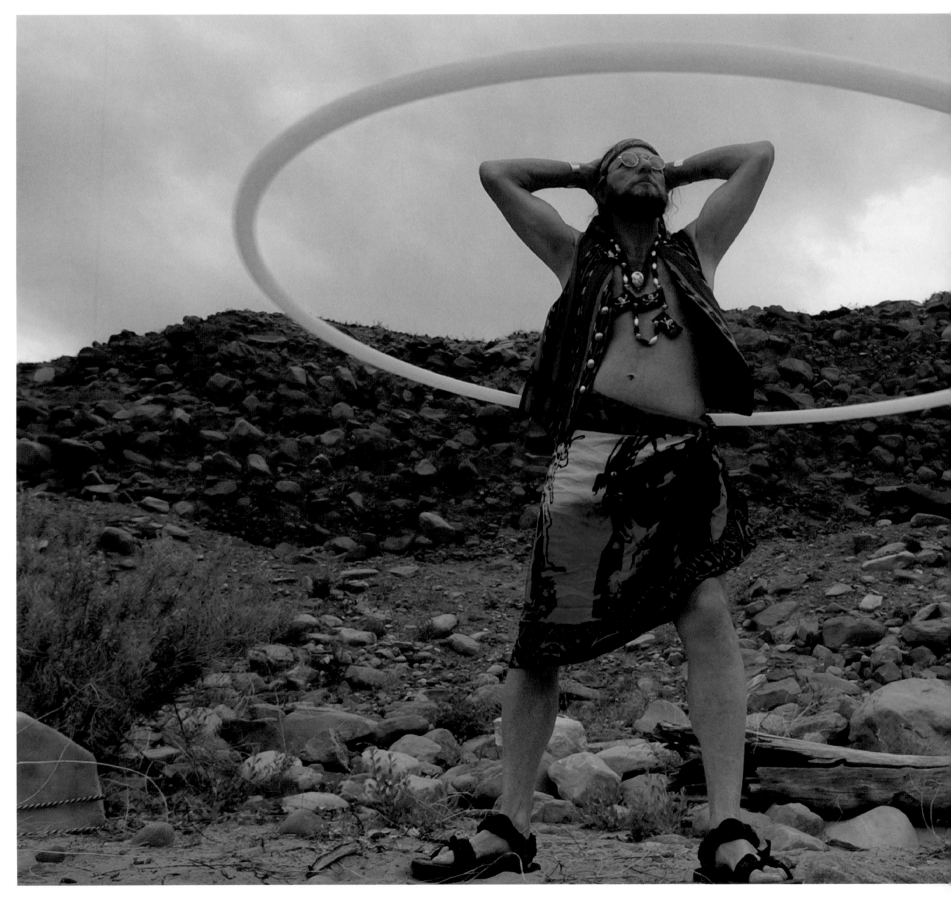

**GRAND COUNTY**

Retired attorney Bob Lippman gets ready for a '60s retro shindig during the SPLORE expedition on the Colorado River. Now a river guide, Lippman volunteers his services to SPLORE, which gives people with disabilities and special needs a chance to participate in outdoor adventures.
*Photos by Rick Egan, The Salt Lake Tribune*

**GRAND COUNTY**

Can you dig it? SPLORE participant Garrett Kadleck, 12, can—and does. It took him an entire day to dig the 4-foot hole, using just his hands and rocks.

**GRAND COUNTY**

All you need is glove: During a little break in the midst of all the canoeing, rafting, rock-climbing—and even tie-dyeing—Preston and Tanner Kadleck show off a trick they learned.

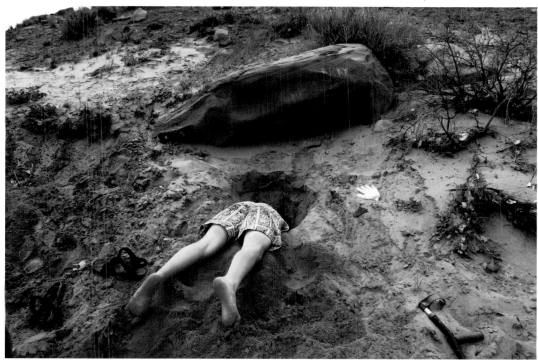

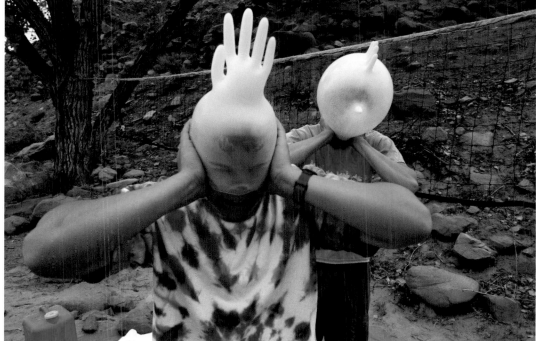

**CENTERVILLE**

During the pregame pep talk, Viewmont High School soccer coach Casey Layton leads his Vikings in the "Pile Up," a unity-building exercise that ends with the chant, "Together we stand! Together we can!" Layton's approach seems to work: Viewmont beat the West Jordan Jaguars 3–1 and finished the state tournament in 2nd place.

*Photo by Ravell Call, Deseret Morning News*

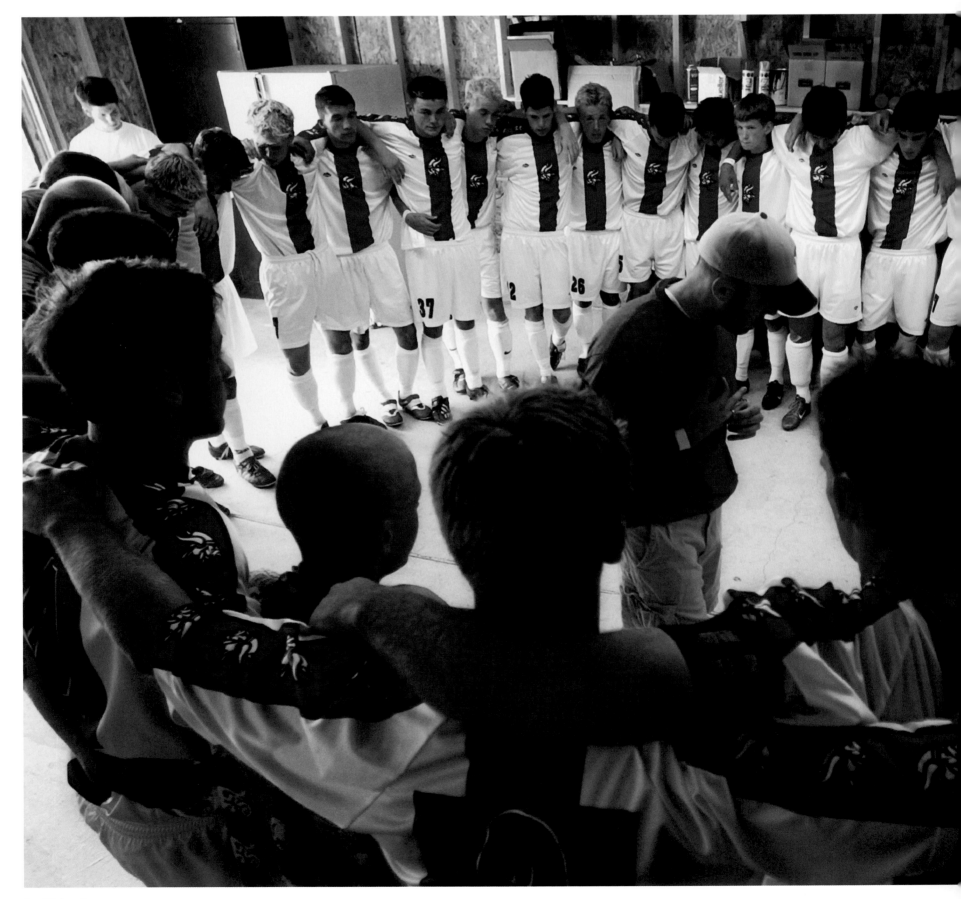

**SALT LAKE CITY**

With the ubiquitous Wasatch Range as backdrop, the Salt Lake Stingers take on the Las Vegas 51's at Franklin Covey Field. The Stingers are the Triple-A affiliate of the Anaheim Angels. In 2002, pitchers Francisco Rodriguez (K-Rod) and John Lackey made the big club—and the World Series.
*Photo by Rick Egan, The Salt Lake Tribune*

**OGDEN**

Utah's first rodeo (of record) was held in 1888. The tradition continues with the monthly Utah Youth Rodeo at the Golden Spike Arena. Open to youngsters from age 3 to 12, it includes the full range of rodeo events, some of them modified to accommodate the young'uns. The 12-year-old rodeo now attracts cowkids from all over the Intermountain West.
*Photo by Leah Hogsten*

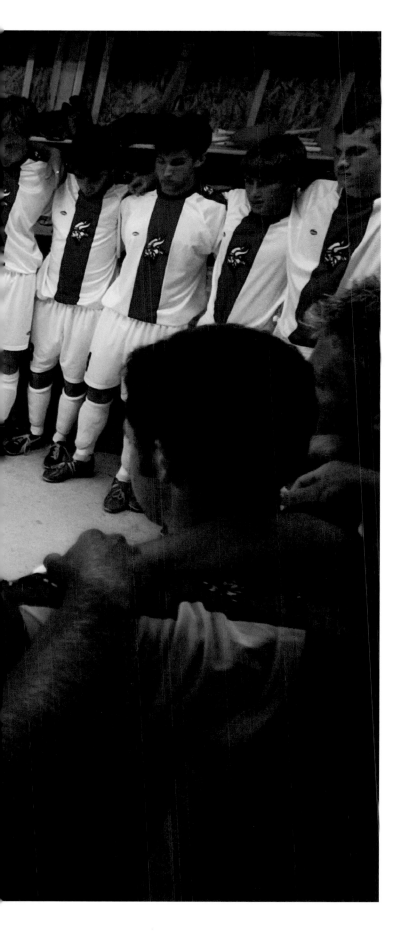

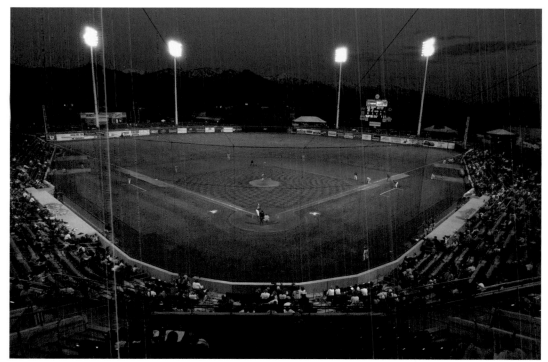

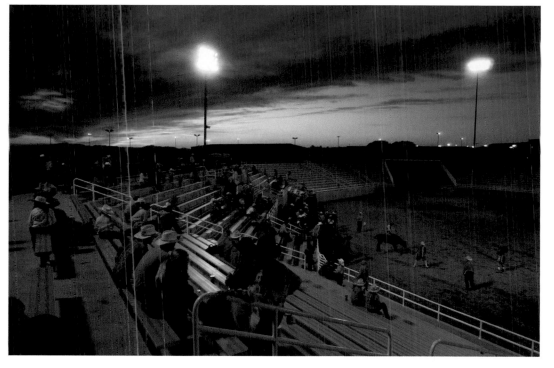

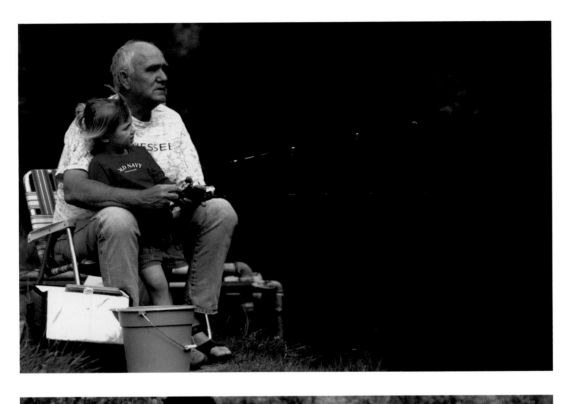

**PROVO**

On her first try, Kiersten Gallagher, 7, caught two rainbow trout. Her grandfather, Clifton Gallagher, a native Californian who moved to Utah in the 1980s in search of a slower-paced life, brought a total of eight of his visiting grandchildren along to his favorite fishing spot on the Provo River.

*Photo by Scott G. Winterton,*
*Deseret Morning News*

**PROVO**

Victoria Beattie began accompanying her father fly-fishing when she was just 2 years old. By age 5, she had wet her first line. Now 7, she's a seasoned trout fisherwoman. Victoria and her father troll Utah's Provo River, which starts as a small stream in the Uinta Mountains, flows through two reservoirs and finally empties 65 miles later into Utah Lake.

*Photo by Scott G. Winterton,*
*Deseret Morning News*

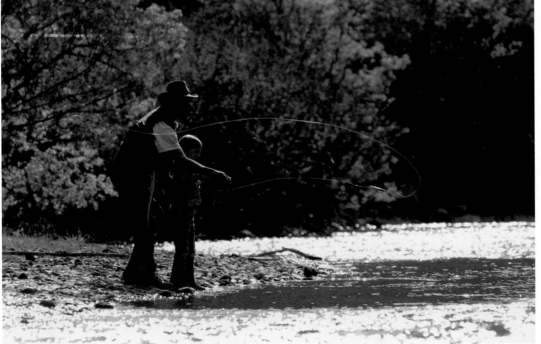

**PROVO**

Utah Lake is a favorite spot with fishermen hoping to land tasty trout. One fish they're not interested in catching is the bland June sucker. The fish exists nowhere else in the world and was classified as an endangered species in 1986. Lakeside locals worry that restrictions designed to protect the fish—like *not* dredging the marina—threaten their businesses.

*Photo by Rick Egan, The Salt Lake Tribune*

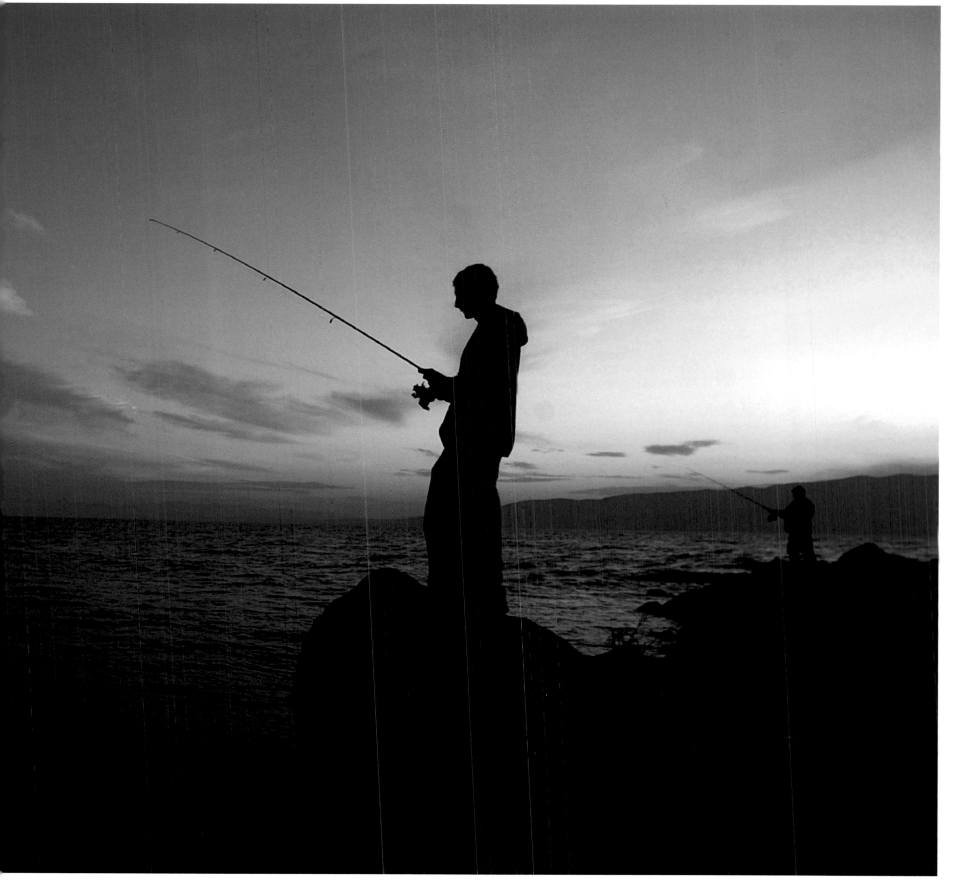

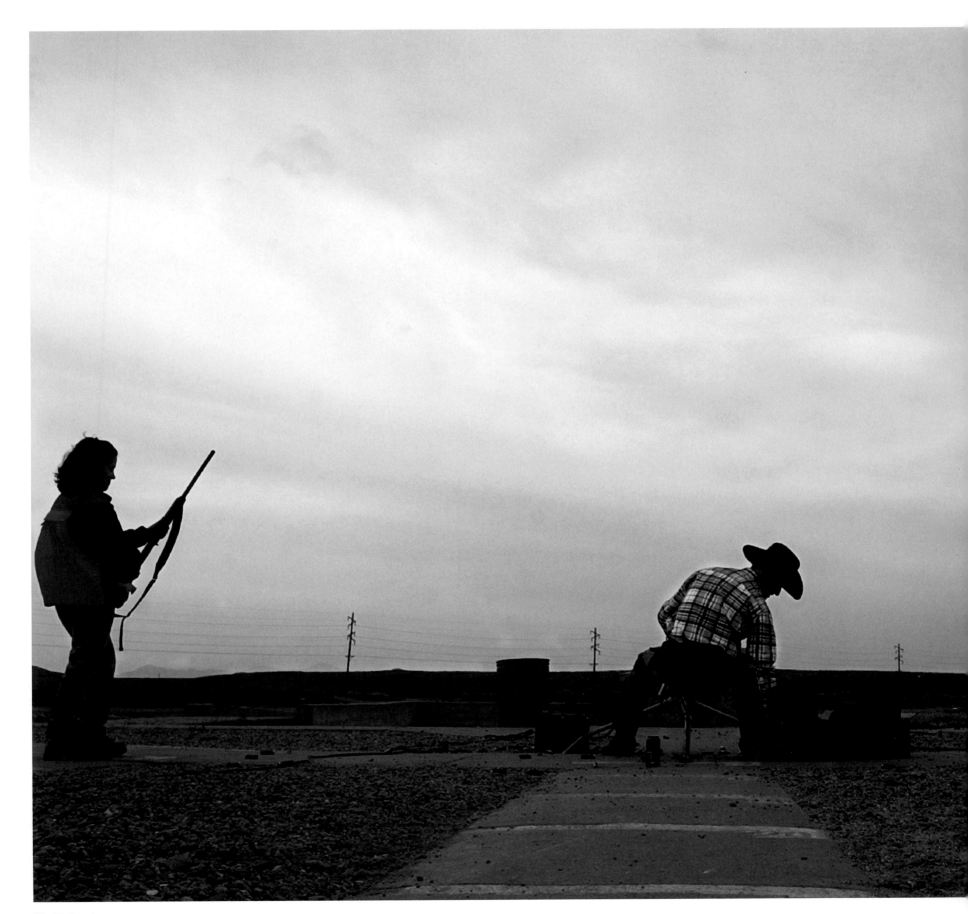

**WEST VALLEY CITY**
Jon Bradshaw prepares to throw another set
of doubles (clay pigeons) for Julie Pawlak (left).
Julie took the six-week shotgun class for women
to improve her shooting skills. She and her four
dogs hunt for game birds and waterfowl.
*Photo by Leah Hogsten*

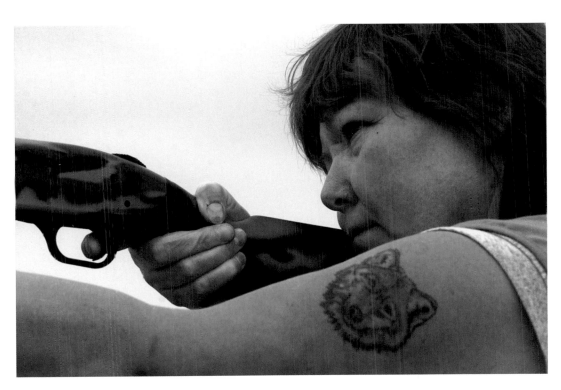

### WEST VALLEY CITY

Paula Minor of Tooele aims her 12-gauge during a women's shotgun class. She and her mother-in-law are amateur skeet shooters and were inspired to enroll after Paula's son took a hunter safety workshop from the same instructors. She says it was cool being with other women and shooting guns.

*Photo by Leah Hogsten*

### VIRGIN

In 2000, Virgin's town council passed a law requiring every household to have a working firearm. It was overturned a year later, but not before bringing worldwide notoriety to the town (pop. 305). Dee Anderson, whose Fort Zion shop sells replica Winchesters, says, "I thought it was stupid; we don't want visitors thinking we're a bunch of crazies."

*Photo by Lin Alder, alderphoto.com*

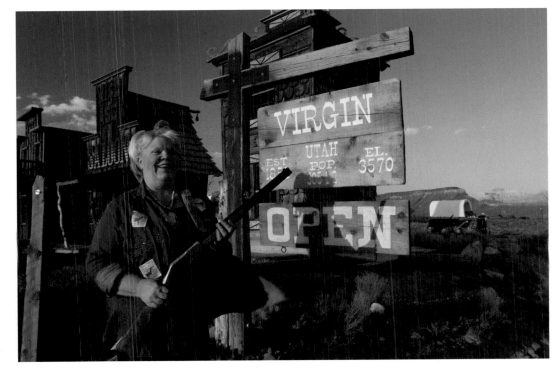

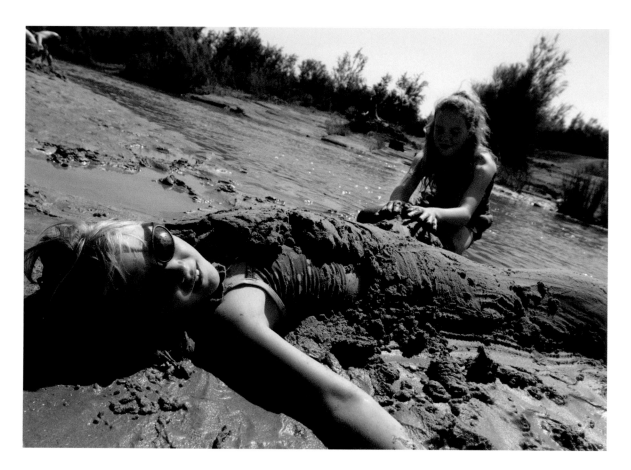

**ST. GEORGE**
Someday, when Celina Brown, 8, and Rachel Adair, 12, are older, they'll probably have to pay for the privilege of wallowing in mud. But for now, Celina's treatment is free, courtesy of the Virgin River mud banks.
*Photo by Nick Adams*

**DEAD HORSE POINT STATE PARK**
Irish tourist Mary Belford takes in the sweeping vista at Dead Horse Point. The point is one of this inveterate traveler's favorite stops in America. According to legend, the park's name has a dark origin. A wild Mustang herd was left corralled on the promontory and died of thirst—within sight of the Colorado River, 2,000 feet below.
*Photo by Lori Adamski-Peek*

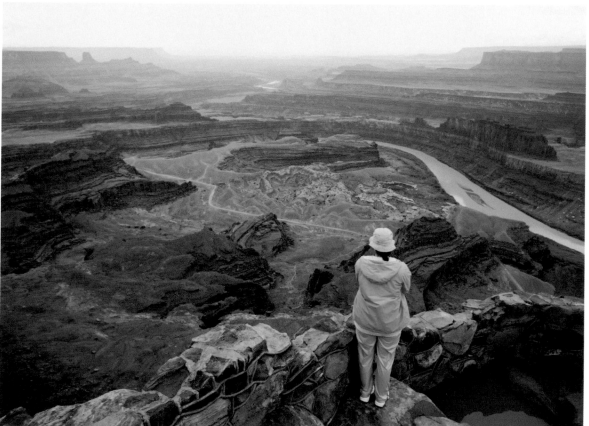

## TORREY

Don Torgerson and son Tyler fit their corriente steers with horn wraps (not ear muffs) before team roping practice. The padded leather wraps prevent rope burns on the ears and at the base of the horns. Torgerson, a retired policeman, competes in small rodeos and owns a 160-acre guest ranch called Cowboy Homestead Cabins.

*Photo by Laura Seitz, Deseret Morning News*

## GRAND COUNTY

Heads up: Ricky Egan, Kerry Athey, Dylan Nauman, and Johnson Orr take turns burying each other. The boys are on a two-day camping trip with their families on the banks of the Colorado River, 20 miles upstream from Moab.

*Photo by Rick Egan, The Salt Lake Tribune*

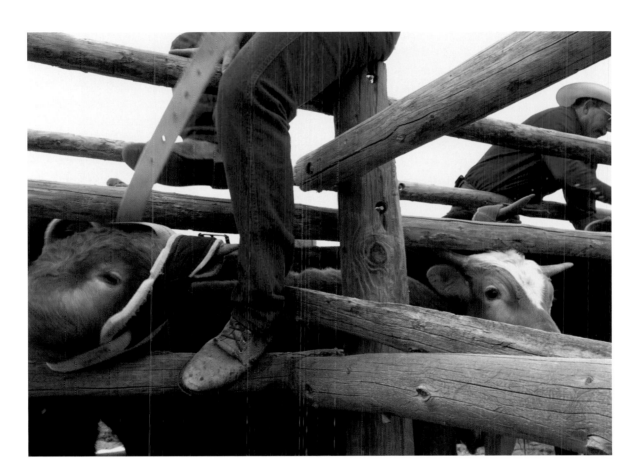

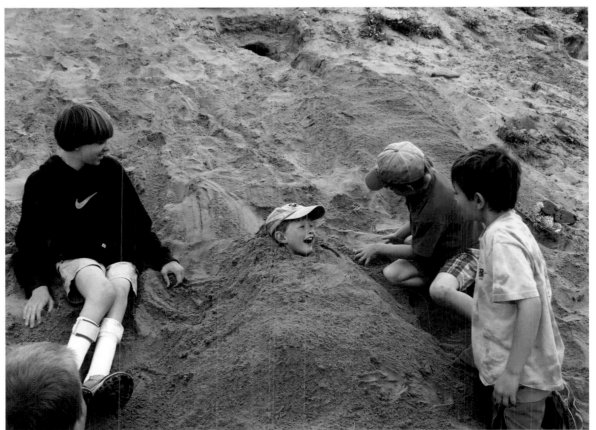

**HOLLADAY**
In the garden of the 8-acre Carmelite Monastery in the Wasatch foothills, Sister Mary Magdalen Perior waters her lilies and tomatoes. A widow with three grown children and four grandsons, Sister Mary Magdalen joined the Carmelite order six years ago.
*Photo by Jeffrey D. Allred,*
*Deseret Morning News*

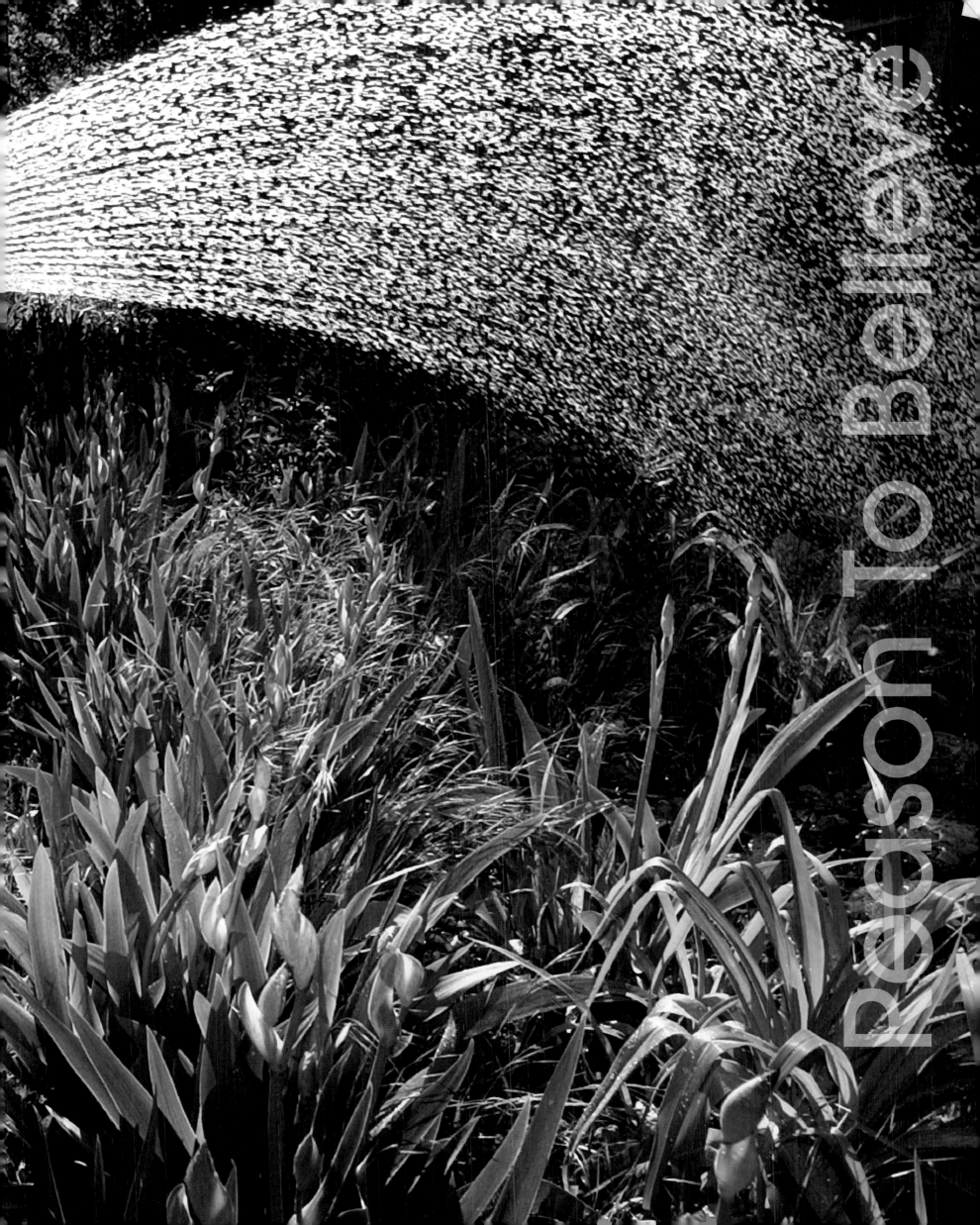

## HOLLADAY

Sister Mary Magdalen hangs sheets and towels in the basement laundry room of the small, eight-member Carmelite Monastery, founded in 1952. The sisters' typical day involves the usual chores, aerobic recreation, and two hours of prayers.

***Photos by Jeffrey D. Allred, Deseret Morning News***

## HOLLADAY

The small skull in front of Mother Superior Maureen Goodwin and Sister Margaret Mary Miller reminds the nuns of their mortality. A skull sits on the dining tables in every Carmelite monastery, as has been the tradition since St. Teresa founded the order in 1562. Although the nuns do not take a vow of silence, mealtimes are quiet and contemplative.

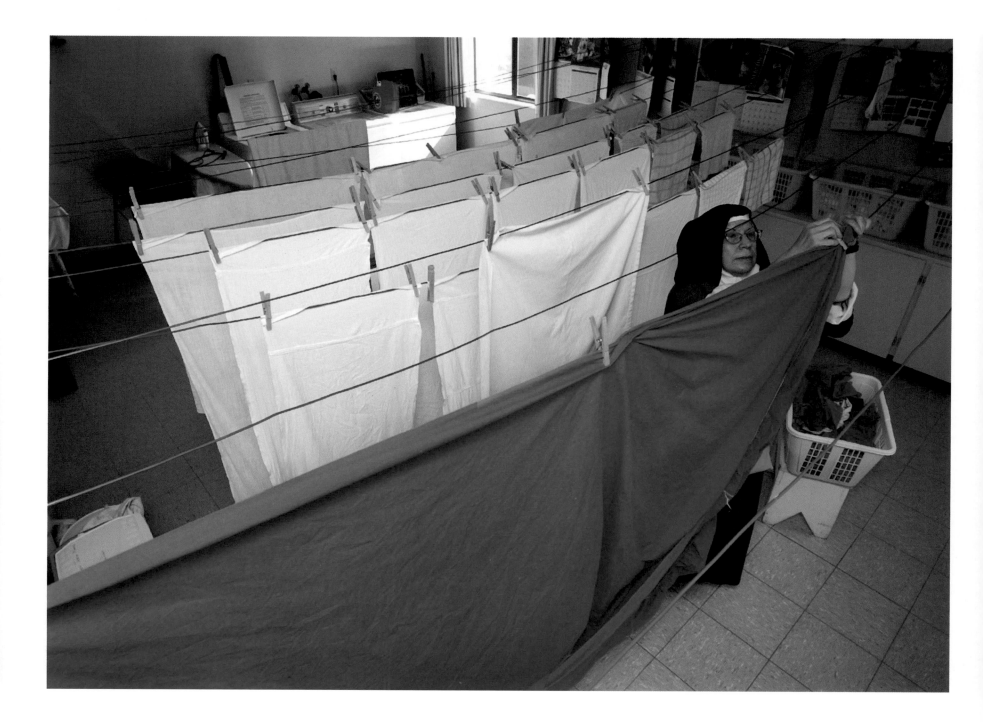

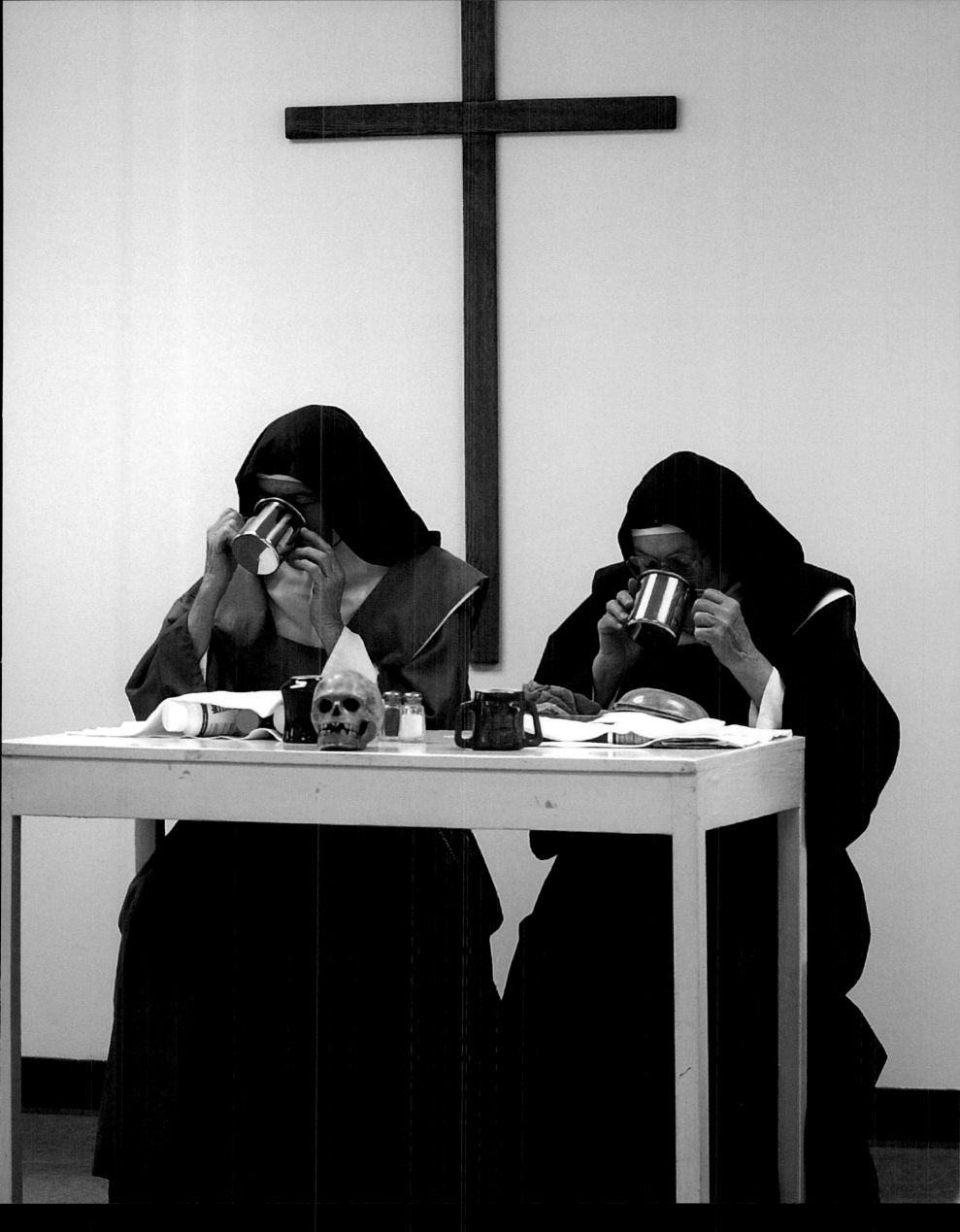

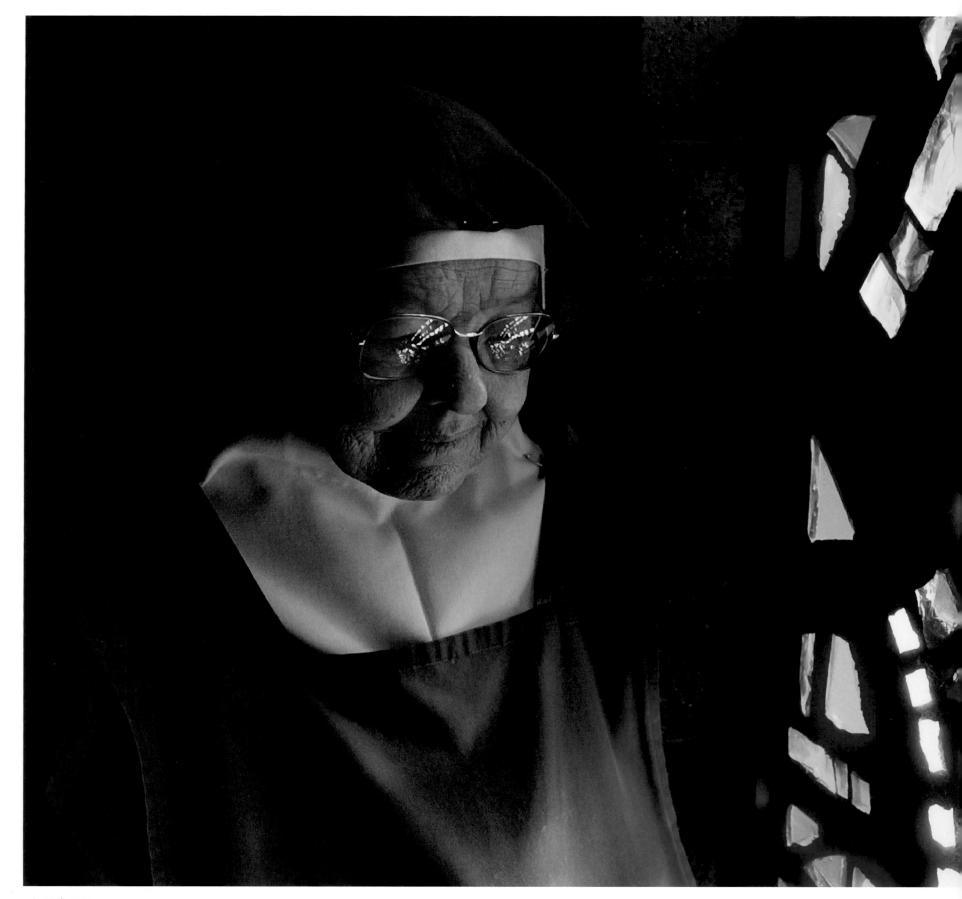

Sister Mary Joseph Whipperman is the extern sister, the one who maintains contact with the outside world for the Carmelite Monastery. Originally a Mormon, she converted to Catholicism 46 years ago after graduating from Brigham Young University with a degree in nursing. "I was a good Mormon, and then I found a better path," she says.

*Photos by Jeffrey D. Allred, Deseret Morning News*

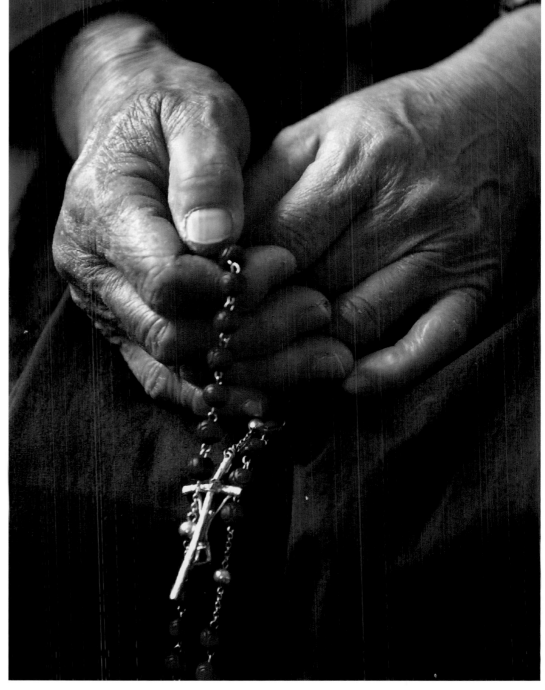

**HOLLADAY**

Korean-born Sister Cecilia Ballinger prays the rosary. For her and Sister Mary Joseph, it's a small world: A high school classmate of Sister Mary Joseph returned from the Korean conflict with a war bride and her young sister, the future Sister Cecilia. "We got to talking and discovered this amazing connection," says Sister Mary Joseph.

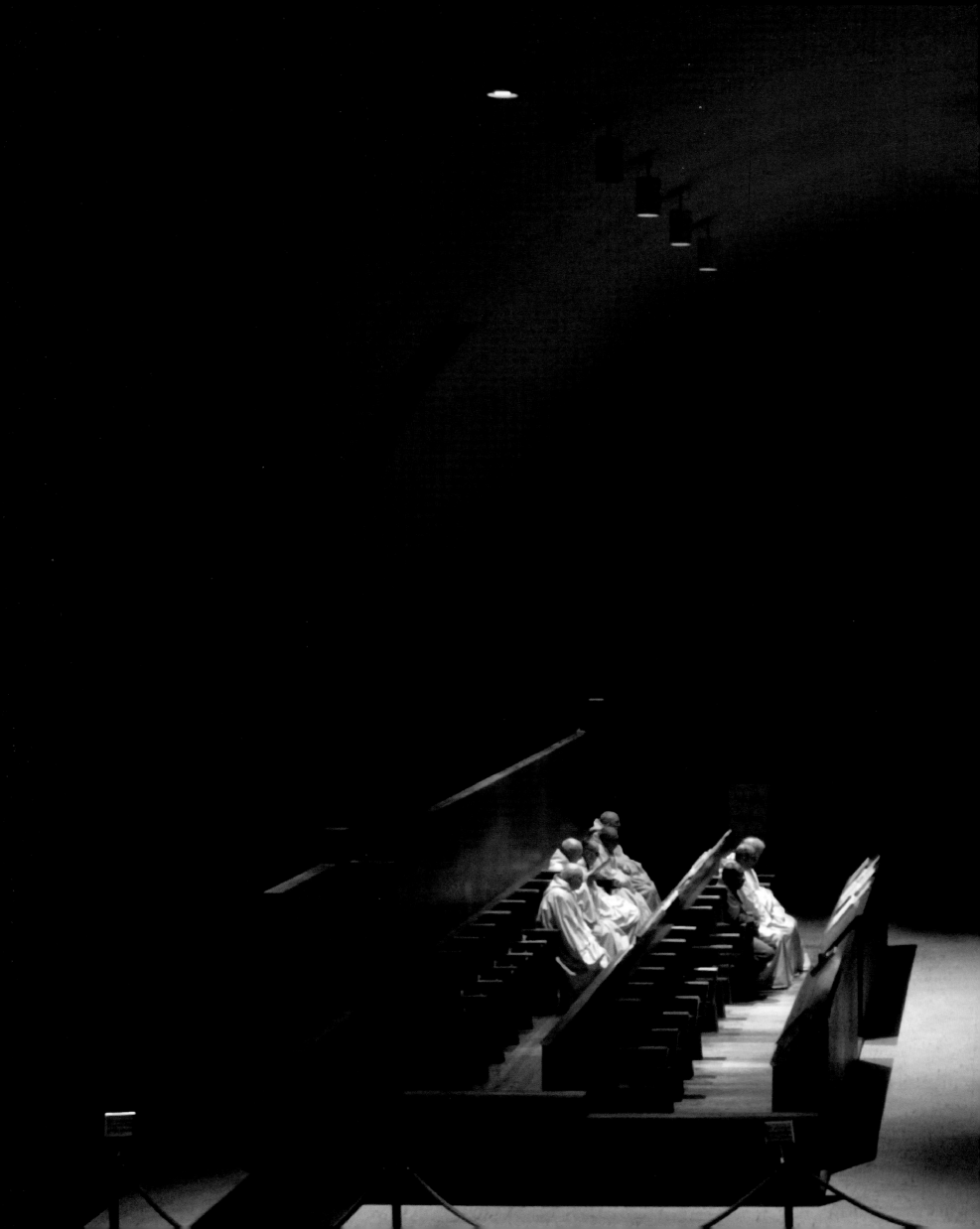

**HUNTSVILLE**

Morning prayers at the Holy Trinity Abbey take place in one of the World War II–era Quonset huts that pepper the property. The 22 resident Trappist monks (down from 80 in the early 1950s) raise beef cattle and grow alfalfa, barley, and hay to meet their obligation of self-sufficiency. They also produce and sell two-grain cereal, peanut butter, and creamed honey.

*Photo by Jeremy Harmon*

**SALT LAKE CITY**

The Church of Jesus Christ of Latter-day Saints' Family History Library is the most comprehensive genealogical resource anywhere, with 2.4 million rolls of microfilm, 742,000 sheets of microfiche, 300,000 books, and 4,500 periodicals. Two thousand patrons, Mormon and non-Mormon, visit the facility daily. Their questions are answered by Elizabeth Perry, who serves her 18-month mission working the information desk.

*Photos by Leah Hogsten*

**SALT LAKE CITY**

Randy Hall thumbs through the Soundex card file as he researches the ancestry of his maternal grandmother, Joyce Bigelow. The Soundex system indexes a surname by phonetic spelling so it can be located even though it may have been recorded under various spellings. Hall eventually found 1830 New York census data containing information about his 4th great-grandfather, Isaac Bigelow.

**SALT LAKE CITY**

Clair Murdock, a retired Naval officer, peruses original North Carolina census records. The Family History Library helped him trace his father's American roots back to the 17th century when the Murdocks sailed from Scotland to Massachusetts. The family eventually came west in 1847 with the original Mormon pioneers. "Whenever we get a chance, we work on our family tree," says Murdock.

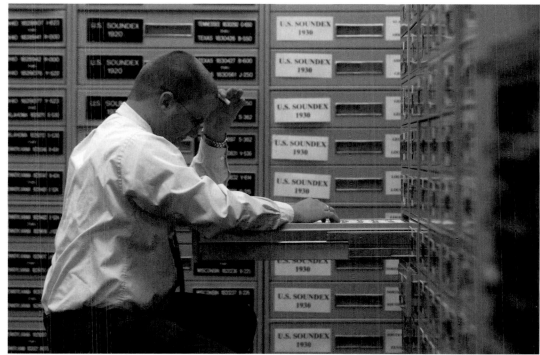

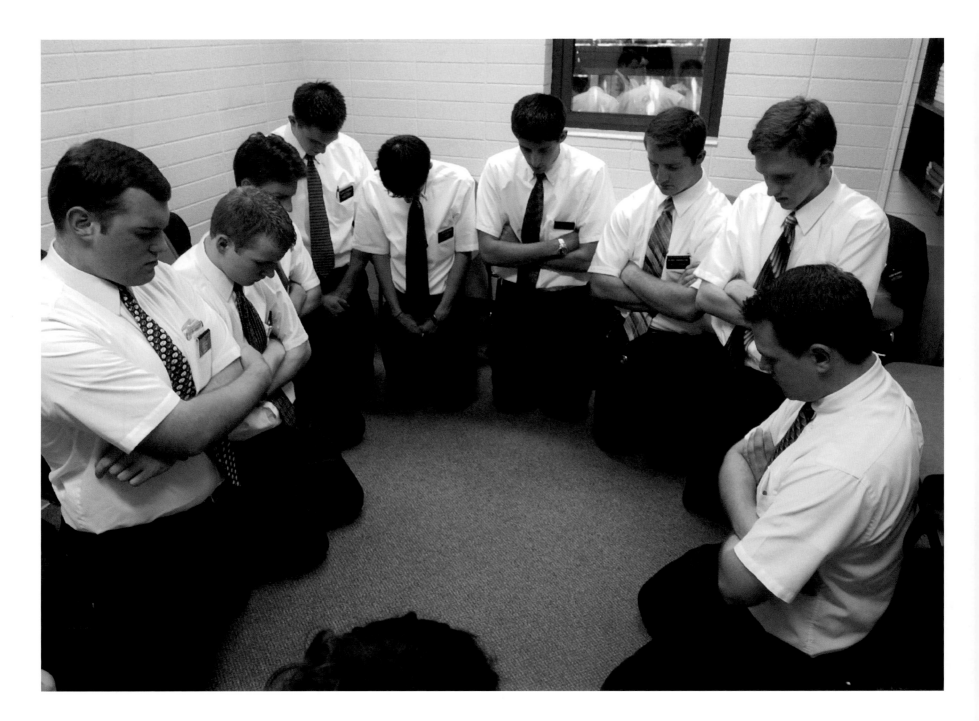

**PROVO**

Each week, about 500 students graduate from the Provo Missionary Training Center, where they're taught to lead religious discussions in English or one of 50 foreign languages. The course can take anywhere from three weeks to three months. Upon completion, the missionaries are posted to 334 Mormon missions in 120 countries.

*Photos by Jeffrey D. Allred, Deseret Morning News*

**PROVO**

Missionaries in training Casey Higley and Nate Smith take a break. Although service is voluntary, the dress code is not—white shirts, ties, and dress pants are required. The two will receive an 18-month posting when their classes end in three weeks. "They come back more grown-up," says Higley's mom Tammy. "And more compassionate."

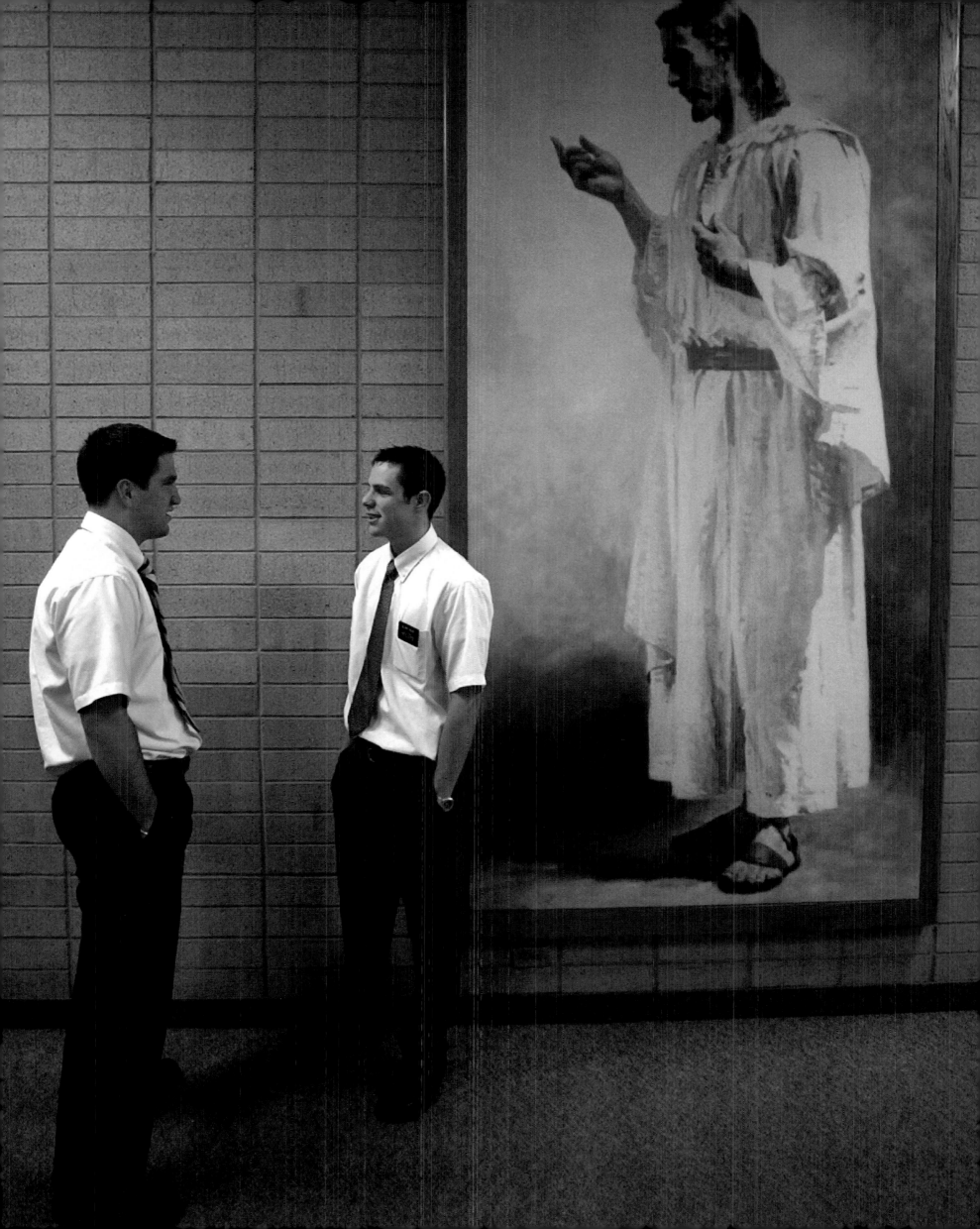

## ST. GEORGE

When Brigham Young saw the original tower on the St. George Temple, he was not pleased. Shortly after the dedication ceremony in 1877, the Mormon leader died. Not long after that, lightening struck the temple and destroyed most of the tower—it was rebuilt to Young's specifications.

*Photo by Ravell Call, Deseret Morning News*

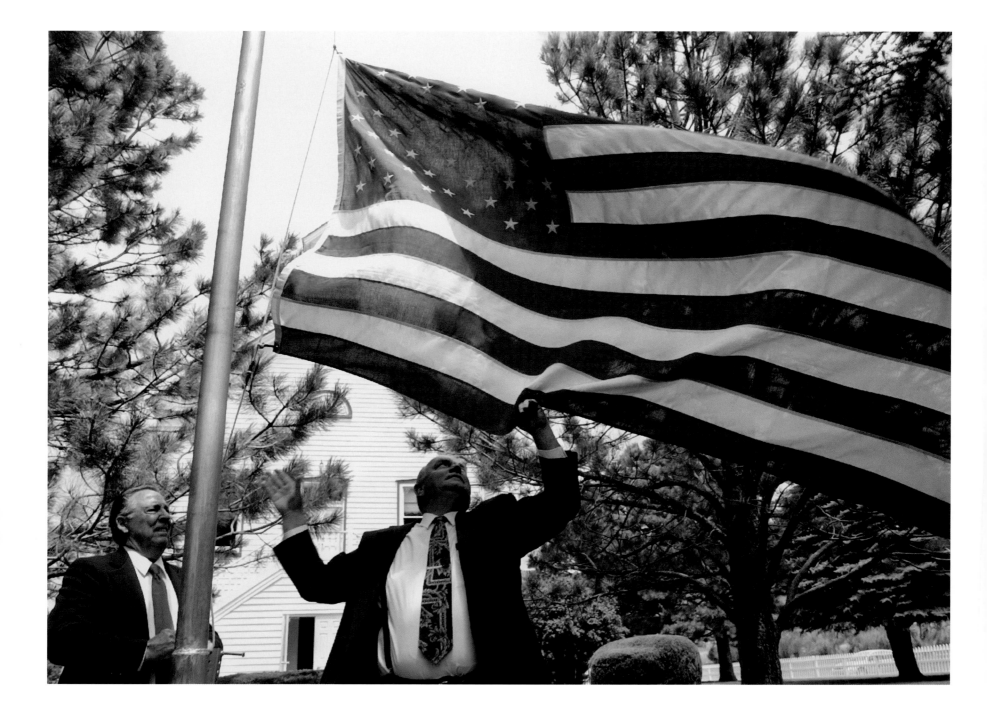

**PINE VALLEY**

Bob Covington and Gerald Schiefer lower the
flag after services at the Pine Valley Chapel,
the oldest chapel still in use by the Mormon
Church. Schiefer, a retired engineer, is now a
consultant to the Defense Department. "We're
a patriotic bunch both as a church and a com-
munity," Schiefer says proudly. "During the Iraq
War, we put up hundreds of yellow ribbons."
*Photos by Ravell Call, Deseret Morning News*

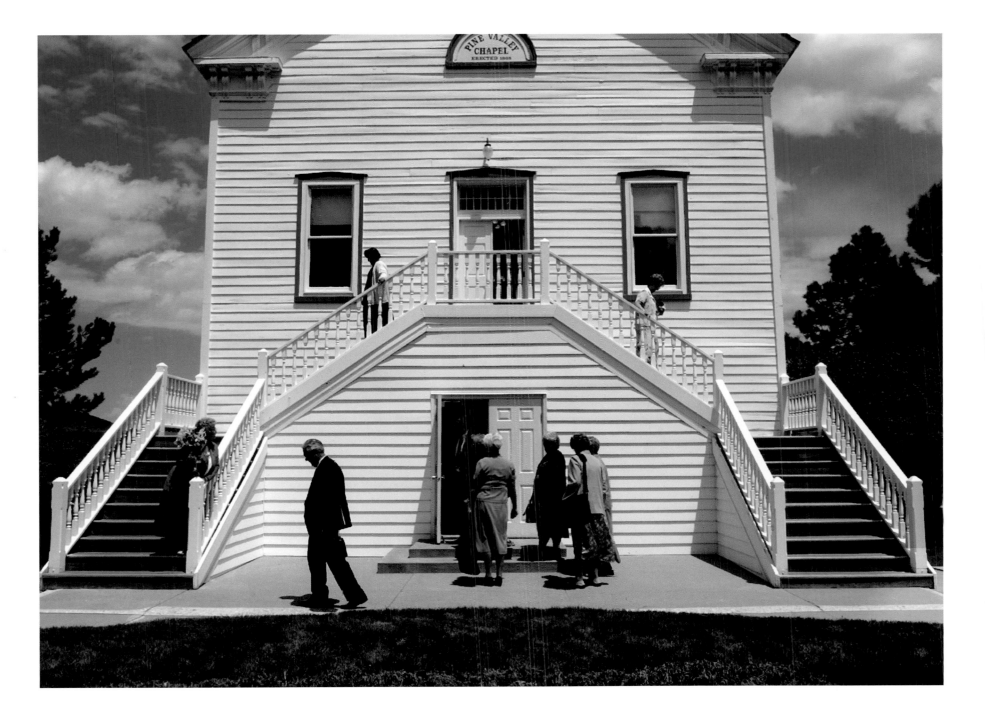

## PINE VALLEY

In 1868, Scottish shipwright Ebenezer Bryce agreed to build the Mormon's Pine Valley Chapel on one condition—he had to do it his way using boat-building techniques. As a result, the attic rafters in the sturdy two-and-a-half story structure looks like the crossbeams in a ship's hull. "If a flood should come, it would float," Bryce promised.

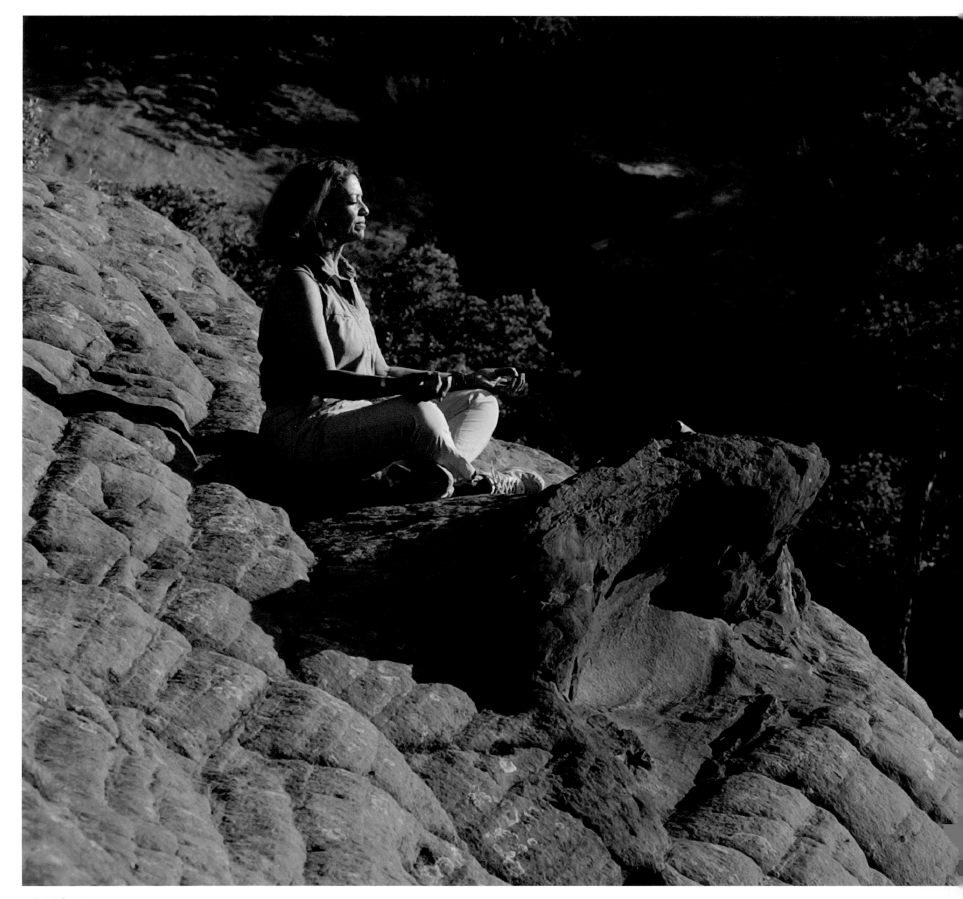

**SNOW CANYON STATE PARK**
During a Spirit Hike, Andrea Hanson meditates on an outcrop in the petrified sand dunes of Snow Canyon State Park. She's been organizing hikes for a dozen years. "We walk in a beautiful, unspoiled location...mostly in silence," she says. "The idea is to raise people's awareness of nature. It's based on the way Native Americans lived seamlessly with their surroundings."
*Photos by Ravell Call, Deseret Morning News*

**SNOW CANYON PARK**

The talking stick passes between two members of a Spirit Hike. As part of a sacred Native American practice, this piece of manzanita, decorated with turkey feathers and symbols of the four elements, represents truth. "The person who receives it must speak from the heart," says Hanson. "The others must listen with the heart."

**SNOW CANYON STATE PARK**

Choosing a reminder rock from Hanson's leather bag of polished agates is part of the closing ceremony for the Spirit Hike. "The stone is my gift to keep the experience alive," says Hanson.

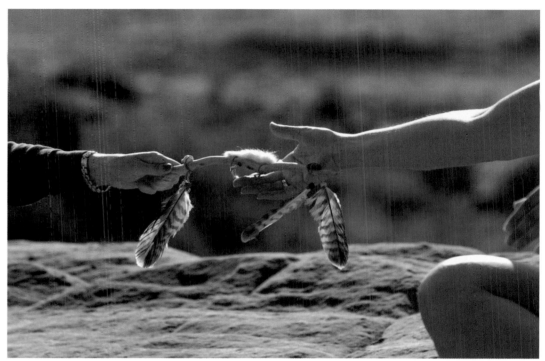

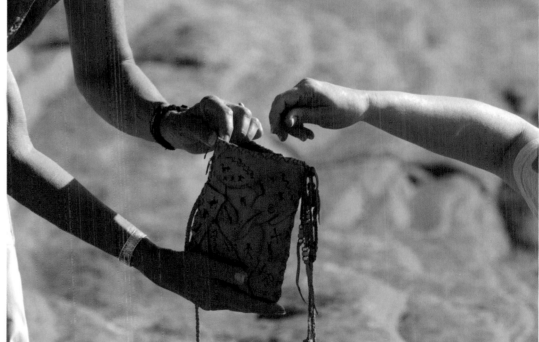

**OGDEN**
Jaela Brown, 20 months, takes naps religiously—especially at Finley Temple Church of God in Christ.
***Photos by Keith Johnson, Deseret Morning News***

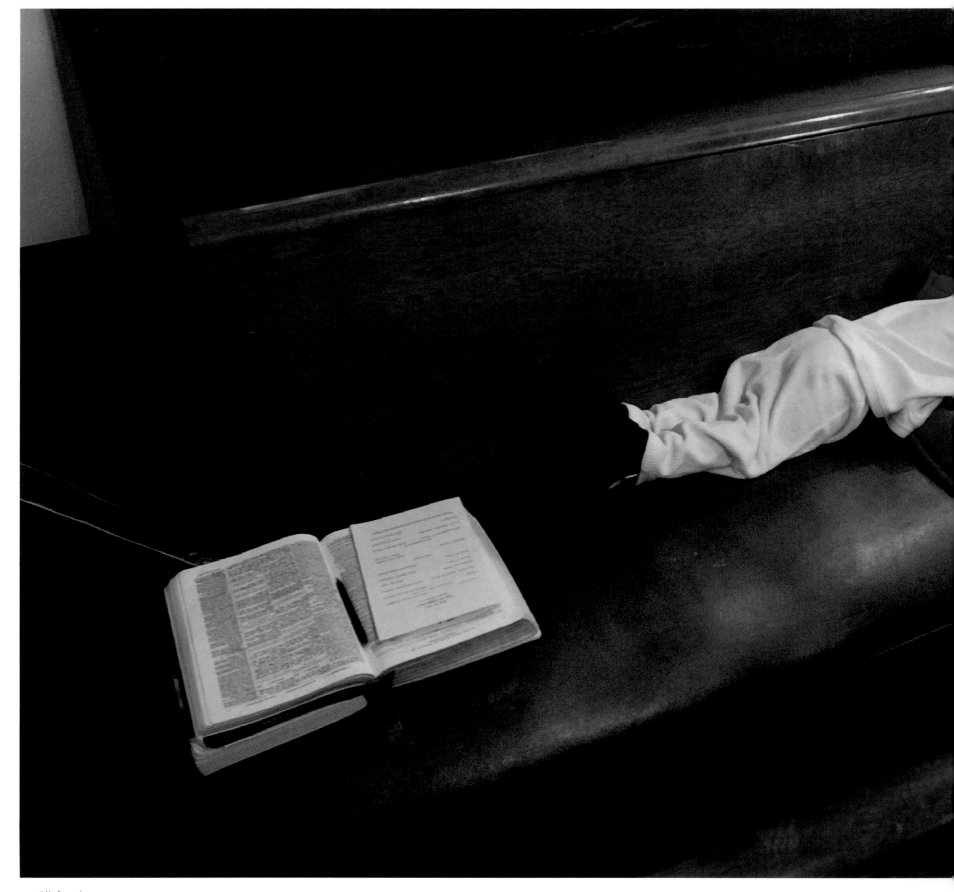

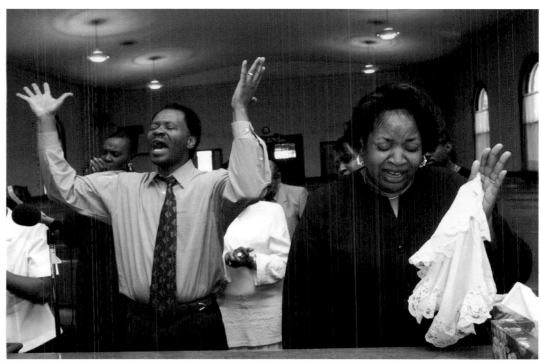

**OGDEN**

Hallelujah! Melvin Champion and Daisy McAllister feel the Spirit during Sunday services at Finley Temple Church of God in Christ. The building, originally a Mormon church, became home to Finley's Pentecostal congregation 50 years ago.

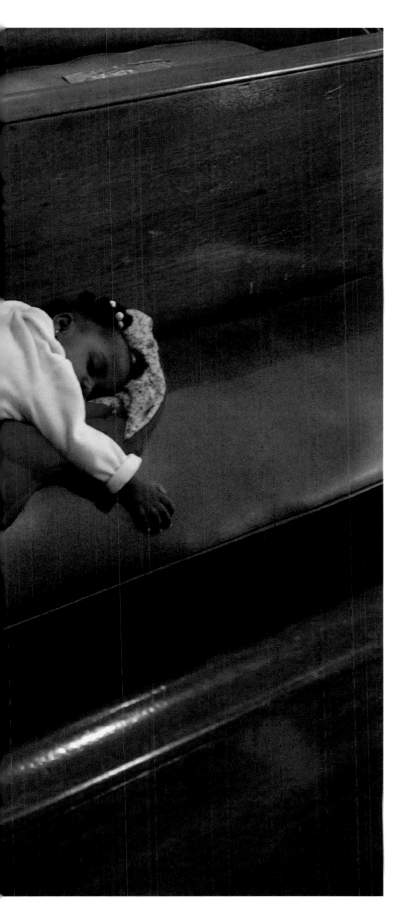

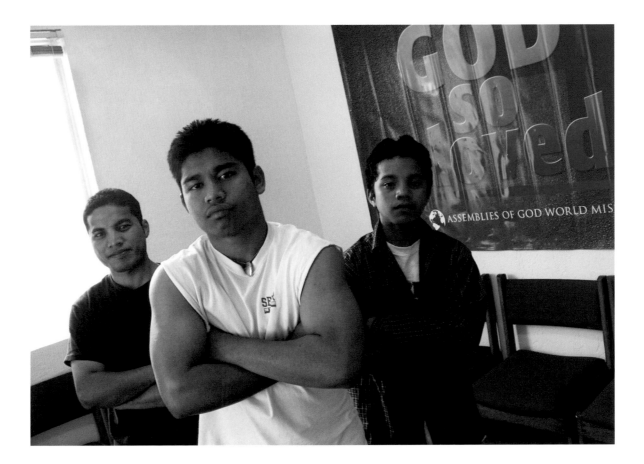

**SALT LAKE CITY**

Marshallese Islanders David Boas, Raymond Kemen, Jr., and Morie Leer distribute meals for the Food Ministry at the Utah Dream Center. Founded by Pastor Alfred Murillo in 2002, the outreach organization caters to at-risk youth with its Metro Kidzz Club, a traveling Nickelodeon-style Bible school that tours Salt Lake City sidewalks every Sunday.

*Photo by Kent Miles*

**ESKDALE**

Fay Carlson cuts sacrament wafers for Saturday services in the Levite commune where she and her husband have lived for 32 years. Levites are Christians who believe they are descendants of Levi, a leader of one of the 12 tribes of Israel. The clan settled in the eastern border town of Eskdale in 1956.

*Photo by Jason Olson, Deseret Morning News*

**LAYTON**

The hands of a Thai Buddhist monk in meditation. In Thailand, it's customary for every male to become a monk in order to be become a man. Vows can be taken for a week, a year, or a lifetime. When a man no longer desires to continue, he "disrobes." That is, he gives back his vows.

*Photo by Rick Egan, The Salt Lake Tribune*

**LAYTON**

Venerable Thawatchai leads the evening chant at the Wat Dhammagunaram Buddhist Temple and Meditation Center, located in a remodeled church on East 1000 North. The chanting is done in Pali, the ancient language of Theravada Buddhism, the oldest Buddhist practice. The monks, all from Thailand, prostrate themselves to show respect for the teachings of Lord Buddha.

*Photo by Rick Egan, The Salt Lake Tribune*

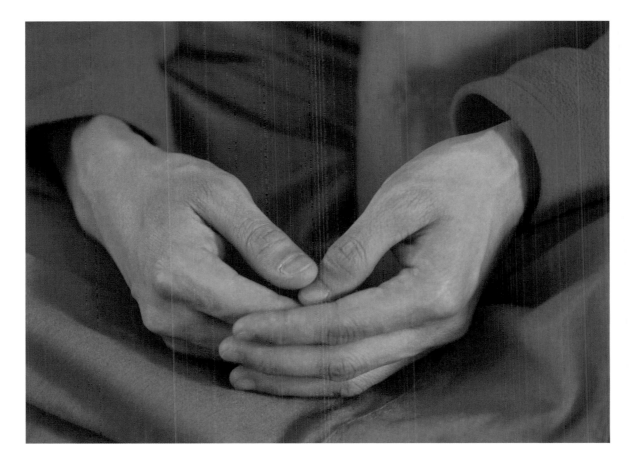

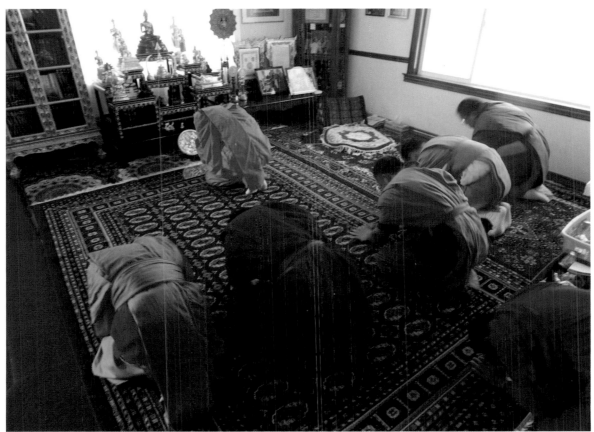

## Our Town

**SALT LAKE CITY**
Fans arriving at Franklin Covey Field's front entrance are greeted by a giant concrete baseball etched into the sidewalk. The stadium is home to the Salt Lake Stingers.
*Photo by Rick Egan, The Salt Lake Tribune*

**BOUNTIFUL**

Killer B: There's now a giant, red, white, and blue
capital "B" in the Wasatch foothills. Challenged
by radio station 102.7 FM, Bountiful High School
students refurbished the formerly all-white letter
to show their support for U.S. troops in Iraq.
*Photo by Keith Johnson, Deseret Morning News*

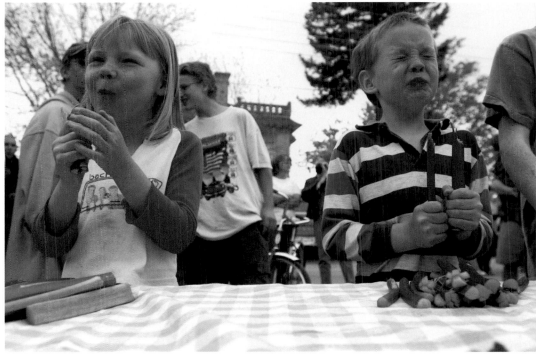

**MOUNT PLEASANT**

Kaitlin and Stone Anderson's first taste of raw rhubarb was a bit of a surprise. Other events at Mount Pleasant's annual Rhubarb Festival were more palatable, though, like the turkey trot, the lamb dress-up contest, the rhubarb pie–eating contest, and the Ugly Truck parade.

*Photo by Leah Hogsten*

**PARK CITY**

Riding horses has been shown to improve muscle tone and coordination for people with disabilities. It also makes them happy. Megan Felt, 24, has Down's syndrome and takes weekly riding lessons at the National Ability Center. The Center also offers skiing, cycling, and rafting, serving 10,000 physically and developmentally disabled clients in 2002.

*Photo by Lori Adamski-Peek*

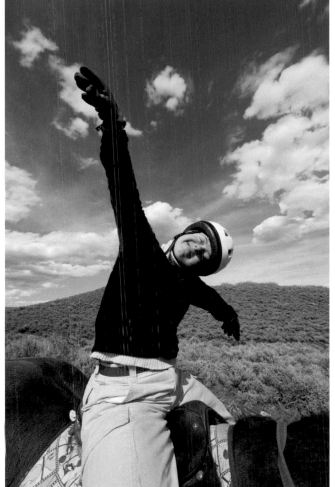

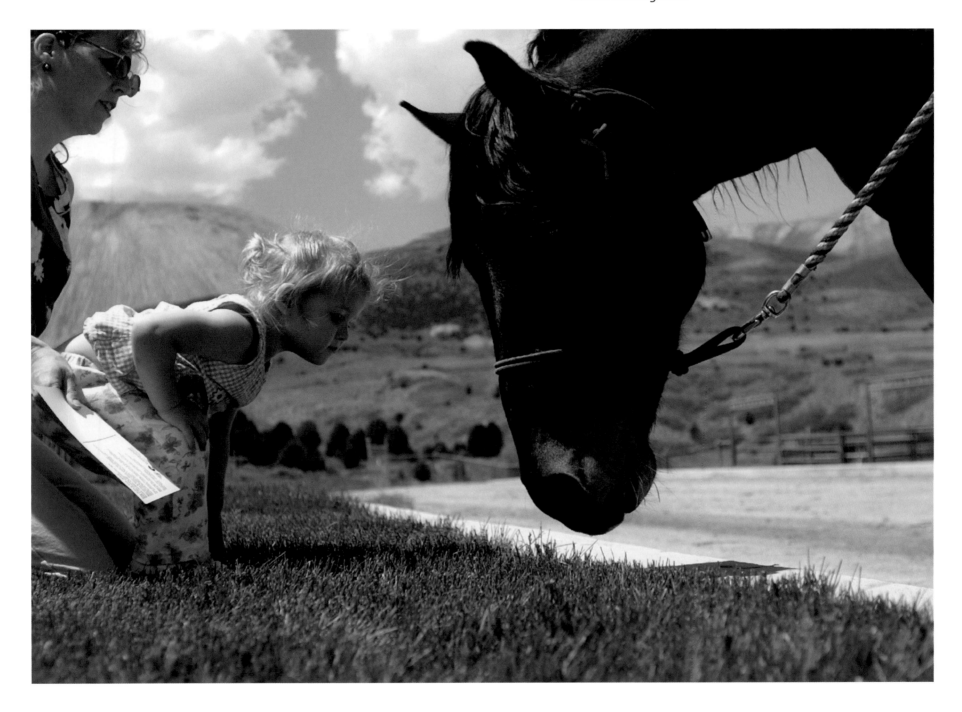

**HERRIMAN**
Katherine Ashland and daughter Paisley at one of the Bureau of Land Management's wild horse and burro adoption sites. The mustang population has grown beyond sustainability due to the decline of natural predators. The Bureau rounds up and trains some of the horses, adopting them out for $125. The Ashlands selected a mustang named Tumbleweed.
*Photo by Scott G. Winterton,*
*Deseret Morning News*

**OGDEN**

Hey good lookin'! Tess, a Yorkshire terrier, plants a kiss on Blue, a German shepherd, at their weekly obedience class. Blue appears smitten, too.

*Photo by Lech Hogsten*

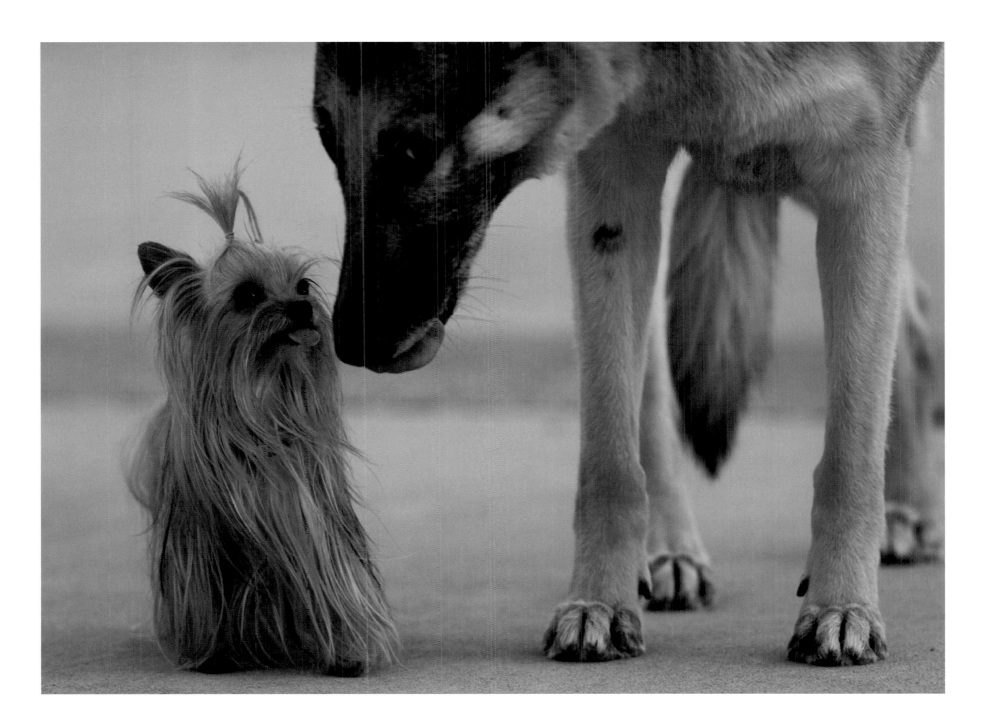

**SPANISH FORK**
Kayden Vacher, 4, attends the Spanish Fork
Livestock Auction every Wednesday with his
father, Zale, the state's livestock reporter, who
keeps track of the going price for farm animals.
*Photos by Jason Olson, Deseret Morning News*

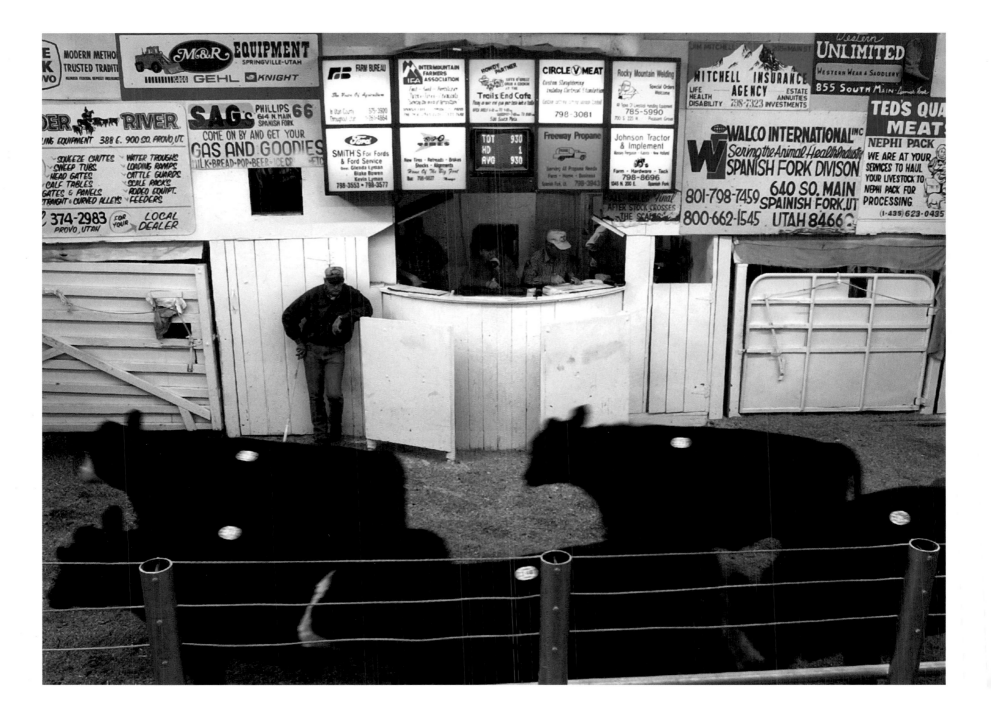

Auctioneer Ty Tingey scans the lot of Angus and Angus Cross heifers parading through the arena of the Spanish Fork Livestock Auction, held weekly since 1932. The day's going price? Forty cents per pound.

**SALT LAKE CITY**

A Somali girl rides home from Highland High School, where she attends ESL classes. At Highland, a magnet school for Salt Lake City's large refugee population, 40 percent of the students speak little or no English. Thirty-seven languages echo through the halls.

*Photos by Kent Miles*

**SALT LAKE CITY**

One of about 10,000 Bosnian refugees living in and around Salt Lake City, this teenager is a member of Utah's largest immigrant community.

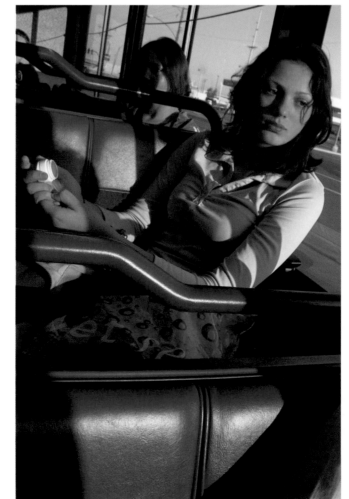

**SALT LAKE CITY**

Newlyweds Stophiann and Mike Johnson hold onto each other in a bittersweet reunion at Fort Williams Army Base. After three months apart, with Stophiann biding her time in her native Jamaica and Mike in Iraq with the Marine Reserves, the couple will separate again after just two weeks of normalcy. Mike ships off for six months in Okinawa.

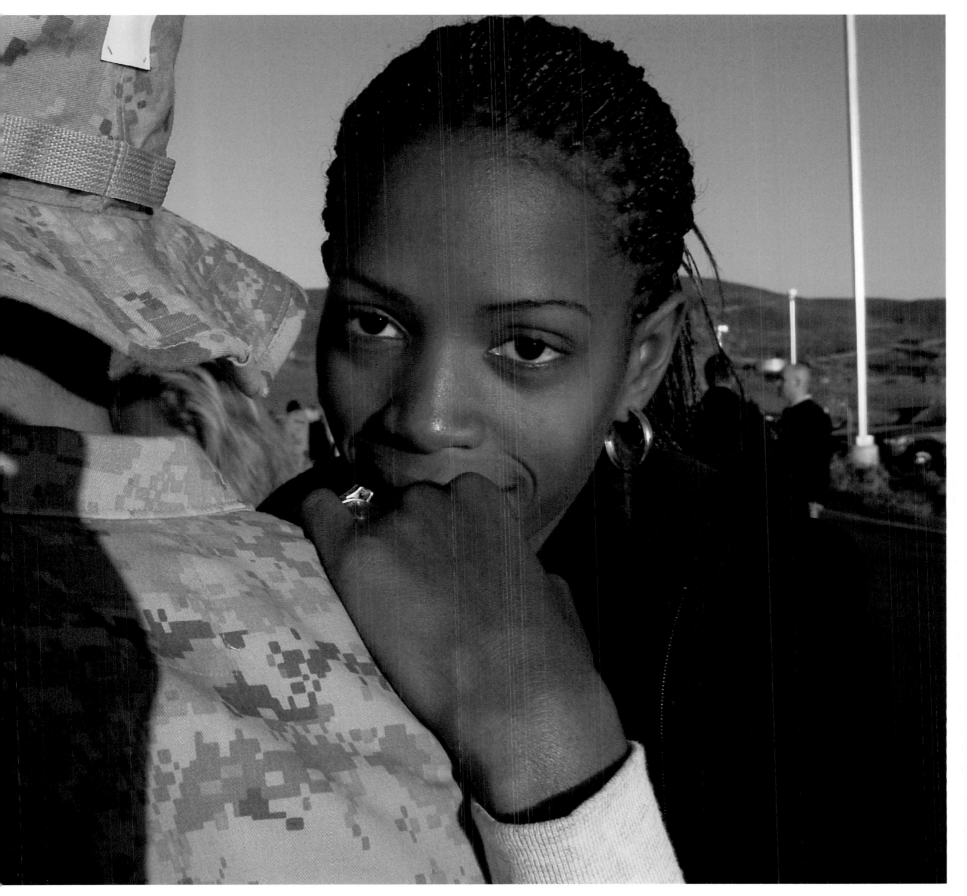

**BOUNTIFUL**

"They practiced all year long," says Lois Lovell proudly of the 60 students in her second-grade class. The program includes 10 chestnuts by rockers like Elvis Presley, the Beach Boys, and Chubby Checker. The school applied for and won a state grant to buy the ukuleles—one for every second-grader.
*Photos by Rick Egan,*
*The Salt Lake Tribune*

**BOUNTIFUL**

Leo J. Muir Elementary School second-graders Thomas Waite, Chandler Whitlock, and Olivia Homer strum out "Blue Suede Shoes" in rehearsal for their school concert, "Ukulele Rock-n-Roll."

**BOUNTIFUL**

You Ain't Nothing but a Hound Dog: Jacob McIntosh channels Elvis Presley.

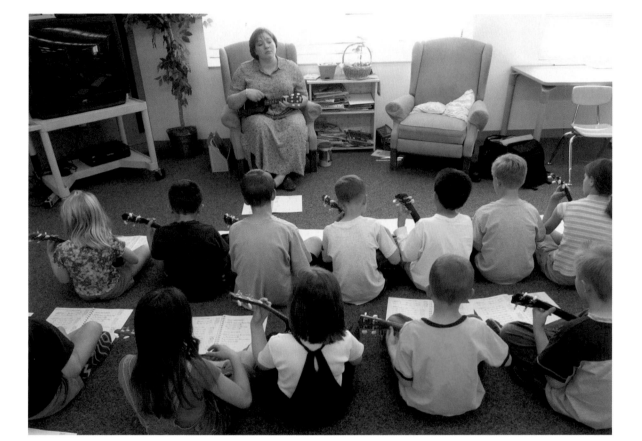

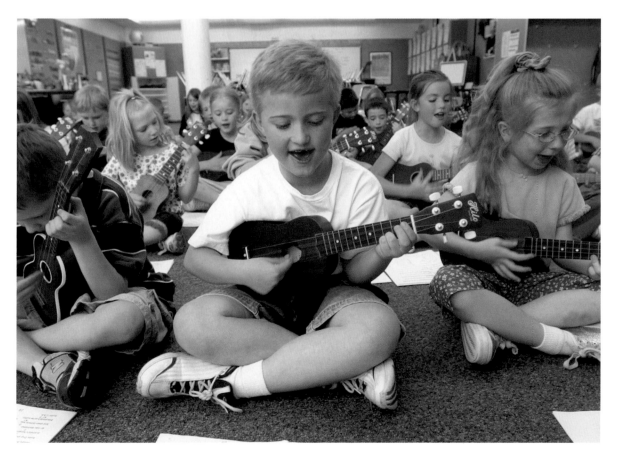

**SALT LAKE CITY**

Richard Reardon sits in his regular spot across from the Olive Garden restaurant in downtown Salt Lake City. Reardon is not homeless but has fallen on hard times. The sign helps him bring in cash to supplement a fixed income.

*Photo by Keith Johnson, Deseret Morning News*

**PARK CITY**

Fourth-graders Blake Lukanowski, Kylie Peek, and Sarah Waugaman catch up between classes at McPolin Elementary School. Kylie went to Carden Christian Academy for a few years because her parents preferred the smaller class size, but she asked to go back to McPolin to be with her friends.

*Photo by Lori Adamski-Peek*

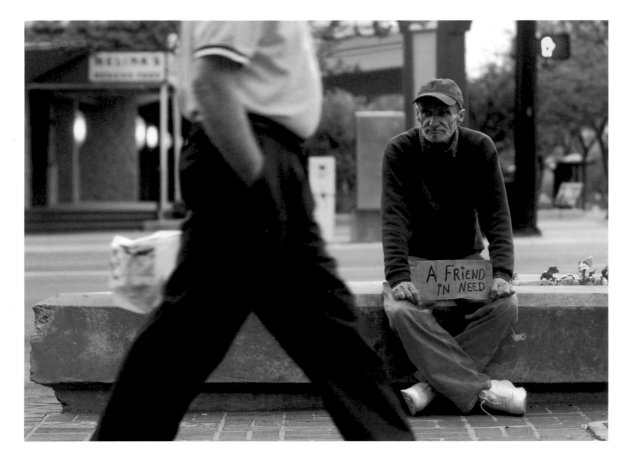

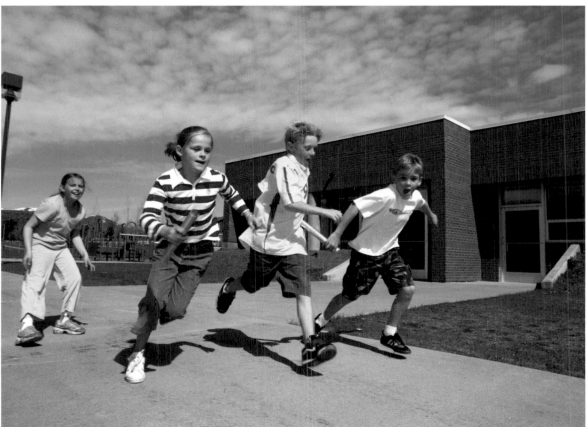

**WASHINGTON**

Any minute now, a freshly minted married couple
will emerge from church, and James Reeder, right,
will ferry the lovebirds to the wedding luncheon
in his horse-drawn carriage. Reeder, shown here
with buddy John Stucki, bought the carriage to
offer visitors (and anyone else who will hire him)
tours of his family's working farm, one of the last
in southern Utah.
*Photo by Nick Adams*

**PARK CITY**

McPolin Elementary School fourth-graders
Madison Webb, Blake Lukanowski, Dominic
Demschar, and Mitch Von Puttkammer go
head-to-head in a boys vs. girls relay race.
This race—a practice for an upcoming track
meet—was won by the girls.
*Photo by Lori Adamski-Peek*

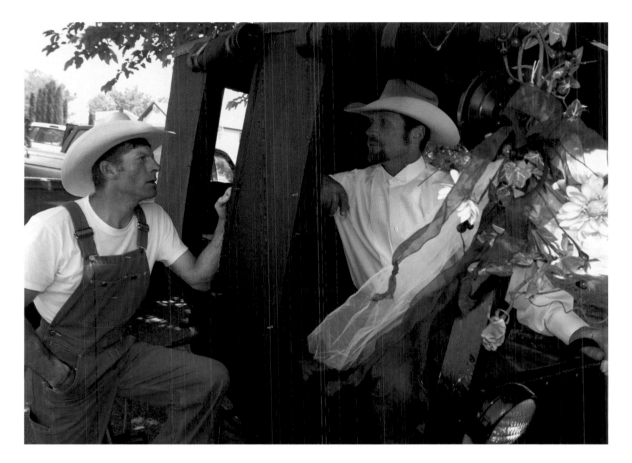

A giant cup of kindness: A soft drink–clad young woman hands out coupons for free chips and soda with any sandwich purchase at the Quiznos sub shop on Main Street.
*Photo by Rick Egan, The Salt Lake Tribune*

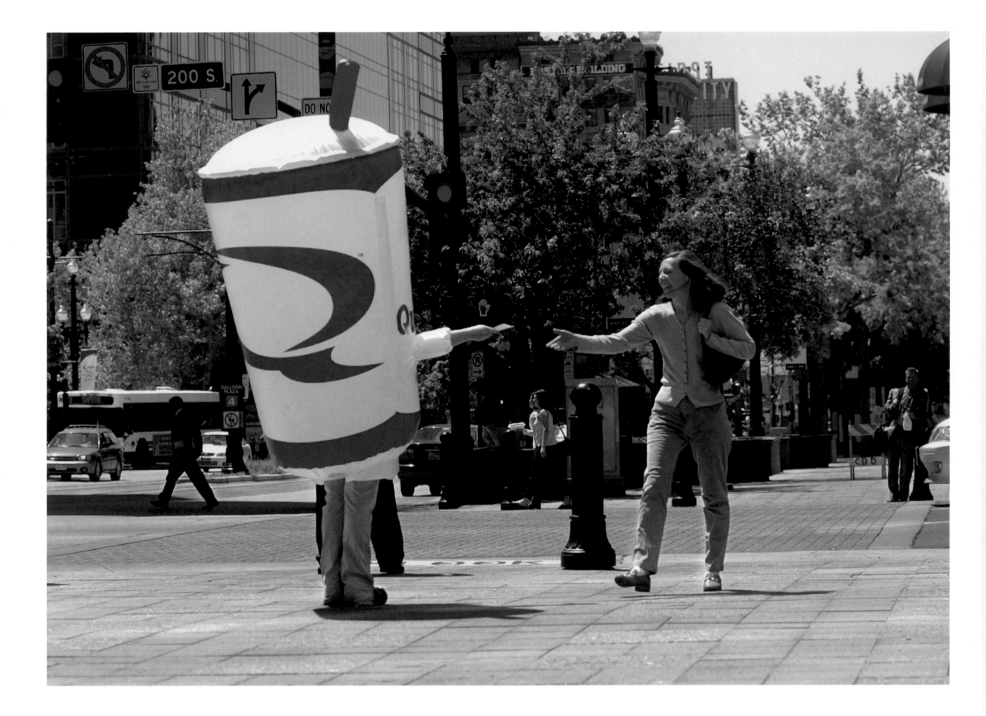

**ELSINORE**

The joy of playing music draws Devere Lott, 78, Jack Terry, 84, and fellow string players to the Elsinore Recreation Hall every Tuesday night. "Jack usually picks out the notes on his banjo," Lott explains. "And I give him a rhythm backing with my chords."

*Photo by Jeremy Harmon*

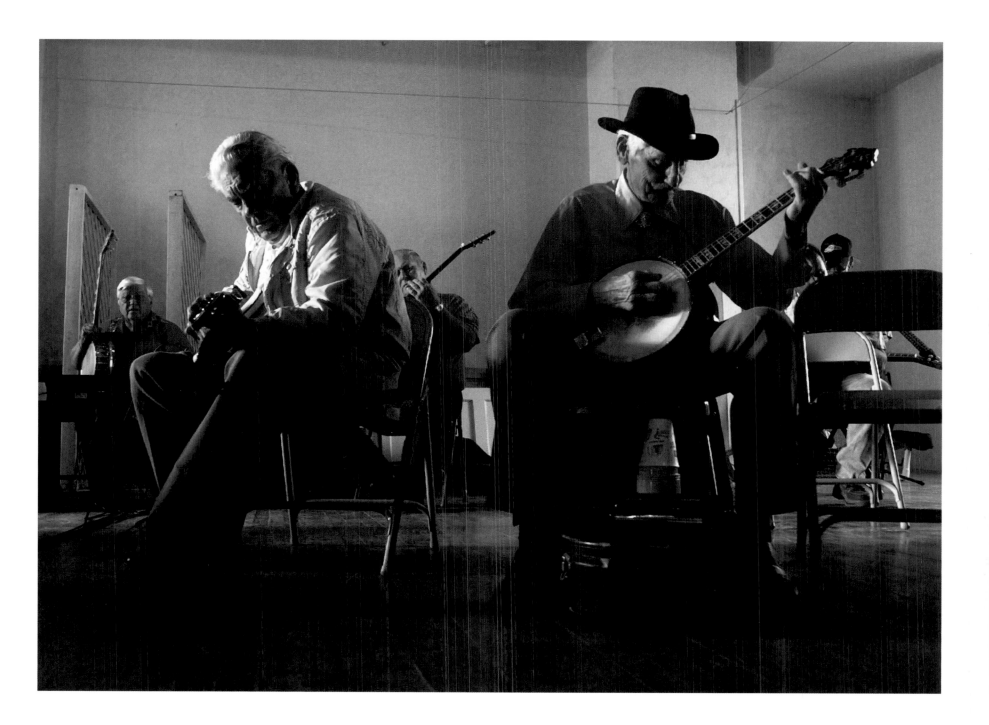

**SALT LAKE CITY**
With trendy stores, restaurants, and a 12-screen theater complex, Salt Lake City's Gateway Plaza is a mecca for teenagers. Lindsay Reed, 18, and her friends passed up the usual attractions to skip through the center's Olympic fountain. "It's usually just the little kids that do this," Lindsay says. "But it was a warm night, and it looked like fun."
*Photo by Leah Hogsten*

**ROCKVILLE**
Flying Zion Ranch, near midnight. Jason Savelsberg is one of several performance artists at a three-day, full-moon goddess party—a celebration of personal expression, the lunar cycle, and the power of women. Guests built fairy wings and learned to belly dance during the day, twirled fire batons and danced around the campfire at night.
*Photo by Sallie Dean Shatz*

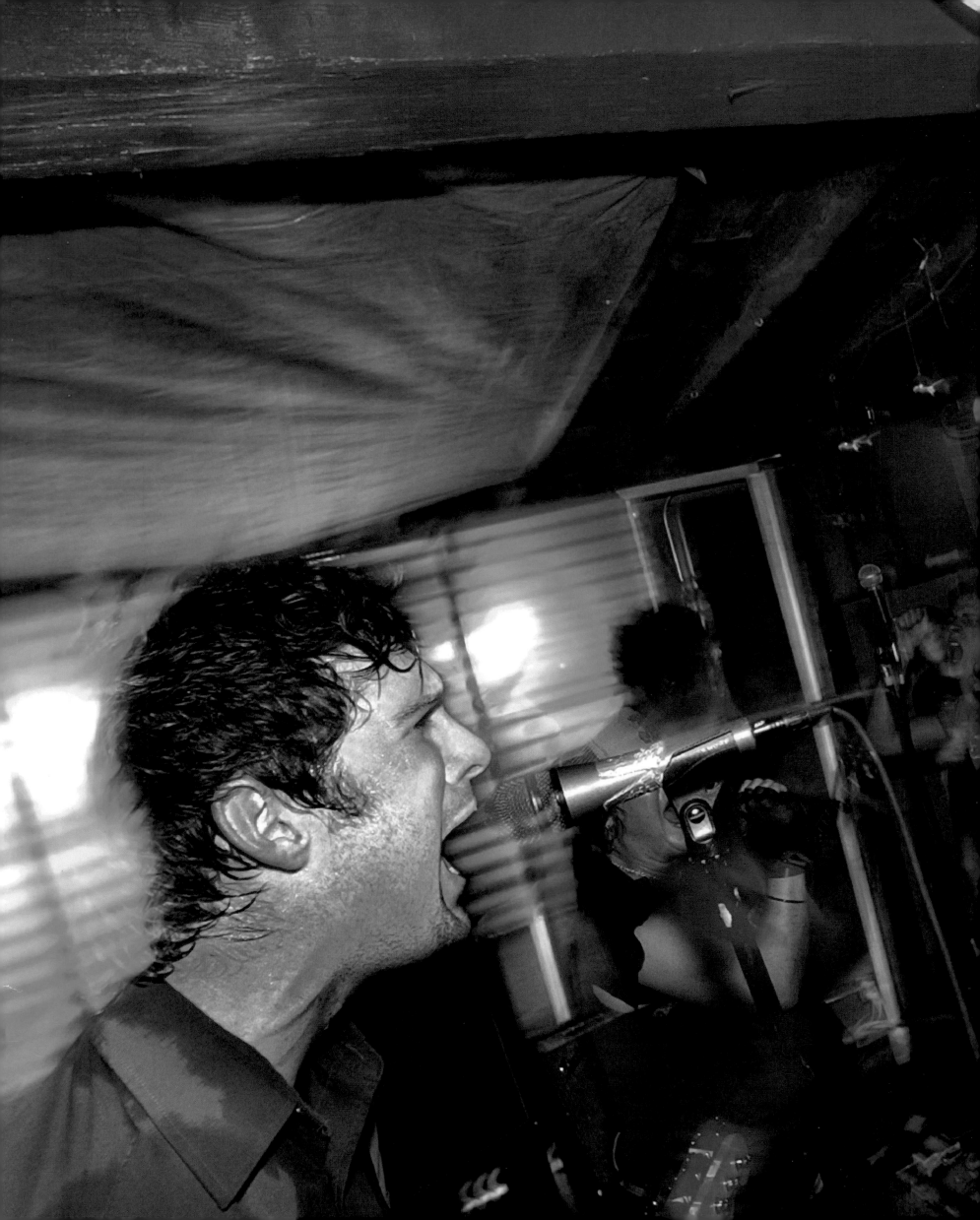

**SALT LAKE CITY**
Derek Fudesco, lead singer of the punk band Pretty Girls Make Graves, whips the crowd into a frenzy at Kilby Court. The club, tucked into a small warehouse, serves no liquor, so kids under 21 can attend. It's the only all-ages club in Salt Lake City.
*Photo by Rick Egan, The Salt Lake Tribune*

**CACHE COUNTY**

The Bear River provides a reflecting pool for Wellsville Ridge at sunrise. In the 1940s, residents concerned about overgrazing on the ridge purchased thousands of acres and deeded them to the U.S. Forest Service, thereby establishing the early boundaries of the Wellsville Wilderness Area. The peaks furnish a crucial watershed for many communities throughout northern Utah.
*Photo by Steve Harrington*

**BRYCE CANYON NATIONAL PARK**

Ranging in height from 5 to 120 feet, thousands of hoodoos decorate Bryce Canyon National Park. The primarily limestone peaks were born about 40 million years ago in the lake that covered much of western Utah. Etched by eons of erosion, the spires continue to be shaped by the elements, losing 2 to 4 feet every 100 years.
*Photo by Susan Bryan*

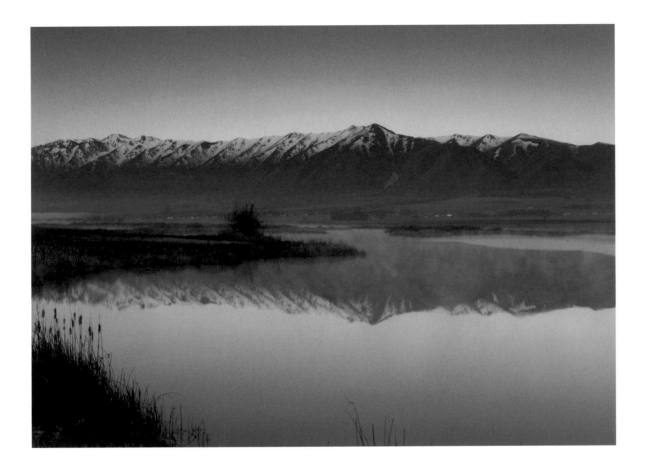

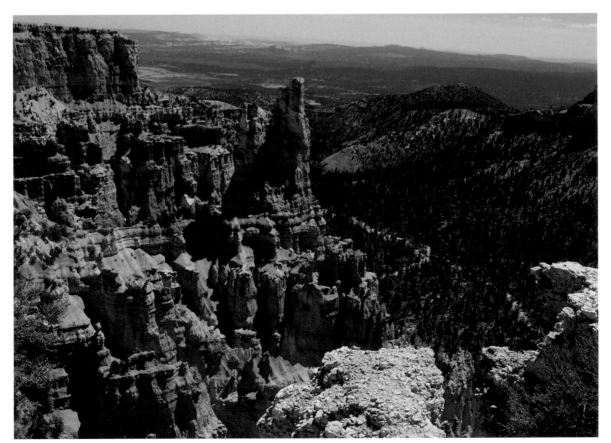

**CAPITOL REEF NATIONAL PARK**

Castle Rock is one of several spectacular cliffs in Capitol Reef National Park. The park is adjacent to Desolation and Flume canyons, two other ranges of ridges and gorges included in the 16,000 acres of previously protected land that the U.S. Bureau of Land Management intends to make available for oil and gas leases.

*Photo by Jeremy Harmon*

**BIG COTTONWOOD CANYON**

Moss Creek tumbles down Big Cottonwood Canyon, 25 miles east of Salt Lake City. On the heels of the 1849 California Gold Rush, gold and silver fever lured hordes of miners into the Wasatch mountains. Remnants of old mines pockmark the 15-mile canyon.

*Photo by Jeremy West*

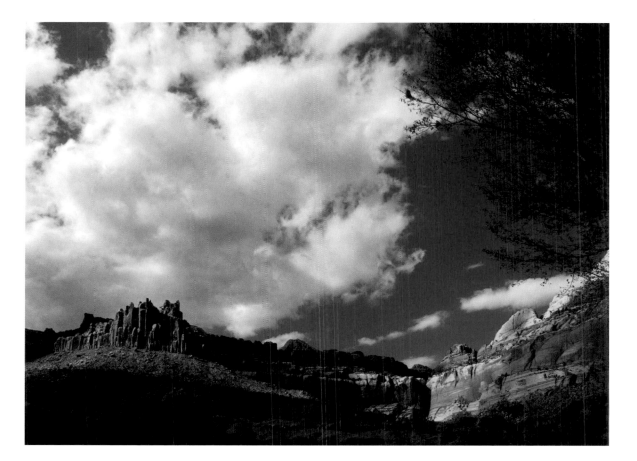

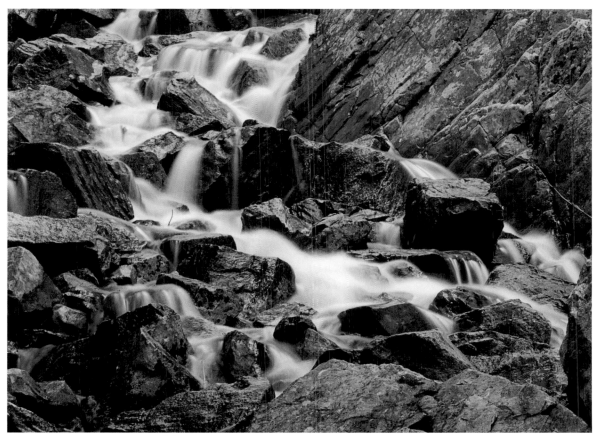

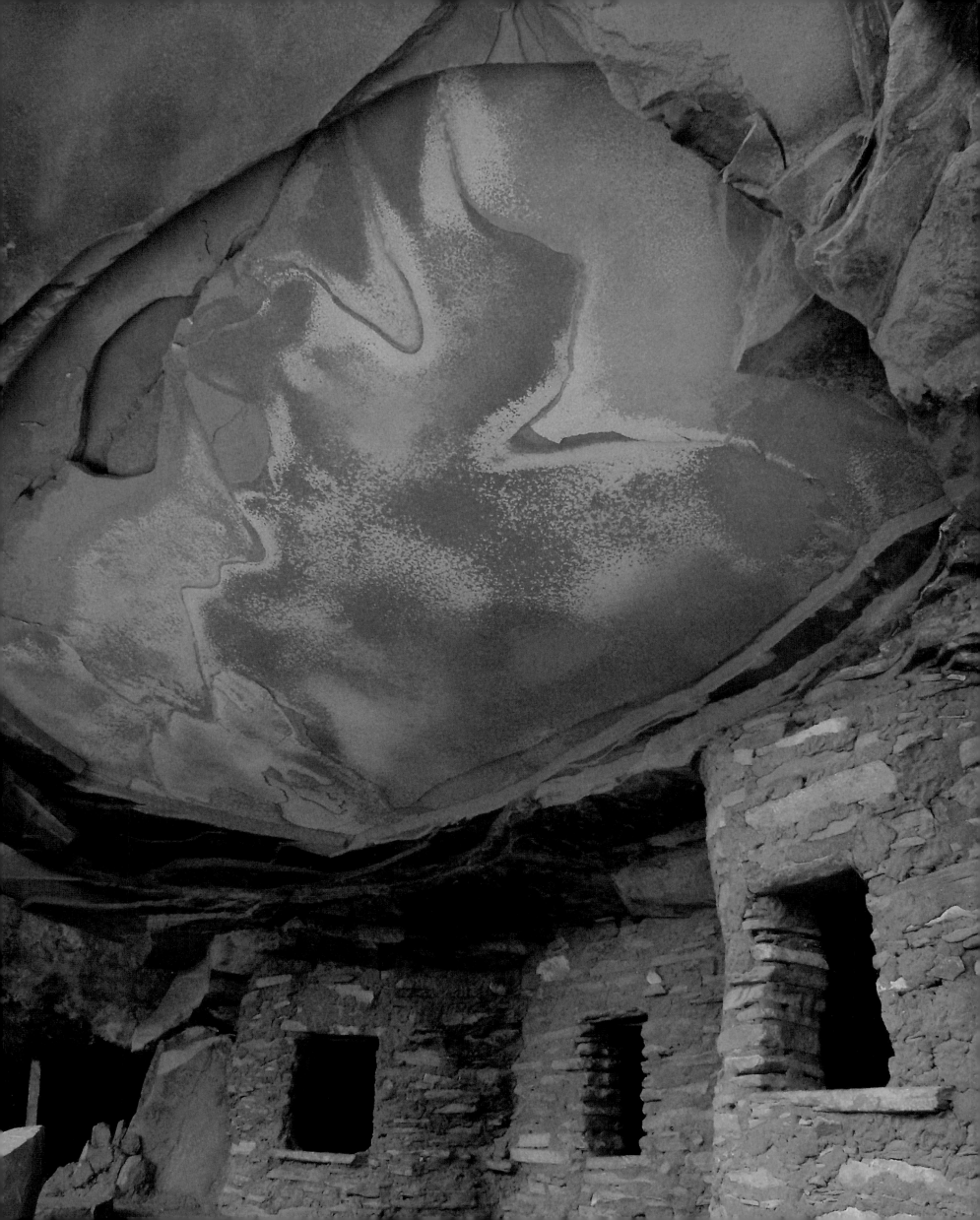

**ROAD CANYON**

Perched hundreds of feet above a remote canyon floor in Four Corners, this pueblo ruin was home to the Anazasi ("ancient ones" in Navajo). The cliff dwellers lived by dry farming corn, beans, and squash. Around A.D. 1300, they migrated to New Mexico and Arizona. It's believed the Anazasi are the forebears of the Hopi, Zuni, Pueblo, and Navajo tribes.

*Photo by Larry C. Price*

**ARCHES NATIONAL PARK**

The nightly parade of stars—and the glow of a waxing moon—silhouette the Delicate Arch, one of 2,000 such sandstone formations protected in 76,500-acre Arches National Park. Hunter-gatherers passed through the area 10,000 years ago at the end of the Ice Age. Their presence is recorded in discarded stone tools.

*Photo by Ravell Call, Deseret Morning News*

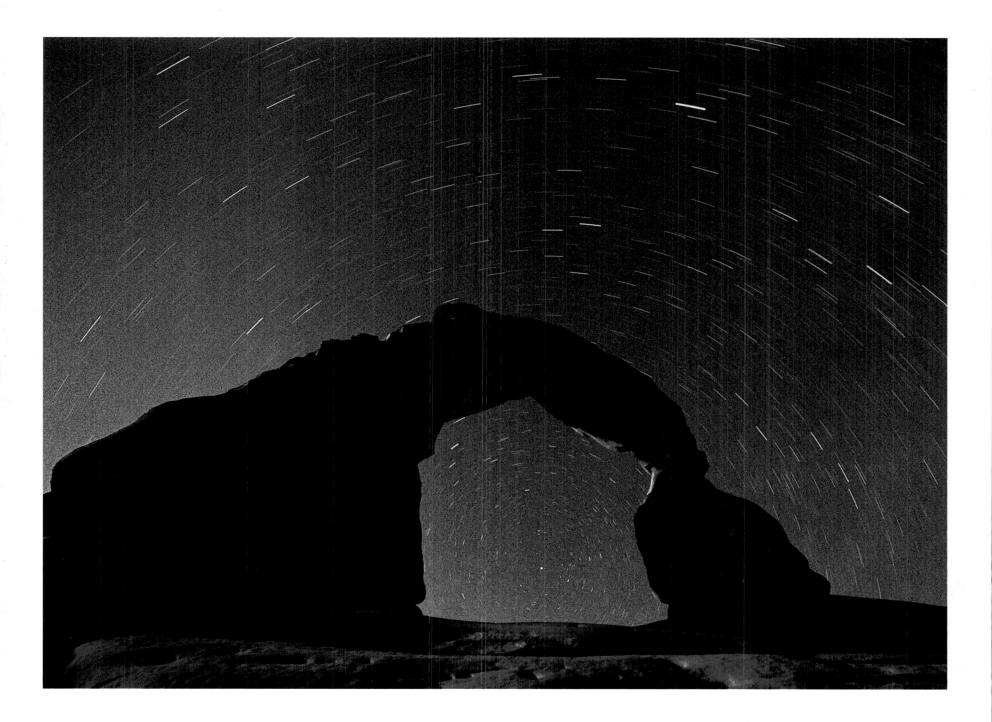

# How It Worked

The week of May 12-18, 2003, more than 25,000 professional and amateur photographers spread out across the nation to shoot over a million digital photographs with the goal of capturing the essence of daily life in America.

The professional photographers were equipped with Adobe Photoshop and Adobe Album software, Olympus C-5050 digital cameras, and Lexar Media's high-speed compact flash cards.

The 1,000 professional contract photographers plus another 5,000 stringers and students sent their images via FTP (file transfer protocol) directly to the *America 24/7* website. Meanwhile, thousands of amateur photographers uploaded their images to Snapfish's servers.

At *America 24/7*'s Mission Control headquarters, located at CNET in San Francisco, dozens of picture editors from the nation's most prestigious publications culled the images down to 25,000 of the very best, using Photo Mechanic by Camera Bits. These photos were transferred into Webware's ActiveMedia Digital Asset Management (DAM) system, which served as a central image library and enabled the designers to track, search, distribute, and reformat the images for the creation of the 51 books, foreign language editions, web and magazine syndication, posters, and exhibitions.

Once in the DAM, images were optimized (and in some cases resampled to increase image resolution) using Adobe Photoshop. Adobe InDesign and Adobe InCopy were used to design and produce the 51 books, which were edited and reviewed in multiple locations around the world in the form of Adobe Acrobat PDFs. Epson Stylus printers were used for photo proofing and to produce large-format images for exhibitions. The companies providing support for the *America 24/7* project offer many of the essential components for anyone building a digital darkroom. We encourage you to read more on the following pages about their respective roles in making *America 24/7* possible.

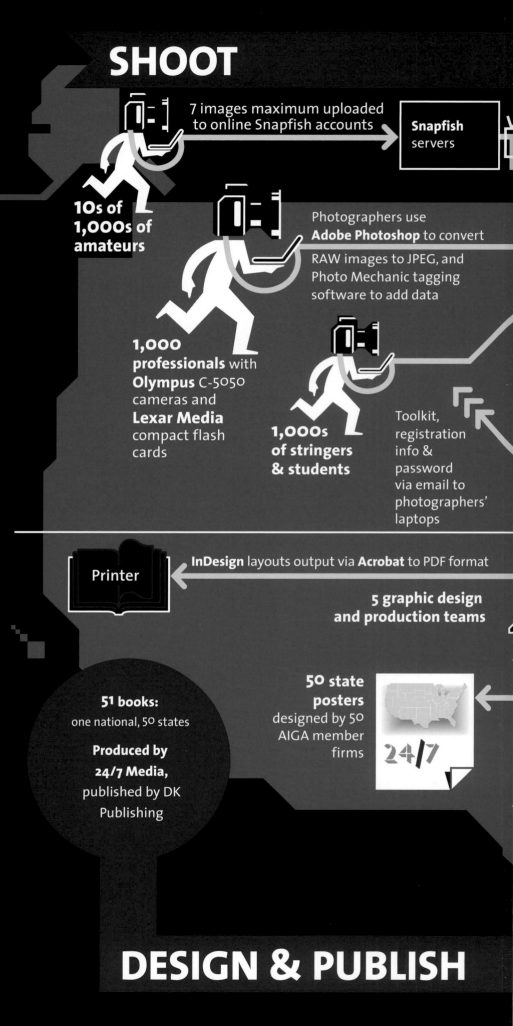

### SHOOT

7 images maximum uploaded to online Snapfish accounts → **Snapfish** servers

**10s of 1,000s of amateurs**

Photographers use **Adobe Photoshop** to convert RAW images to JPEG, and Photo Mechanic tagging software to add data

**1,000 professionals** with **Olympus** C-5050 cameras and **Lexar Media** compact flash cards

**1,000s of stringers & students**

Toolkit, registration info & password via email to photographers' laptops

**InDesign** layouts output via **Acrobat** to PDF format

Printer

**5 graphic design and production teams**

**51 books:** one national, 50 states

**Produced by 24/7 Media,** published by DK Publishing

**50 state posters** designed by 50 AIGA member firms

24/7

### DESIGN & PUBLISH

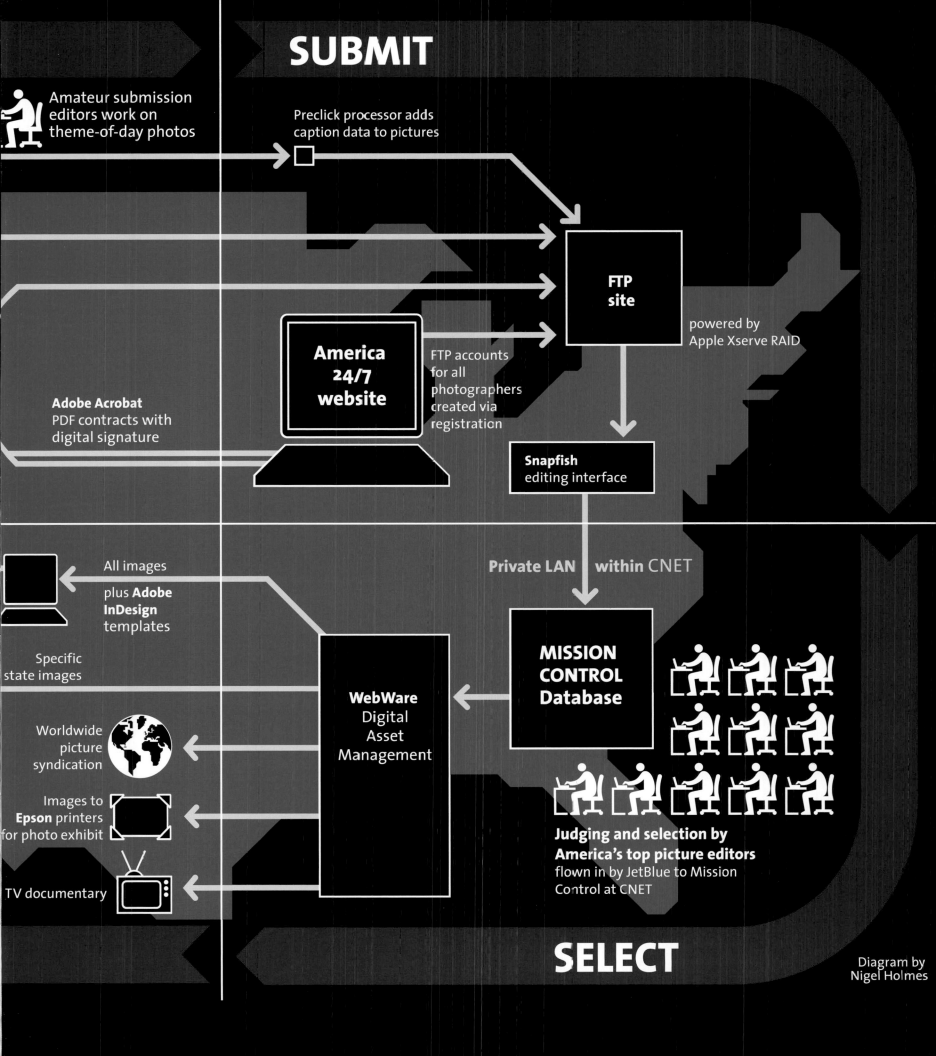

# SUBMIT

Amateur submission editors work on theme-of-day photos

Preclick processor adds caption data to pictures

**Adobe Acrobat** PDF contracts with digital signature

**America 24/7 website**

FTP accounts for all photographers created via registration

**FTP site**

powered by Apple Xserve RAID

**Snapfish** editing interface

All images plus **Adobe InDesign** templates

Specific state images

**Private LAN** **within** CNET

Worldwide picture syndication

Images to **Epson** printers for photo exhibit

TV documentary

**WebWare** Digital Asset Management

**MISSION CONTROL Database**

**Judging and selection by America's top picture editors** flown in by JetBlue to Mission Control at CNET

# SELECT

Diagram by Nigel Holmes

Utah 24/7

# About Our Sponsors

*America 24/7* gave digital photographers of all levels the opportunity to share their visions of what it means to live in the United States. This project was made possible by a digital photography revolution that is dramatically changing and improving picture-taking for professionals and amateurs alike. And an Adobe product, Photoshop®, has been at the center of this sea change.

Adobe's products reflect our customers' passion for the creative process, be it the photographer, graphic designer, layout artist, or printer. Adobe is the Publishing and Imaging Software Partner for *America 24/7* and products such as Adobe InDesign®, Photoshop, Acrobat®, and Illustrator® were used to produce this stunning book in a matter of weeks. We hope that our software has helped do justice to the mythic images, contributed by well-known photographers and the inspired hobbyist.

Adobe is proud to be a lead sponsor of *America 24/7*, a project that celebrates the vibrancy of the American spirit: the same spirit that helped found Adobe and inspires our employees and customers to deliver the very best.

Bruce Chizen
President and CEO
Adobe Systems Incorporated

Olympus, a global technology leader in designing precision healthcare solutions and innovative consumer electronics, is proud to be the official digital camera sponsor of *America 24/7*. The opportunity to introduce Americans from coast to coast to the thrill, excitement, and possibility of digital photography makes the vision behind this book a perfect fit for Olympus, a leader in digital cameras since 1996.

For most people, the essence of digital photography is best grasped through firsthand experience with the technology, which is precisely what *America 24/7* is about. We understand that direct experience is the pathway to inspiration, and welcome opportunities like this sponsorship to bring the power of the digital experience into the lives of people everywhere. To Olympus, *America 24/7* offers a platform to help realize a core mission: to deliver and make accessible the power of the digital experience to millions of American photographers, amateurs, and professionals alike.

The 1,000 professional photographers contracted to shoot on the America 24/7 project were all equipped with Olympus C-5050 digital cameras. Like all Olympus products, the C-5050 is offered by a company well known for designing, manufacturing, and servicing products used by professionals to perform their work, every day. Olympus is a customer-centric company committed to working one-to-one with a diverse group of professionals. From biomedical researchers who use our clinical microscopes, to doctors who perform life-saving procedures with our endoscopes, to professional photographers who use cameras in their daily work, Olympus is a trusted brand.

The digital imaging technology involved with *America 24/7* has enabled the soul of America to be visually conveyed, not just by professional observers, but by the American public who participated in this project—the very people who collectively breath life into this country's existence each day.

We are proud to be enabling so many photographers to capture the pictures on these pages that tell the story of who we are as a nation. From sea to shining sea, digital imagery allows us to connect to one another in ways we never dreamed possible.

At Olympus, our ideas have proliferated as rapidly as technology has evolved. We have channeled these visions into breakthrough products and solutions to meet the demands of our changing world—products like microscopes, endoscopes, and digital voice recorders, supported by the highly regarded training, educational, and consulting services we offer our customers.

Today, 83 years after we introduced our first microscope, we remain as young, as curious, and as committed as ever.

Lexar Media has grown from the digital photography revolution, which is why we are proud to have supplied the digital memory cards used in the America 24/7 project. Lexar Media's high-performance memory cards utilize our unique and patented controller coupled with high-speed flash memory from Samsung, the world's largest flash memory supplier. This powerful combination brings out the ultimate performance of any digital camera.

Photographers who demand the most from their equipment choose our products for their advanced features like write speeds up to 40X, Write Acceleration technology for enabled cameras, and Image Rescue, which recovers previously deleted or lost images. Leading camera manufacturers bundle Lexar Media digital memory cards with their cameras because they value its performance and reliability.

Lexar Media is at the forefront of digital photography as it transforms picture-taking worldwide, and we will continue to be a leader with new and innovative solutions for professionals and amateurs alike.

Snapfish, which developed the technology behind the *America 24/7* amateur photo event, is a leading online photo service, with more than 5 million members and 100 million photos posted online. Snapfish enables both film and digital camera owners to share, print, and store their most important photo memories, at prices that cannot be equaled. Digital camera users upload photos into a password-protected online album for free. Users can also order film-quality prints on professional photographic paper for as low as 25¢. Film camera users get a full set of prints, plus online sharing and storage, for just $2.99 per roll.

Founded in 1995, eBay created a powerful platform for the sale of goods and services by a passionate community of individuals and businesses. On any given day, there are millions of items across thousands of categories for sale on eBay. eBay enables trade on a local, national and international basis with customized sites in markets around the world.

Through an array of services, such as its payment solution provider PayPal, eBay is enabling global e-commerce for an ever-growing online community.

JetBlue Airways is proud to be *America 24/7's* preferred carrier, flying photographers, photo editors, and organizers across the United States.

Winner of Condé Nast Traveler's Readers' Choice Awards for Best Domestic Airline 2002, JetBlue provides friendly service and low fares for travelers in 22 cities in nine states across America.

On behalf of JetBlue's 5,000 crew members, we're excited to be involved in this remarkable project, and for the opportunity to serve American travelers each and every day, coast to coast, 24/7.

## DIGITAL POND

Digital Pond has been a leading creator of large graphic displays for museums, corporations, trade shows, retail environments and fine art since 1992.

We were proud to bring together our creative, print and display capabilities to produce signage and displays for mission control, critical retouching for numerous key images for the book, and art galleries for the New York Public Library and Bryant Park.

The Pond's team and SplashPic® Online service enabled us to nimbly design, produce and install over 200 large graphic panels in two NYC locations within the truly "24/7" production schedule of less than ten days.

WebWare Corporation is pleased to be a major sponsor of the America 24/7 project. We take pride in being part of a groundbreaking adventure that is stretching the boundaries—and the imagination—in digital photography, digital asset management, publishing, news, and global events.

Our ActiveMedia Enterprise™ digital asset management software is the "nerve center" of *America 24/7*, the central repository for managing, sharing, and collaborating on the project's photographs. From photo editors and book publishers to 24/7's media relations and marketing personnel, ActiveMedia provides the application support that links all facets of the project team to the content worldwide.

WebWare helps Global 2000 firms securely manage, reuse, and distribute media assets locally or globally. Its suite of ActiveMedia software products provide powerful media services platforms for integrating rich media into content management systems marketing and communication portals; web publishing systems; and e-commerce portals.

## Google™

Google's mission is to organize the world's information and make it universally accessible and useful.

With our focus on plucking just the right answer from an ocean of data, we were naturally drawn to the America 24/7 project. The book you hold is a compendium of images of American life distilled from thousands of photographs and infinite possibilities. Are you looking for emotion? Narrative? Shadows? Light? It's all here, thanks to a multitude of photographers and writers creating links between you, the reader, and a sea of wonderful stories. We celebrate the connections that constitute the human experience and are pleased to help engender them. And we're pleased to have been a small part of this project, which captures the results of that interaction so vividly, so dynamically, and so dramatically.

**Special thanks to additional contributors:** FileMaker, Apple, Camera Bits, LaCie, Now Software, Preclick, Outpost Digital, Xerox, Microsoft, WoodWing Software, net-linx Publishing Solutions, and Radical Media. The Savoy Hotel, San Francisco; The Pan Pacific, San Francisco; Four Seasons Hotel, San Francisco; and The Queen Anne Hotel. Photography editing facilities were generously hosted by CNET Networks, Inc.

# Participating Photographers

**Coordinator:** Chuck Wing, Assistant Photo Editor, *Deseret Morning News*

Nick Adams
Lori Adamski-Peek
Lin Alder, alderphoto.com
Jeffrey D. Allred, *Deseret Morning News*
Susan Bryan
Ravell Call, *Deseret Morning News*
Mark Christensen
Peter A. Chudleigh
Ryan Clayton
Patrick Cunningham
James Donat
Rick Egan, *The Salt Lake Tribune*
Robert Fullerton
Jim Hardy
Jeremy Harmon
Steve Harrington
Leah Hogsten
Robert Johnson, *The Standard Examiner*
Keith Johnson, *Deseret Morning News*

Johanna Kirk, *Deseret Morning News*
Eli Lucero
Mitch Mascaro, *Herald Journal*
Kent Miles
Trent Nelson
Jason Olson, *Deseret Morning News*
Larry C. Price*
William Sams, Jr.
Laura Seitz, *Deseret Morning News*
Sallie Dean Shatz
Bruce Shields
Marianne Sidwell
David Therrien
Jeremy West
Chuck Wing, *Deseret Morning News*
Scott G. Winterton, *Deseret Morning News*

*Pulitzer Prize winner

# Thumbnail Picture Credits

Credits for thumbnail photographs are listed by the page number and are in order from left to right.

**20** Lori Adamski-Peek
Chuck Wing, *Deseret Morning News*
Lori Adamski-Peek
Kent Miles
Kent Miles
Kent Miles
Lori Adamski-Peek

**21** Lori Adamski-Peek
Ravell Call, *Deseret Morning News*
Lori Adamski-Peek
Lori Adamski-Peek
Steve Harrington
Lori Adamski-Peek
Trent Nelson

**24** Leah Hogsten
Ravell Call, *Deseret Morning News*
Jeffrey D. Allred, *Deseret Morning News*
Jeremy West
Ravell Call, *Deseret Morning News*
Nick Adams
Ravell Call, *Deseret Morning News*

**25** Thomas B. Szalay
Scott G. Winterton,
*Deseret Morning News*
Ravell Call, *Deseret Morning News*
Thomas B. Szalay
Robyn L. Poarch
Thomas B. Szalay
Ravell Call, *Deseret Morning News*

**26** Chuck Wing, *Deseret Morning News*
Rick Egan, *The Salt Lake Tribune*
Leah Hogsten
Chuck Wing, *Deseret Morning News*
Jeremy Harmon
Chuck Wing, *Deseret Morning News*
Robyn L. Poarch

**27** Kent Miles
Lori Adamski-Peek
Ravell Call, *Deseret Morning News*
Thomas B. Szalay

Chuck Wing, *Deseret Morning News*
Sallie Dean Shatz
Kent Miles

**28** Lori Adamski-Peek
Lori Adamski-Peek
Laura Seitz, *Deseret Morning News*
Laura Seitz, *Deseret Morning News*
Laura Seitz, *Deseret Morning News*
Leah Hogsten
Laura Seitz, *Deseret Morning News*

**30** Bruce Shields
Bruce Shields
Bruce Shields
Bruce Shields
Bruce Shields
Scott G. Winterton,
*Deseret Morning News*
Bruce Shields

**31** Nick Adams
Bruce Shields
Leah Hogsten
Scott G. Winterton,
*Deseret Morning News*
Bruce Shields
Jeremy Harmon
Nick Adams

**32** Kent Miles
Kent Miles
Kent Miles
Kent Miles
Kent Miles
Kent Miles
Kent Miles

**40** Jeremy Harmon
Nick Adams
Jason Olson, *Deseret Morning News*
Steve Harrington
Nick Adams
Jeremy Harmon
Nick Adams

**41** Jeremy Harmon
Nick Adams
Nick Adams
Nick Adams
Nick Adams
Nick Adams
Jeremy Harmon

**45** Nick Adams
Johanna Kirk, *Deseret Morning News*
Johanna Kirk, *Deseret Morning News*
Johanna Kirk, *Deseret Morning News*
Nick Adams
Johanna Kirk, *Deseret Morning News*
Johanna Kirk, *Deseret Morning News*

**46** Jason Olson, *Deseret Morning News*
Jeremy West
Rick Egan, *The Salt Lake Tribune*
Nick Adams
Steve Harrington
Nick Adams
Kent Miles

**47** Mitch Mascaro, *Herald Journal*
Nick Adams
Steve Harrington
Rick Egan, *The Salt Lake Tribune*
Nick Adams
Mitch Mascaro, *Herald Journal*
Steve Harrington

**50** Lori Adamski-Peek
Scott G. Winterton,
*Deseret Morning News*
Lori Adamski-Peek
Lori Adamski-Peek
Sallie Dean Shatz
Lori Adamski-Peek
Jason Olson, *Deseret Morning News*

**51** Scott G. Winterton,
*Deseret Morning News*
Scott G. Winterton,
*Deseret Morning News*
Scott G. Winterton,
*Deseret Morning News*
Scott G. Winterton,
*Deseret Morning News*
Lori Adamski-Peek
Scott G. Winterton,
*Deseret Morning News*
Scott G. Winterton,
*Deseret Morning News*

**52** Chuck Wing, *Deseret Morning News*
Lori Adamski-Peek
Jeremy Harmon
Lori Adamski-Peek
Lori Adamski-Peek
Lori Adamski-Peek

**53** Lori Adamski-Peek
Robert Johnson, *The Standard Examiner*
Nick Adams
Lori Adamski-Peek
Chuck Wing, *Deseret Morning News*
Sallie Dean Shatz
Tom Story

**60** Rick Egan, *The Salt Lake Tribune*
Nick Adams
Johanna Kirk, *Deseret Morning News*
Leah Hogsten
Rod Hanna
Nick Adams
Rick Egan, *The Salt Lake Tribune*

**61** Trent Nelson
Nick Adams
Trent Nelson
Nick Adams

Trent Nelson
Ravell Call, *Deseret Morning News*
Rod Hanna

**64** Ravell Call, *Deseret Morning News*
Laura Seitz, *Deseret Morning News*
Ravell Call, *Deseret Morning News*
Ravell Call, *Deseret Morning News*
Ravell Call, *Deseret Morning News*
Ravell Call, *Deseret Morning News*
Sallie Dean Shatz

**65** Ravell Call, *Deseret Morning News*
Ravell Call, *Deseret Morning News*
Ravell Call, *Deseret Morning News*
Sallie Dean Shatz
Ravell Call, *Deseret Morning News*
Trent Nelson
Ravell Call, *Deseret Morning News*

**68** Lori Adamski-Peek
Leah Hogsten
Lori Adamski-Peek
Leah Hogsten
Lori Adamski-Peek
Lori Adamski-Peek
Lori Adamski-Peek

**69** Leah Hogsten
Lori Adamski-Peek
Lori Adamski-Peek
Lori Adamski-Peek
Lori Adamski-Peek
Lori Adamski-Peek
Lori Adamski-Peek

**72** Sallie Dean Shatz
Sallie Dean Shatz
Sallie Dean Shatz
Sallie Dean Shatz
Sallie Dean Shatz
Sallie Dean Shatz
Sallie Dean Shatz

**76** Kent Miles
Scott G. Winterton,
*Deseret Morning News*
Scott G. Winterton,
*Deseret Morning News*
Kent Miles
Scott G. Winterton,
*Deseret Morning News*
Kent Miles
Scott G. Winterton,
*Deseret Morning News*

**77** Leah Hogsten
Scott G. Winterton,
*Deseret Morning News*
Scott G. Winterton,
*Deseret Morning News*
Trent Nelson
Scott G. Winterton,
*Deseret Morning News*
Leah Hogsten
Trent Nelson

**78** Johanna Kirk, *Deseret Morning News*
Jason Olson, *Deseret Morning News*
Lori Adamski-Peek
Lori Adamski-Peek
Lori Adamski-Peek
Steve Harrington
Rick Egan, *The Salt Lake Tribune*

**82** Rick Egan, *The Salt Lake Tribune*
Rick Egan, *The Salt Lake Tribune*
Rick Egan, *The Salt Lake Tribune*
Rick Egan, *The Salt Lake Tribune*
Rick Egan, *The Salt Lake Tribune*
Rick Egan, *The Salt Lake Tribune*
Rick Egan, *The Salt Lake Tribune*

**83** Rick Egan, *The Salt Lake Tribune*
Rick Egan, *The Salt Lake Tribune*
Rick Egan, *The Salt Lake Tribune*
Rick Egan, *The Salt Lake Tribune*
Rick Egan, *The Salt Lake Tribune*
Rick Egan, *The Salt Lake Tribune*
Rick Egan, *The Salt Lake Tribune*

**84** Chuck Wing, *Deseret Morning News*
Chuck Wing, *Deseret Morning News*
Ravell Call, *Deseret Morning News*
Leah Hogsten
Lori Adamski-Peek
Rick Egan, *The Salt Lake Tribune*
Ravell Call, *Deseret Morning News*

**85** Ravell Call, *Deseret Morning News*
Rick Egan, *The Salt Lake Tribune*
Ravell Call, *Deseret Morning News*
Leah Hogsten
Chuck Wing, *Deseret Morning News*
Leah Hogsten
Steve Harrington

**86** Jeffrey D. Allred,
*Deseret Morning News*
Ravell Call, *Deseret Morning News*
Scott G. Winterton,
*Deseret Morning News*
Jeffrey D. Allred, *Deseret Morning News*
Jeffrey D. Allred, *Deseret Morning News*
Scott G. Winterton,
*Deseret Morning News*
Jeremy Harmon

**87** Leah Hogsten
Ravell Call, *Deseret Morning News*
Rick Egan, *The Salt Lake Tribune*
Jeffrey D. Allred, *Deseret Morning News*
Leah Hogsten
Nick Adams
Scott G. Winterton,
*Deseret Morning News*

**88** Leah Hogsten
Keith Johnson, *Deseret Morning News*
Leah Hogsten
Leah Hogsten
Keith Johnson, *Deseret Morning News*
Sallie Dean Shatz
Keith Johnson, *Deseret Morning News*

**89** Leah Hogsten
Kent Miles
Leah Hogsten
Keith Johnson, *Deseret Morning News*
Lin Alder, alderphoto.com
Thomas B. Szalay
Keith Johnson, *Deseret Morning News*

**90** Robert Johnson,
*The Standard Examiner*
Nick Adams
Lori Adamski-Peek
Laura Seitz, *Deseret Morning News*
Lori Adamski-Peek
Robert Johnson, *The Standard Examiner*
Nick Adams

**91** Lori Adamski-Peek
Laura Seitz, *Deseret Morning News*
Rick Egan, *The Salt Lake Tribune*
Rick Egan, *The Salt Lake Tribune*
Rick Egan, *The Salt Lake Tribune*
Rick Egan, *The Salt Lake Tribune*
Rick Egan, *The Salt Lake Tribune*

**94** Jeremy Harmon
Jeffrey D. Allred, *Deseret Morning News*
Jeffrey D. Allred, *Deseret Morning News*
Nick Adams

Jeffrey D. Allred, *Deseret Morning News*
Lori Adamski-Peek
Jeremy Harmon

**96** Jeffrey D. Allred,
*Deseret Morning News*
Jeremy Harmon
Kent Miles
Sallie Dean Shatz
Jeffrey D. Allred, *Deseret Morning News*
Leah Hogsten
Leah Hogsten

**97** Leah Hogsten
Keith Johnson, *Deseret Morning News*
Peter A. Chudleigh
Lori Adamski-Peek
Jeffrey D. Allred, *Deseret Morning News*
Trent Nelson
Steve Harrington

**100** Jeffrey D. Allred,
*Deseret Morning News*
Jeremy Harmon
Leah Hogsten
Leah Hogsten
Lin Alder, alderphoto.com
Scott G. Winterton,
*Deseret Morning News*
Leah Hogsten

**101** Jeffrey D. Allred,
*Deseret Morning News*
Leah Hogsten
Leah Hogsten
Scott G. Winterton,
*Deseret Morning News*
Leah Hogsten
Scott G. Winterton,
*Deseret Morning News*
Steve Harrington

**102** Nick Adams
Jeffrey D. Allred, *Deseret Morning News*
Scott G. Winterton,
*Deseret Morning News*
Jeffrey D. Allred, *Deseret Morning News*
Jeffrey D. Allred, *Deseret Morning News*
Jeffrey D. Allred, *Deseret Morning News*
Jeffrey D. Allred, *Deseret Morning News*

**106** Chuck Wing, *Deseret Morning News*
Ravell Call, *Deseret Morning News*
Jeremy West
Ravell Call, *Deseret Morning News*
Nick Adams
Eli Lucero
Leah Hogsten

**107** Nick Adams
Nick Adams
Trent Nelson
Nick Adams
Ravell Call, *Deseret Morning News*
Leah Hogsten
Thomas B. Szalay

**108** Ravell Call, *Deseret Morning News*
Ravell Call, *Deseret Morning News*
Ravell Call, *Deseret Morning News*
Ravell Call, *Deseret Morning News*
Ravell Call, *Deseret Morning News*
Ravell Call, *Deseret Morning News*
Ravell Call, *Deseret Morning News*

**109** Ravell Call, *Deseret Morning News*
Ravell Call, *Deseret Morning News*
Ravell Call, *Deseret Morning News*
Ravell Call, *Deseret Morning News*
Ravell Call, *Deseret Morning News*
Ravell Call, *Deseret Morning News*
Ravell Call, *Deseret Morning News*

**110** Keith Johnson, *Deseret Morning News*
Keith Johnson, *Deseret Morning News*
Keith Johnson, *Deseret Morning News*
Trent Nelson
Keith Johnson, *Deseret Morning News*
Lori Adamski-Peek
Keith Johnson, *Deseret Morning News*

**111** Kent Miles
Keith Johnson, *Deseret Morning News*
Kent Miles
Keith Johnson, *Deseret Morning News*
Keith Johnson, *Deseret Morning News*
Kent Miles
Scott G. Winterton,
*Deseret Morning News*

**112** Rick Egan, *The Salt Lake Tribune*
Jason Olson, *Deseret Morning News*
Kent Miles
Jason Olson, *Deseret Morning News*
Jason Olson, *Deseret Morning News*
Jason Olson, *Deseret Morning News*
Rick Egan, *The Salt Lake Tribune*

**113** Rick Egan, *The Salt Lake Tribune*
Rick Egan, *The Salt Lake Tribune*
Rick Egan, *The Salt Lake Tribune*
Jason Olson, *Deseret Morning News*
Rick Egan, *The Salt Lake Tribune*
Kent Miles
Rick Egan, *The Salt Lake Tribune*

**116** Leah Hogsten
Keith Johnson, *Deseret Morning News*
Lori Adamski-Peek
Keith Johnson, *Deseret Morning News*
Leah Hogsten
Leah Hogsten
Leah Hogsten

**117** Leah Hogsten
Leah Hogsten
Keith Johnson, *Deseret Morning News*
Lori Adamski-Peek
Leah Hogsten
Leah Hogsten
Keith Johnson, *Deseret Morning News*

**118** Mitch Mascaro, *Herald Journal*
Jeremy Harmon
Leah Hogsten
Steve Harrington
Scott G. Winterton,
*Deseret Morning News*
Mitch Mascaro, *Herald Journal*
Jeremy West

**119** Nick Adams
Scott G. Winterton,
*Deseret Morning News*
Leah Hogsten
Steve Harrington
Rick Egan, *The Salt Lake Tribune*
Leah Hogsten
Scott G. Winterton,
*Deseret Morning News*

**120** Nick Adams
Jason Olson, *Deseret Morning News*
Jeremy Harmon
Jeremy Harmon
Chuck Wing, *Deseret Morning News*
Jason Olson, *Deseret Morning News*
Lori Adamski-Peek

**121** Jeremy Harmon
Ravell Call, *Deseret Morning News*
Laura Seitz, *Deseret Morning News*
Sallie Dean Shatz
Jason Olson, *Deseret Morning News*

Steve Harrington
Scott G. Winterton,
*Deseret Morning News*

**122** Kent Miles
Kent Miles
Kent Miles
Ravell Call, *Deseret Morning News*
Kent Miles
Nick Adams
Kent Miles

**123** Kent Miles
Kent Miles
Kent Miles
Kent Miles
Kent Miles
Kent Miles
Kent Miles

**124** Rick Egan, *The Salt Lake Tribune*
Rick Egan, *The Salt Lake Tribune*
Rick Egan, *The Salt Lake Tribune*
Rick Egan, *The Salt Lake Tribune*
Rick Egan, *The Salt Lake Tribune*
Rick Egan, *The Salt Lake Tribune*
Rick Egan, *The Salt Lake Tribune*

**126** Lori Adamski-Peek
Keith Johnson, *Deseret Morning News*
Kent Miles
Lori Adamski-Peek
Lori Adamski-Peek
Lori Adamski-Peek
Kent Miles

**127** Lori Adamski-Peek
Nick Adams
Lori Adamski-Peek
Nick Adams
Lori Adamski-Peek
Lori Adamski-Peek
Nick Adams

**128** Rick Egan, *The Salt Lake Tribune*
Rick Egan, *The Salt Lake Tribune*
Jeremy Harmon
Jeremy Harmon
Rick Egan, *The Salt Lake Tribune*
Robyn L. Poarch
Ravell Call, *Deseret Morning News*

**129** Trent Nelson
Rick Egan, *The Salt Lake Tribune*
Rick Egan, *The Salt Lake Tribune*
Jeremy Harmon
Sallie Dean Shatz
Sallie Dean Shatz
Rick Egan, *The Salt Lake Tribune*

**134** Larry C. Price
Steve Harrington
Jeremy Harmon
Leah Hogsten
Susan Bryan
Lori Adamski-Peek
Sallie Dean Shatz

**135** Sallie Dean Shatz
Jeremy Harmon
Sallie Dean Shatz
Rod Hanna
Jeremy West
Larry C. Price
Ravell Call, *Deseret Morning News*

**137** Larry C. Price
Larry C. Price
Lori Adamski-Peek
Ravell Call, *Deseret Morning News*
Larry C. Price
Jim Hardy
Larry C. Price

# Staff

The *America 24/7* series was imagined years ago by our friend Oscar Dystel, a publishing legend whose vision and enthusiasm have been a source of great inspiration.

We also wish to express our gratitude to our truly visionary publisher, DK.

Rick Smolan, Project Director
David Elliot Cohen, Project Director

## Administrative
Katya Able, Operations Director
Gina Privitere, Communications Director
Chuck Gathard, Technology Director
Kim Shannon, Photographer Relations Director
Erin O'Connor, Photographer Relations Intern
Leslie Hunter, Partnership Director
Annie Polk, Publicity Manager
John McAlester, Website Manager
Alex Notides, Office Manager
C. Thomas Hardin, State Photography Coordinator

## Design
Brad Zucroff, Creative Director
Karen Mullarkey, Photography Director
Judy Zimola, Production Manager
David Simoni, Production Designer
Mary Dias, Production Designer
Heidi Madison, Associate Picture Editor
Don McCartney, Production Designer
Diane Dempsey Murray, Production Designer
Jan Rogers, Associate Picture Editor
Bill Shore, Production Designer and Image Artist
Larry Nighswander, Senior Picture Editor
Bill Marr, Sarah Leen, Senior Picture Editors
Peter Truskier, Workflow Consultant
Jim Birkenseer, Workflow Consultant

## Editorial
Maggie Canon, Managing Editor
Curt Sanburn, Senior Editor
Teresa L. Trego, Production Editor
Lea Aschkenas, Writer
Olivia Boler, Writer
Korey Capozza, Writer
Beverly Hanly, Writer
Bridgett Novak, Writer
Alison Owings, Writer
Fred Raker, Writer
Joe Wolff, Writer
Elise O'Keefe, Copy Chief
Daisy Hernández, Copy Editor
Jennifer Wolfe, Copy Editor

## Infographic Design
Nigel Holmes

## Literary Agent
Carol Mann, The Carol Mann Agency

## Legal Counsel
Barry Reder, Coblentz, Patch, Duffy & Bass, LLP
Phil Feldman, Coblentz, Patch, Duffy & Bass, LLP
Gabe Perle, Ohlandt, Greeley, Ruggiero & Perle, LLP
Jon Hart, Dow, Lohnes & Albertson, PLLC
Mike Hays, Dow, Lohnes & Albertson, PLLC
Stephen Pollen, Warshaw Burstein, Cohen, Schlesinger & Kuh, LLP
Rick Pappas

## Accounting and Finance
Rita Dulebohn, Accountant
Robert Powers, Calegari, Morris & Co. Accountants
Eugene Blumberg, Blumberg & Associates
Arthur Langhaus, KLS Professional Advisors Group, Inc.

## Picture Editors
J. David Ake, Associated Press
Caren Alpert, formerly *Health* magazine
Simon Barnett, *Newsweek*
Caroline Couig, *San Jose Mercury News*
Mike Davis, formerly *National Geographic*
Michel duCille, *Washington Post*
Deborah Dragon, *Rolling Stone*
Victor Fisher, formerly Associated Press
Frank Folwell, *USA Today*
MaryAnne Golon, *Time*
Liz Grady, formerly *National Geographic*
Randall Greenwell, *San Francisco Chronicle*
C. Thomas Hardin, formerly *Louisville Courier-Journal*
Kathleen Hennessy, *San Francisco Chronicle*
Scot Jahn, *U.S. News & World Report*
Steve Jessmore, *Flint Journal*
John Kaplan, University of Florida
Kim Komenich, *San Francisco Chronicle*
Eliane Laffont, *Hachette Filipacchi Media*
Jean-Pierre Laffont, *Hachette Filipacchi Media*
Andrew Locke, MSNBC
Jose Lopez, *The New York Times*
Maria Mann, formerly AFP
Bill Marr, formerly *National Geographic*
Michele McNally, *Fortune*
James Merithew, *San Francisco Chronicle*
Eric Meskauskas, *New York Daily News*
Maddy Miller, *People* magazine
Michelle Molloy, *Newsweek*
Dolores Morrison, *New York Daily News*
Karen Mullarkey, formerly *Newsweek, Rolling Stone, Sports Illustrated*
Larry Nighswander, Ohio University School of Visual Communication
Jim Preston, *Baltimore Sun*
Sarah Rozen, formerly *Entertainment Weekly*
Mike Smith, *The New York Times*
Neal Ulevich, formerly Associated Press

## Website and Digital Systems
Jeff Burchell, Applications Engineer

## Television Documentary
Sandy Smolan, Producer/Director
Rick King, Producer/Director
Bill Medsker, Producer

## Video News Release
Mike Cerre, Producer/Director

## Digital Pond
Peter Hogg
Kris Knight
Roger Graham
Philip Bond
Frank De Pace
Lisa Li

## Senior Advisors
Jennifer Erwitt, Strategic Advisor
Tom Walker, Creative Advisor
Megan Smith, Technology Advisor
Jon Kamen, Media and Partnership Advisor
Mark Greenberg, Partnership Advisor
Patti Richards, Publicity Advisor
Cotton Coulson, Mission Control Advisor

## Executive Advisors
Sonia Land
George Craig
Carole Bidnick

## Advisors
Chris Anderson
Samir Arora
Russell Brown
Craig Cline
Gayle Cline
Harlan Felt
George Fisher
Phillip Moffitt
Clement Mok
Laureen Seeger
Richard Saul Wurman

## DK Publishing
Bill Barry
Joanna Bull
Therese Burke
Sarah Coltman
Christopher Davis
Todd Fries
Dick Heffernan
Jay Henry
Stuart Jackman
Stephanie Jackson
Chuck Lang
Sharon Lucas
Cathy Melnicki
Nicola Munro
Eunice Paterson
Andrew Welham

## Colourscan
Jimmy Tsao
Eddie Chia
Richard Law
Josephine Yam
Paul Koh
Chee Cheng Yeong
Dan Kang

## Chief Morale Officer
Goose, the dog